DBA
Dórea
Books and Art

Photographs by

CLAUDIO EDINGER

CARNAVAL

Texts by

ARNALDO JABOR

JORGE AMADO

ROBERTO DAMATTA

DEWI LEWIS

PUBLISHING

First printing, 1996

U.K. edition published by
Dewi Lewis Publishing
8, Broomfield Road
Heaton Moor
Stockport SK 4ND
0161 442 9450

Original Publisher
Alexandre Dórea Ribeiro

General Coordination
Maiá Mendonça
Photo Consultant
Pamela Duffy
Executive Coordination
Adriana Amback
DBA Studio Coordinator
Fernando Moser

Art Director
Marcelo Menegolli
Assistant Art Director
Mauricio Nisi Gonçalves
Bob Lima
Text Revision
Plural Assessoria
Translation
C. Stuart Birkinshaw

Films and Printing
Dai Nippon Press - Japan

Photographs Copyright © 1996 by
Claudio Edinger

Copyright © 1996 by
DBA® Dórea Books and Art
Alameda Franca, 1185 cj 31 e 32
cep 01422-010 Cerqueira César
São Paulo, SP, Brasil

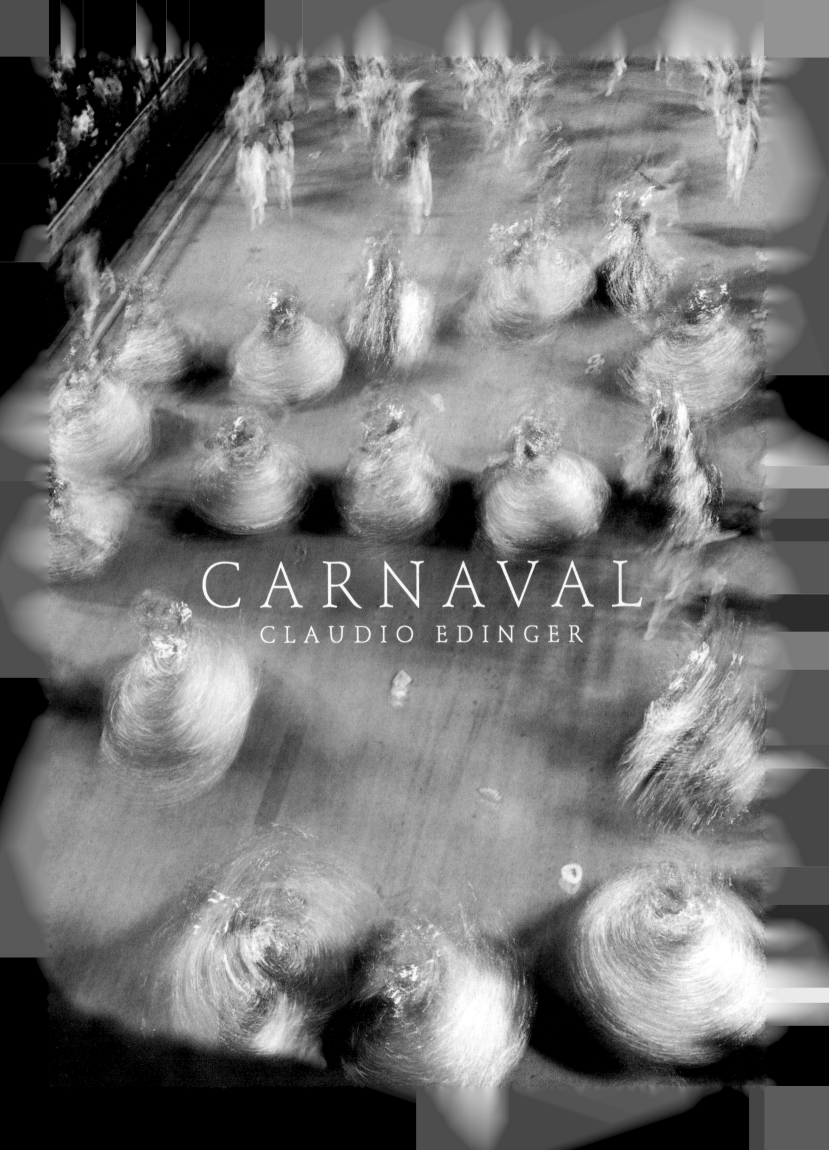

CARNAVAL

CLAUDIO EDINGER

Acknowledgments

To Alexandre Dórea Ribeiro, Maiá Mendonça and all the DBA team, Adriana Amback, Marcelo Menegolli, Mauricio Nisi Gonçalves, Fernando Moser, Bob Lima, Carmem Sílvia de Carvalho, Sílvia Ghirello, Linda Vilas Boas e Maria do Socorro Sabóia, for all the support and guidance that made this book possible.

To Dascha Edinger, Pamela Duffy, Jay Colton, Abigail Heyman, Zelio Alves Pinto, Nessia Pope, Dewi Lewis, Orlando Azevedo, Carlos Carvalhosa, Luis Carlos Scholz, Max Feffer, Fabio Starace Fonseca, Alberto de Carvalho Alves, Renato Ganhito, Joelson e Fanny Amado, Claudio Willer, Thomas Csiha, Jenny Gorman, Cathy Colon, Sharon Gallagher, Bill Hochhausen, Rodrigo Monte, Peter Howe, Cornell Capa, Sudie Redmond, Thomaz Farkas, Marly Mariano, João Farkas, Fátima Leão, Carlos Eduardo and Carminha de Barros, Gilda Mattar, Scott Mlyn, Bert Wolf, Alex Chacon, Didier Kelly, Isabel Amado, Solange Farkas, Suzana Villas-Boas, Marcelo Kahns, Claudio Kahns, Mika Lins, Fabíola Chiminazzo, Juan Ugarte, Tereza Mainardi, Clifford Li, Paulo Marcos de Mendonça Lima, Zita Carvalhosa, Roberto Muggiati, Tarlis Batista, Marisa Baer, Joaquim e Beth Pedrinha, Katrina Del Mar, Raul Dias, Toninho El Ottra, Kiko Piratininga, Adailson Reis, Christina Cunali and Christopher Idone, for their advice, kindness, support and patience during this project. This book would not have been possible without you.

This book would not have come about without the generosity of Labtec, who developed all the films and Aurora Color Lab, in New York, who did all the enlargements; of *Manchete* magazine who gave me access to all the events; of Vitae Foundation, whose grant was fundamental.

My special thanks to Paramahansa Yogananda, for his sweet wisdom.

All the photos were taken with Mamiya 6 cameras, Kodak 120 plus X film, Vivitar 285 flash and Armatar power pack.

To Thomaz Farkas

This book is a homage to the creative spirit of a people who, in spite of poverty, injustice, corruption, surreal government and lack of development, continue to live with humor, wit, dancing and enjoying themselves.

Arnaldo Jabor

Carnival can show who we are, and through its "perverse reason", it tells us more about ourselves.

Carnival is not the object of study – it is we who are under scrutiny. It is better to understand Brazil through its Carnival than to see Carnival as a departure from reason. How can the present world find it a madness, when the world itself shocks us continuously with its own irrational behavior?

Carnival shows that Brazil has another form of seriousness, above the gravity of the Anglo-Saxon world. Carnival unmasks our bravery, our fake seriousness. Carnival reveals what we are made of behind this mime of the "West" that the country has been trying to imitate for four centuries. There's an "African Orientalness" in our lives. Africa and the Indians saved us, just as they saved the USA. What would have become of America without jazz? Can you imagine a country peeled white, full of sad WASPs?

Carnival shows that the Unconscious is only skin deep in Brazil. The harder it is repressed, the more civilized is the country. We are as the earth and the sea. Can you imagine a Carnival in Switzerland? Maybe Carnival is a saving affliction, an epidemic of delirium that the world needs, being familiar only with war, speed or the heartless marketplace. "Perverse reason" is the reason for Carnival. Not the perversion of sin, but perversion as a mimic of liberty, the seeking of an "uncivilized" civilization, of a return to an animality that is lost but nevertheless pulsing. The West has its rock music, no doubt; but rock usually speaks of a transgressive fight (especially current rock), of a social revolt unlike the feminine tenderness of Carnival.

Just as rock is masculine, Carnival is feminine. Rock is war; Carnival is luxury and voluptuousness. The tropics believe that there is no sin south of the Equator.

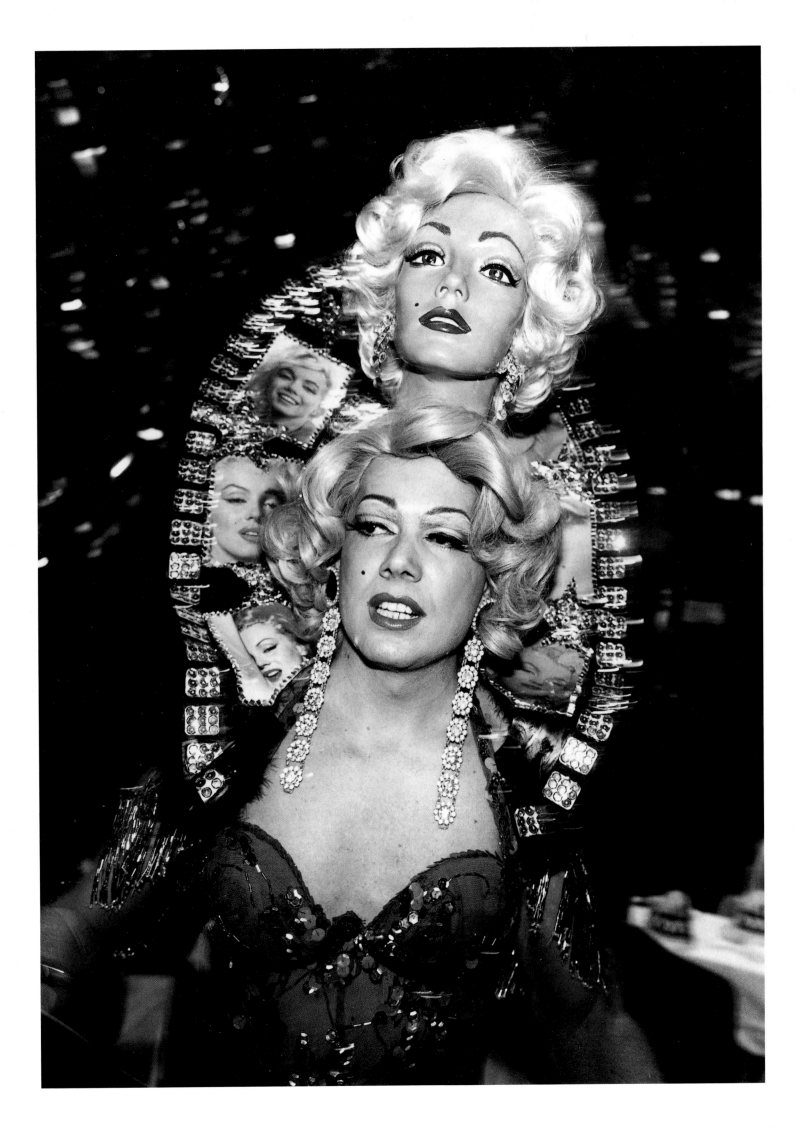

In Carnival there is something higher than morality: there is a saintliness in this explosion of flesh that is unexplainable, as unexplainable as an orgasm, creatures emerging from the water, a lightning bolt setting fire to a forest.

Nowhere else in the world does this exist. Where else can you find these mountains of bodies throwing themselves at one another, at the top of pyramids of fire and under fountains of water? Where else can you find this blend of nudity, sex and music other than in Brazilian Carnival or in the depths of Africa? In Brazil there is a desire for "Indianisation" as a form of future. Not a future of backwardness or chaos, but a future return to happiness. That is our origin, born deep in the forests, different to the Calvinistic orgies of New York, where they invented the tortured, sad sex of sick nightclubs and wound up with AIDS. Carnival does not aspire to a deep disorder, though it may seem so to the enraptured tourist. There is an underlying desire for order. Carnival is a utopia of sex, and as such seeks to attain the essential ultimate pleasure, flesh beyond space and time revealing all: the why of life and matter, the mystery of reproduction, the destiny of DNA. In Carnival there is a lust for mating that is so primitive, so prehistoric and natural that it reveals all the secrets, like an epiphany.

Carnival tries to transform culture into nature, the actual real sexuality of Carnival having a symbolic pain. There is no reality or sexual conquest to explain this ancient fantasy. The women floating in the air above the parades are beyond real desire. Conquered, reached, they would be real, mortal and no longer the goddesses of metaphysical sex. Our desire does not want to be realised in Carnival, wants to remain inconclusive, infinite, utopic. One can only understand Brazil by the nudity of the women and of the men who also want to become women. The men also want to be women during Carnival. Everyone wants to be everything: the men want to have breasts and fecundity and the women want to be as agile and effective in their seduction as if they were machines for exciting dancing phalluses. Hence the importance of transvestism in

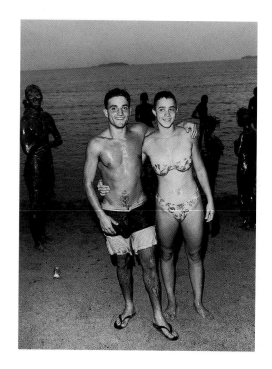

The Mud Parade, Parati, 1995

Carnival. Transvestism is a baroque procedure; there are no classic transvestites. For this reason, Carnival is also a gay's paradise. This search for femininity is unique in the world. A world that is *macho,* or has a violent sexuality, has a lot to learn from the Carnival women, the daughters of cinema mythologies, the black mamas of Negro Brazil, slaves as beautiful as Hollywood stars. Perhaps the closest thing to Rio's Carnival were the American musicals. Bubsy Berkeley invented the samba school without knowing he had done so.

The Carnival in our soul is strongly resistant as we enter the so-called "new world order". Today's world stems from a violent Protestant rationality, where delirious art has been transformed into "American services". This pragmatism goes against our Dionysian and Shakespearean spirit. Against a modern society made up of the prosperous in globalised informatics, we are opposed like a band of happy Calinas and ballet dancers. This resistance to civilisation is our trade mark. Maybe some day we will be able to contribute to the world's progress through this sensuality.

But even in Rio's Carnival the influence of virtualisation and "modernity" is felt. *Being* has given way to *seeing.* The official Carnival of the samba schools has become a tourist attraction, even for Brazilians. On the official avenue, everybody will see and be seen. For this reason the true Brazilian Carnival is in the

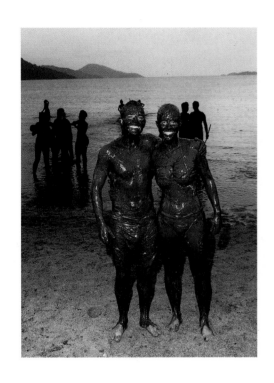

The Mud Parade, Parati, 1995

back streets and in anonymous individuals. This is the great feature of Claudio Edinger's book; to discover in these streets the precious origin of real Carnival. Claudio Edinger goes out, camera in hand and snaps poetic madmen. His lens shows those who are desperate, starving for love, failed stars, the famous unknown, whores, street madmen, those excluded from the official festivities. It is among them that new poetic senses can arise, that is where new symbols are always born, out of a basic phenomenon – popular culture.

Carnival in the streets is a far cry from the populism that transforms the popular into kitsch. There they are, the Carnival dancers of the blocks of the

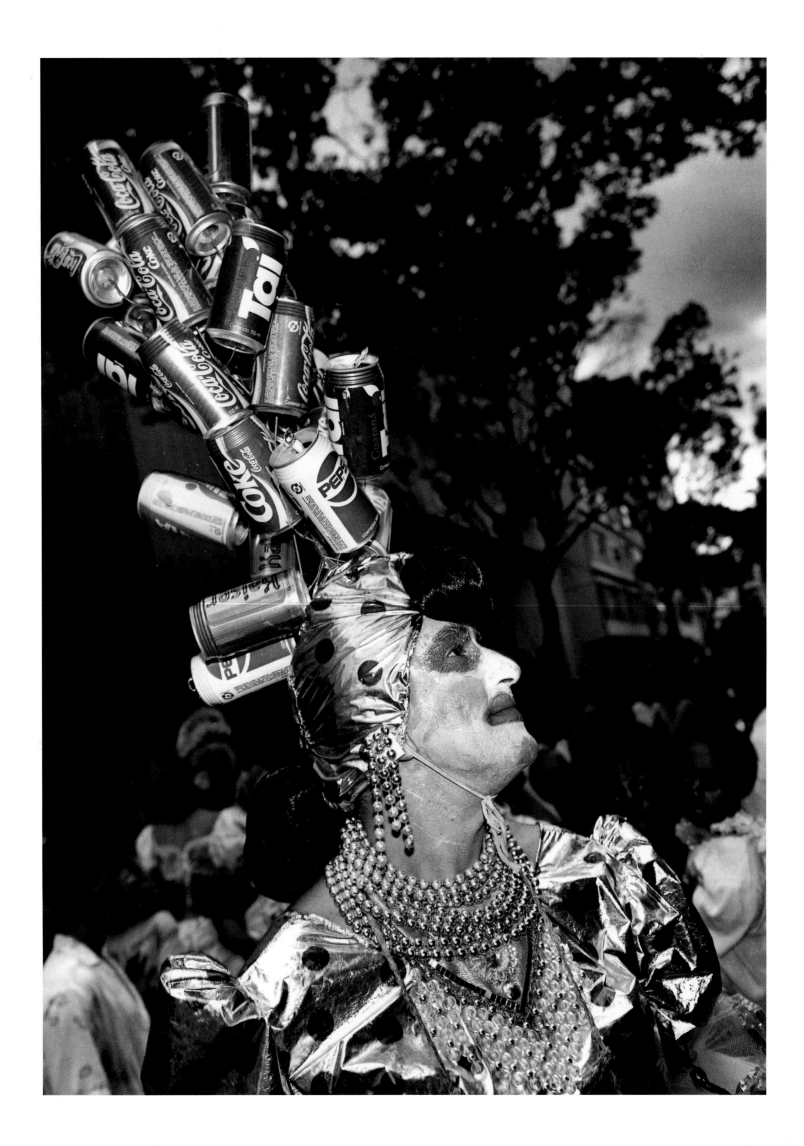

unwashed. Unwashed angels with dirty faces, blocks of ruffians, the block of vagabonds, of ornamental drunks, of the poor Negroes. These misfits exert upon us and upon Claudio Edinger the great fascination of madness, the secret of anonymous and solitary euphoria, the beauty of the mud into which the dancers will throw themselves, the primeval ooze from where we all came, a fecund mud that generates new discoveries. In some way these "dirty" people hold the secret and the solution to our pain. Excluded from the clean world, only the "dirty" are saints. Here before Claudio Edinger's camera is the revolt against the inhuman labour that the world imposes upon us, the pleasure of mocking the obvious beauty of a universe of good design.

And in the destruction of this clean beauty, there is the invasion of a grotesque poetry. A poetry that has come down through centuries, from Brueghel and Bosch, through Goya, Ensor, Magritte and Picasso, to a Brazilian baroque of coloured chaos. Edinger's book is anti-Mapplethorpe. Against sex as pain and death, for sex as life and fun. Something more profound is hidden in the madness of these hoboes dancing in their Brazilian misery.

The book tries to show this mystery, which like every good mystery remains pulsing and unsolved. The three Brazilian races entwined in the hope of total orgy, of a mad group marriage: Negroes, Whites and Indians, giving birth to a great half-caste chuckling baby - may it teach the world that logic is Death.

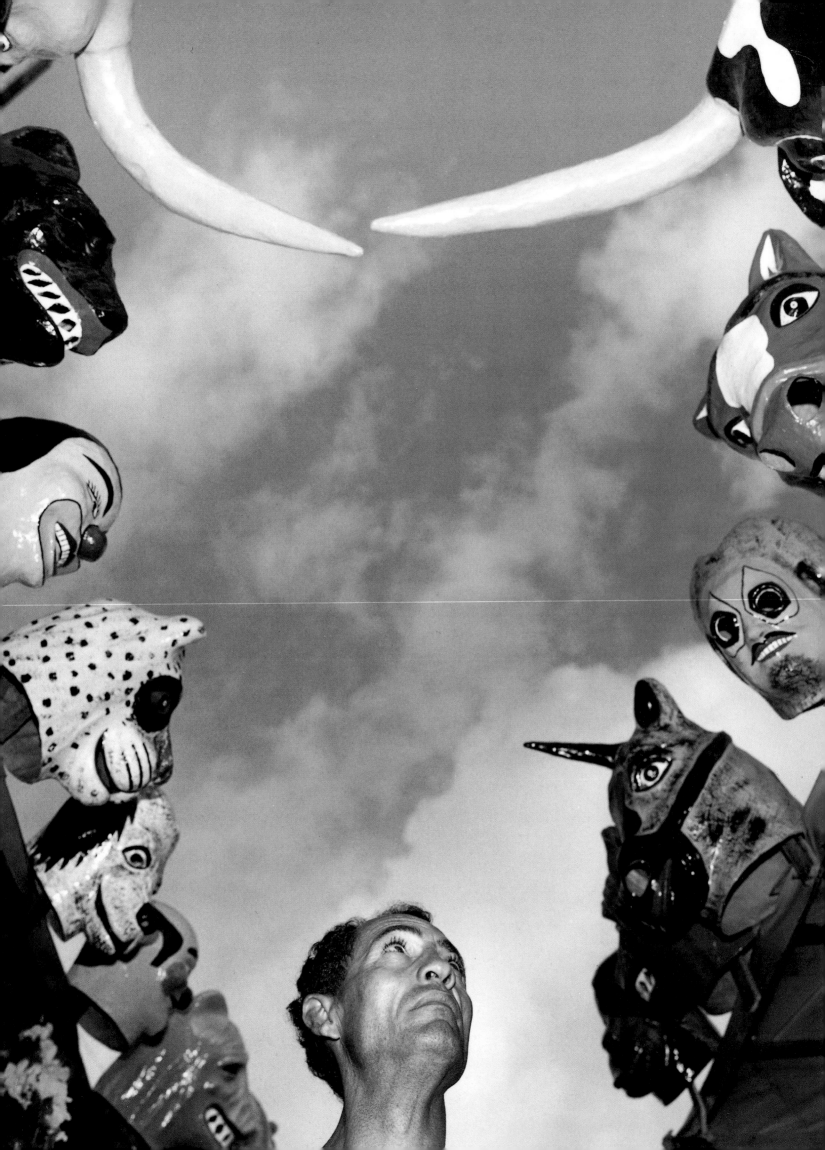

Roberto Damatta

My Dear Claudio Edinger, I am certain that the Carnival photos you invent will be a success. First, because they show that you can "see" and, as you said, "invent" Carnival. All right, we all know that Carnival is not something that you can make immediately understandable to someone. Just as to participate you have to use costume (even if it's no more than a pirate's earring, a cheap mask, a rattle, some old clothes or a gaudy striped shirt), it is necessary to take a certain vantage point to view it both in its diversity and as a whole, in its easy gaiety, in its paradoxes and more profound contradictions that reveal the tear behind the smile; the authoritative speech behind the lyrics of the samba; the hunger and garbage behind plenty and luxury; the femininity that really embraces Brazilian society, behind the ball-room *machismo*, put on for appearance and no more.

Yes, my dear Claudio, you show yourself to be a master, able to "read" and create Carnival, running your magic eye over some of the more fundamental aspects of our revelry – this national madness that possesses all of Brazil and its people for almost a whole week.

Carnival in Brazil is different from other "mardi gras" in that it is not localised, although it has many obviously regional aspects. In the United States there is Carnival only in New Orleans and, of course wherever there is a colony of Brazilians who will not forget it; in France "mardi gras" is celebrated in Nice while in Germany it occurs in Hamburg and in Italy in Venice, but in Brazil *King Momo*[1] governs throughout the country, from the great urban centres, monstrously impersonal and callous in their attitude toward poverty, hardship and crime, the cities on

[1] King Momo *(Rei Momo)* - An individual, usually selected for his stoutness, dressed up as the King of the Carnival for the season.

the far boundaries of Brazilian civilization, or those most distant communities, as I was able to note one day, celebrating Carnival in Tocantinópolis, Goiás, an Indian village that I was studying as an anthropologist.

These, as one might call them, universal aspects of Brazilian Carnival you pick up during the course of your work, which explains my insistence on claiming that you know how to "navigate" through the mad world that is King Momo's kingdom, or through disorder as a great captain on a long voyage. You know how to recognize the dynamics of the almost formal parades of the samba schools, when the poor become transformed into aristocrats, imparting a certain dignity to the money of the *bicheiros*[2] that finance the operation; and you also know how to interpret the thousands of microscopic Carnival dramas, these tiny plays of the people in which every citizen has the right to act and participate, once he or she is duly garbed in fancy dress and steps into the streets, revealing what they may have liked to have been, or could have been. This is the profound sense that we Brazilians call *"fantasia"* – this dream that Brazil's **Carnival awakens and materialises.** You capture so splendidly showing this redemption of the equality and liberty of the individual in a profoundly controlled, authoritarian and hierarchical society in which social life revolves around family ties and relationships.

Salvador, 1993

In the same way, you capture the human and mysterious individuality of each reveller. This individuality contrasts brutally with the sense of place and social position which dominates our national daily existence. Your photography illustrates that overflowing and essential creativity hiding behind every humble and apparently ignorant face: behind each poor man a nobleman; behind each rich man a common man; behind each suburban woman a

[2] *Bicheiro* - An owner of an illegal "numbers game". Bicheiros (a *bicho* = an animal) also organise their lottery based upon animals as well as groups of numbers. Wealthy bicheiros have traditionally sponsored many samba schools.

Hollywood star; behind each homosexual a show-girl. Behind each, another personality, as if to show that the world has shadows, highlights, angels, ghosts and, of course, Carnival and fantasia, a ritual of possession in the *Umbanda*[3] and *Candomblé*[4] courts which comes to the fore openly and clearly during Carnival.

Every Brazilian has at least two personalities; one for the home and the other for the street; one for the routine of work and another for parties and unusual moments.

You show how Brazil still has the capacity to enchant itself. In contrast to other modern countries where the national dream is simply to consume, and where the joy of living has been depleted to a certain extent through industry and commerce, progress and science, Brazil by celebrating Carnival shows how it retains the secret of an enchantment that allows one to see the same street, the same city, the same mass of people, the same poor people, the same governors, the same employees and the same bosses in a different light. From one side or another, from above or below – as a mass and as people, as an individual (as an anonymous number, a Mister Nobody, part and parcel of a mass to be exploited to be destined for suffering) and as a special person, a son of the family and a Someone – as "a person" with a right to life, happiness and joy. As if society as a whole had put on a new cloak or simply turned its clothing inside out, or had deliberately decided to stand on its head, intentionally subverting its most sacred standards of behaviour.

Perhaps this is Brazil's secret and great symbolic asset. Maybe it is through Carnival, that we will find the path to rescue Brazil through love and through the passion to be seen in these faces, in these lives, in these paradoxes. I wish you every success, and send you a true Brazilian Carnival embrace.

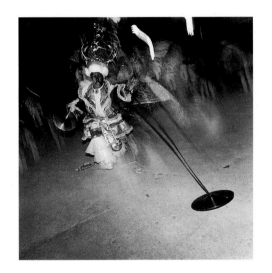

Sambódromo, Rio de Janeiro, 1991

[3] Umbanda - A cult originating from the assimilation of Afro-Brazilian religious elements and Brazilian urban Spiritualism.

[4] Candomblé - An African religion of the Ioruba negroes of Bahia.

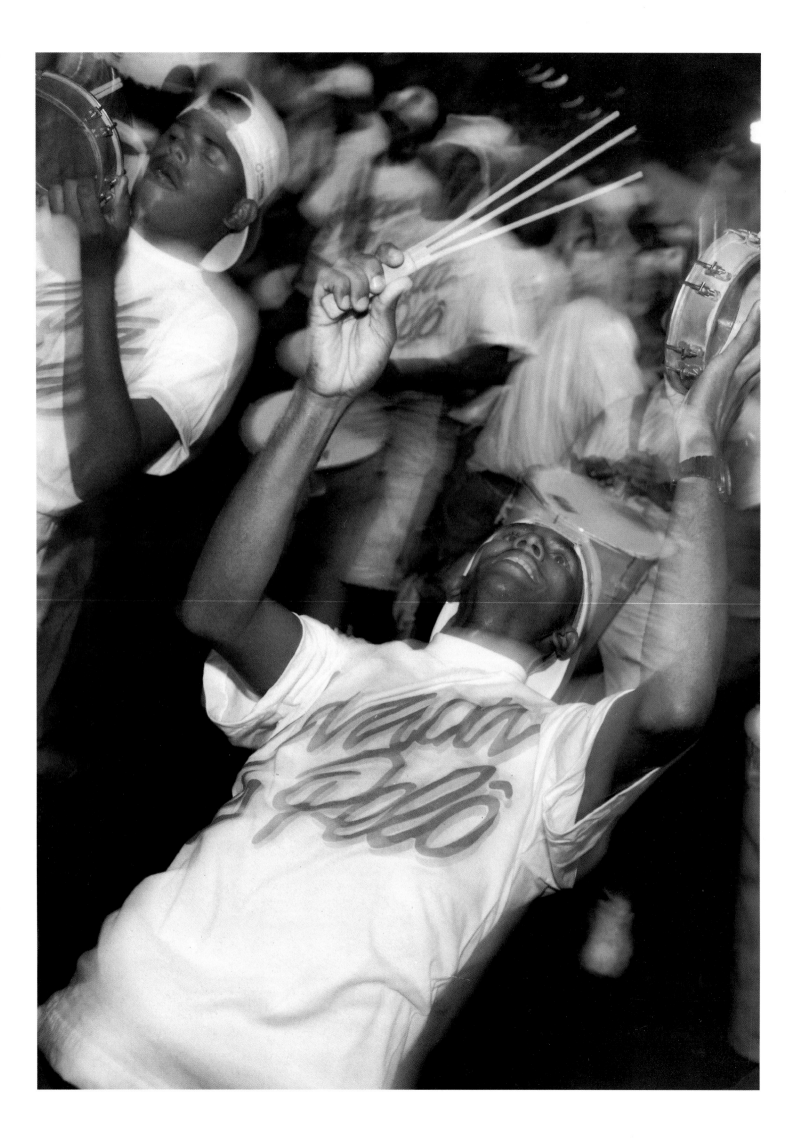

Jorge Amado

Brazil's greatest popular festivity is celebrated completely in its original form and character only here in Bahia. Predatory tourism has not managed to transform this spontaneous revelry of the people into a show to be witnessed rather than participated in by the populace. One of the main characteristics of Carnival in Bahia, a festival to end the Summer season, is this total participation; no one can stay at home everyone must come out into the streets and clubs and dance until they can no more. And the three traditional days of festivity have been increased to include the entire week: collective holidays for all the population and a generalised orgy – a Dionysian celebration which today involves, along with the Bahianos, two hundred thousand tourists from other Brazilian states and from abroad.

Along with the traditional Carnival *blocos*[1] and *cordões*[2], the great festivity in Bahia also includes elements unique to Bahia; the *"trios elétricos"* and *"afoxés"*. The first are bands assembled on decorated trucks equipped with powerful sound amplifiers. A popular *frevo*[3] by the great Bahiano composer Caetano Veloso tells a truth everyone admits to: *"You have to be dead to not follow the trio elétrico"*. The *afoxés* are direct descendants from *candomblé*, and are blocks formed by young black people playing, singing and dancing songs with a distinct African origin tinged with local rhythmic beats. *Afoxés* have a strong presence in Carnival, but the major force of this great popular festival is still the massive participation of the population - united in their desire to have fun, cast all their worries aside and surrender fully to the revelry.

[1] Bloco - A block, or group of dancers following a pre-determined choreography, usually organized by one of the samba schools.

[2] Cordão - Literally, a cord or rope; in Brazilian Carnival dances best described as a "snake", where the dancers form an indian file, each holding onto the waist of the participant in front, the leader then leading the group into whorls and convolutions among the other dancers, doubling back and forth, sometimes himself joining onto the "tail" of the snake, to the general confusion and hilarity of the participants.

[3] Frevo - A Carnival dance popular in Bahia.

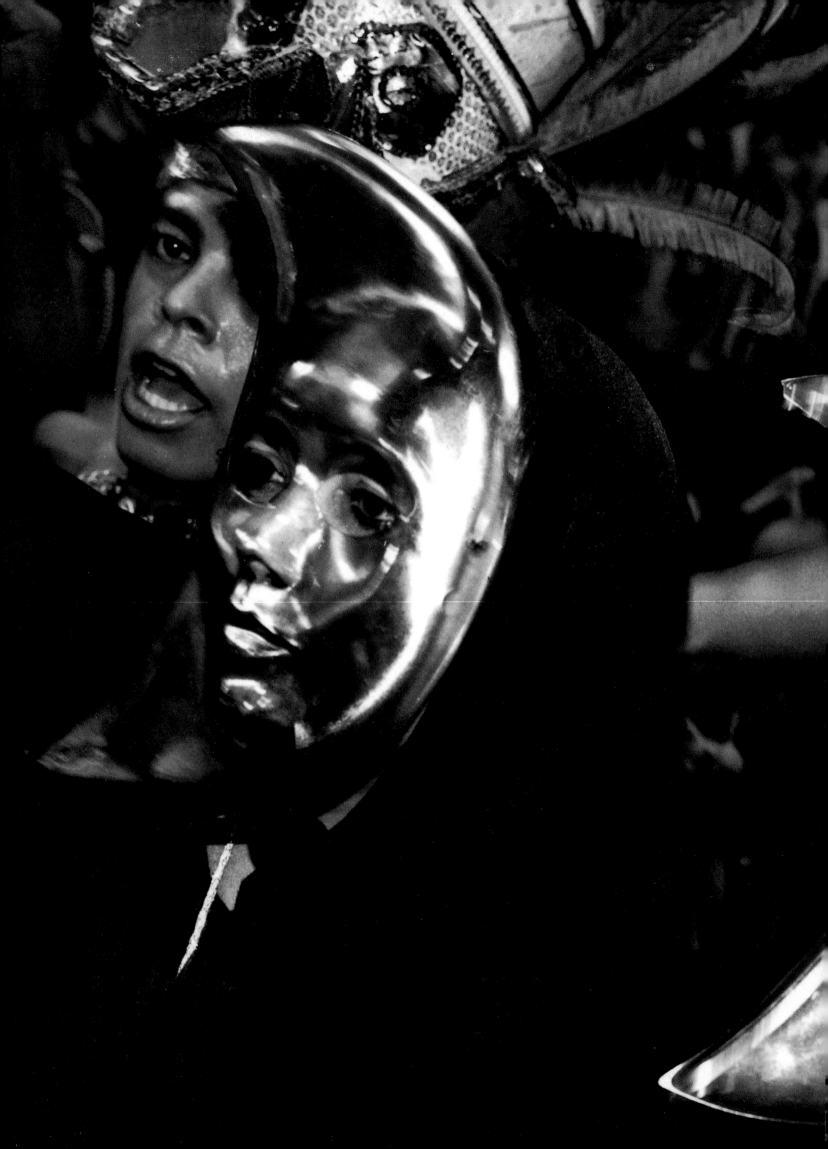

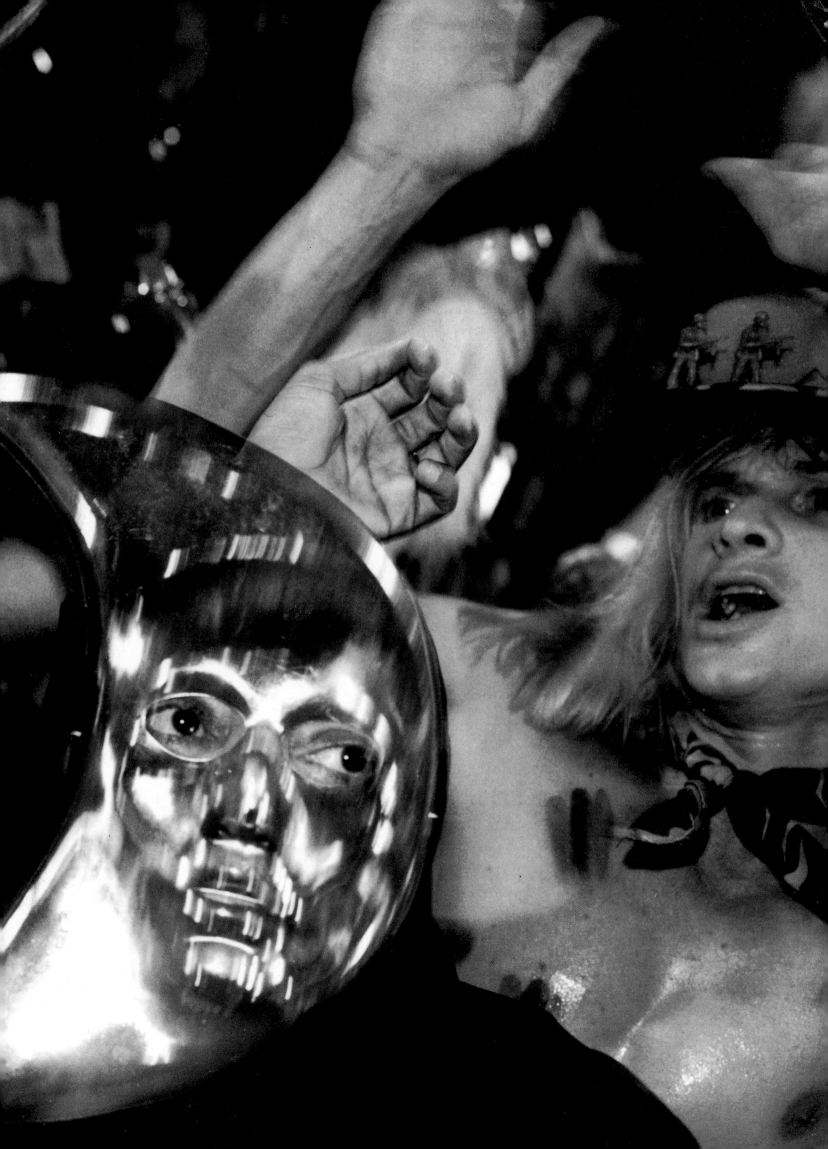

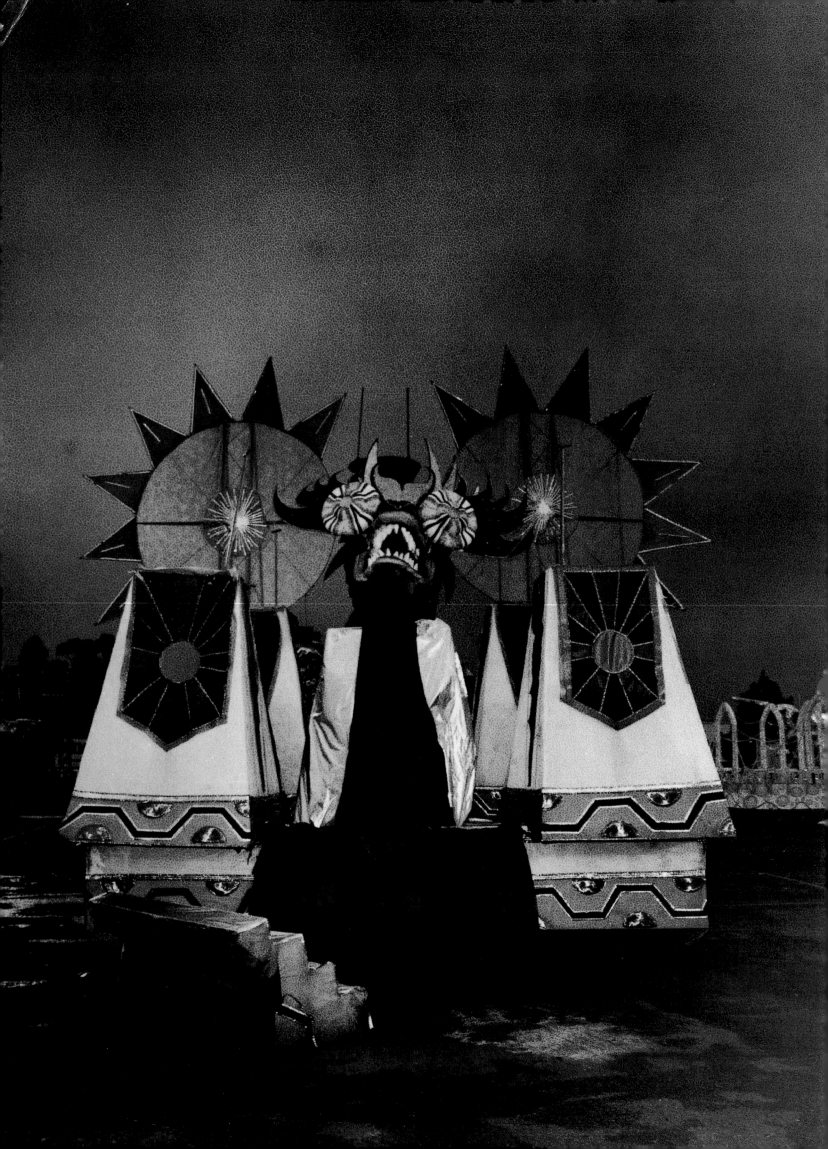

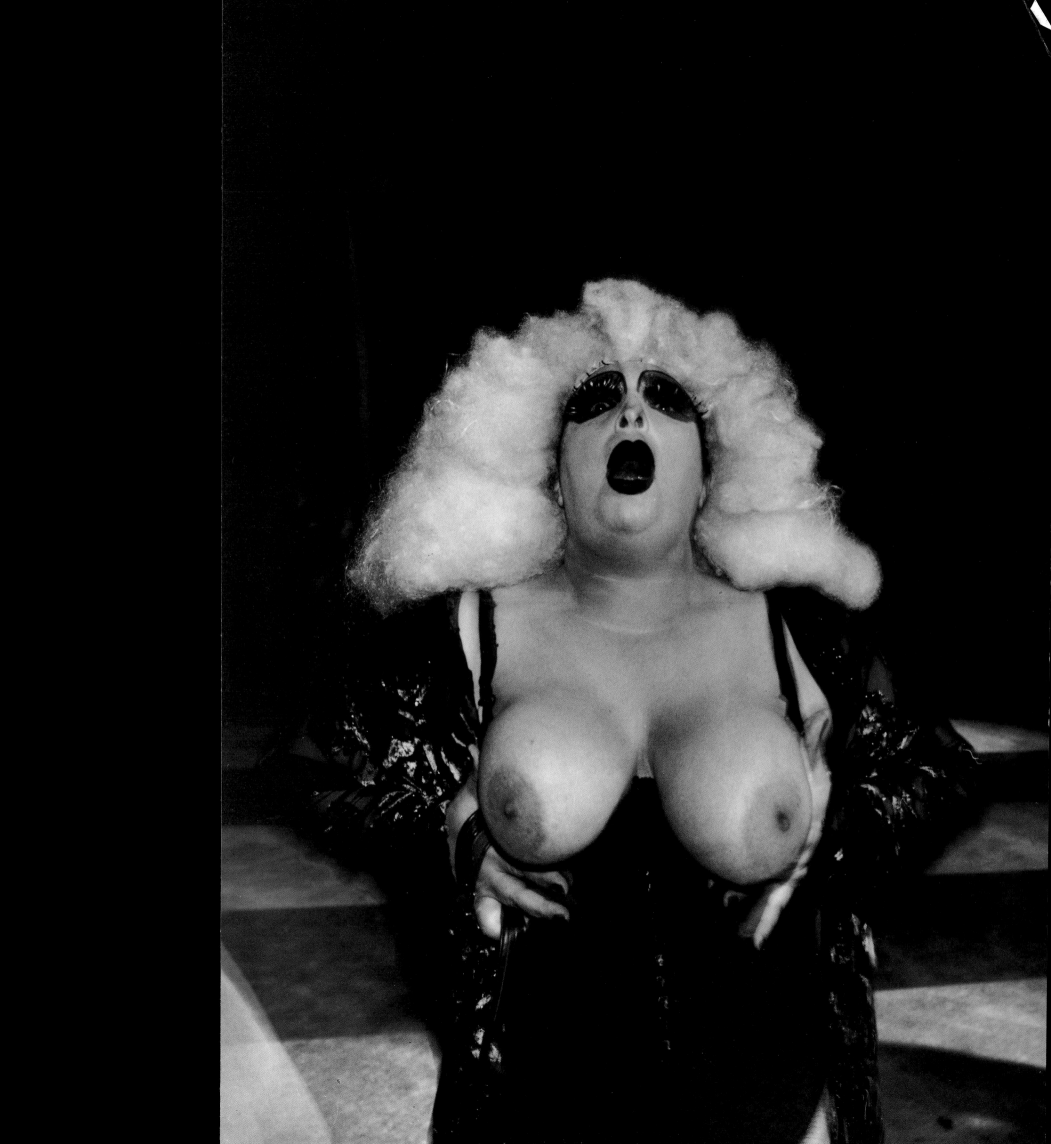

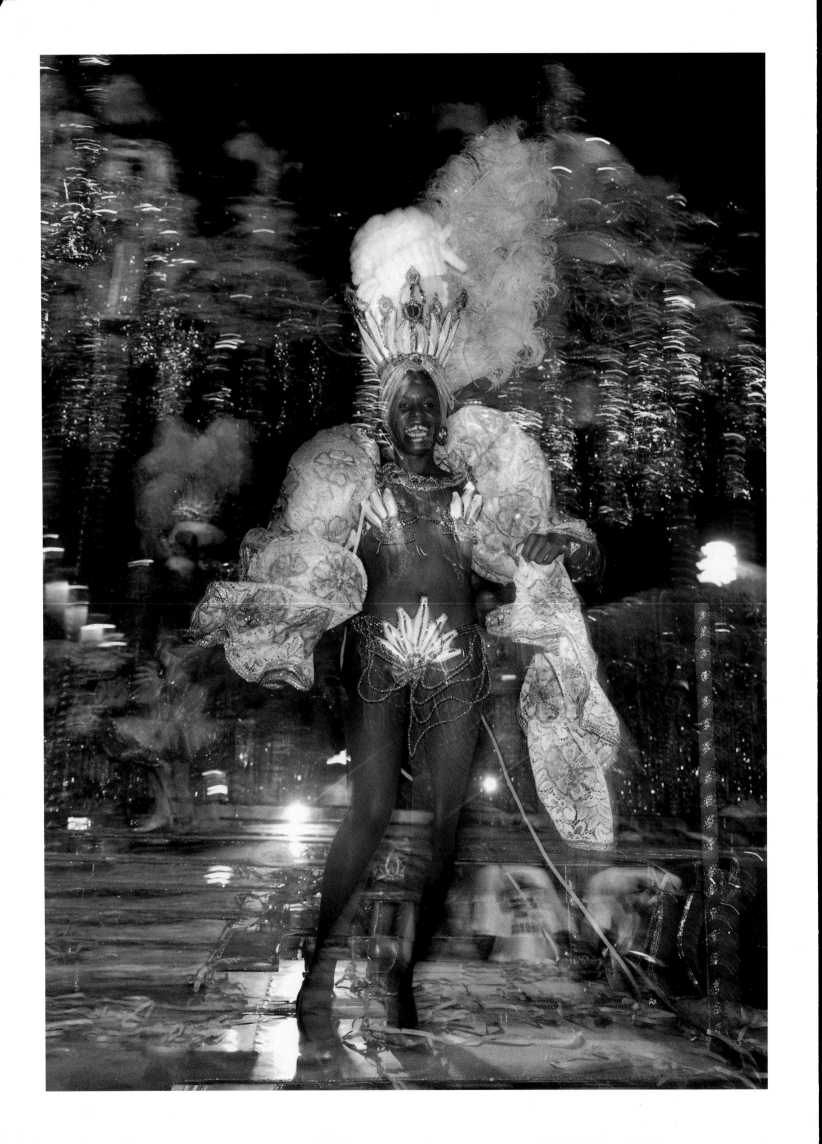

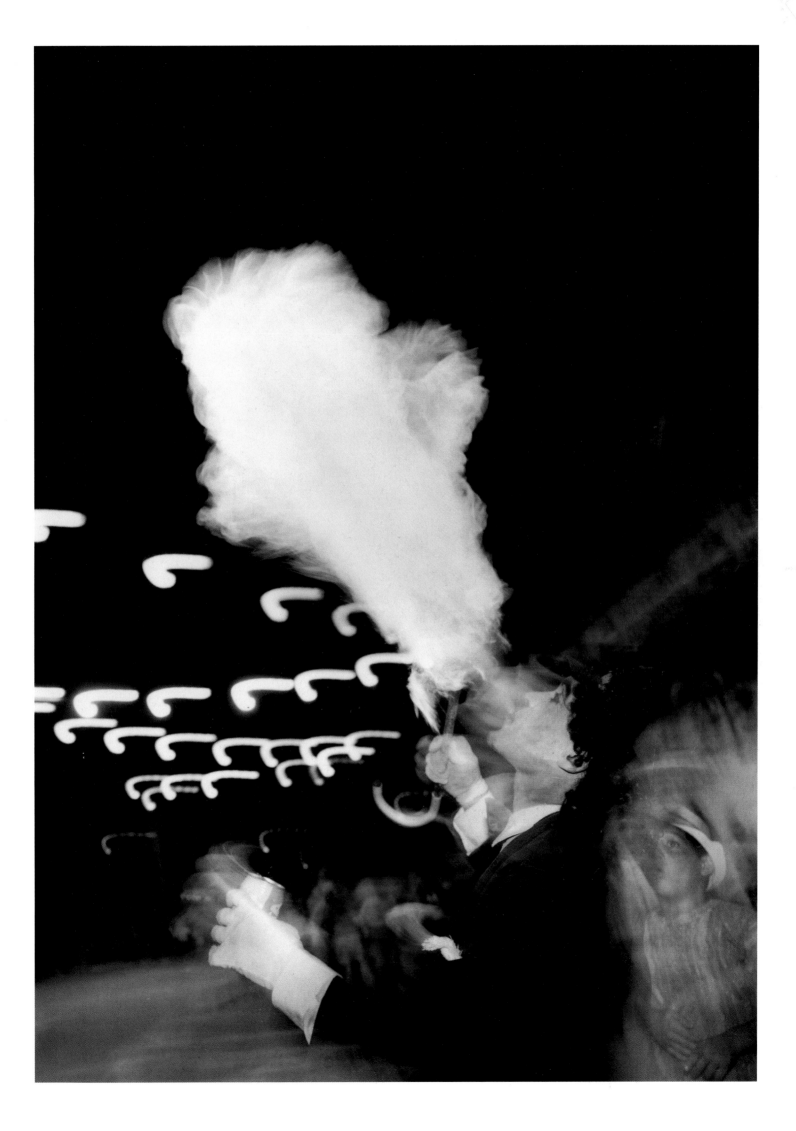

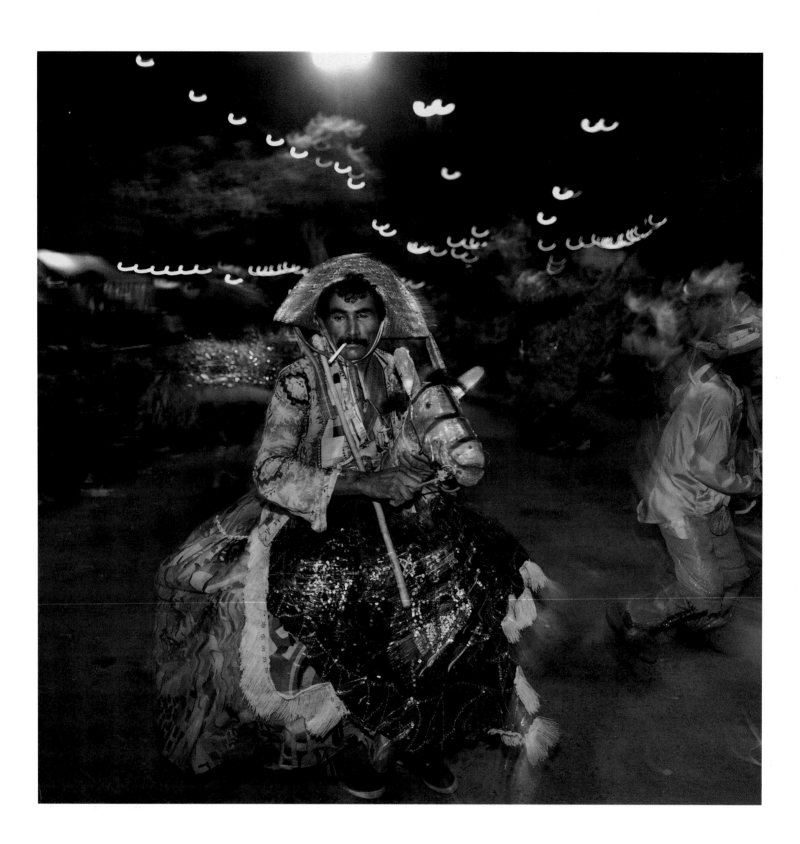

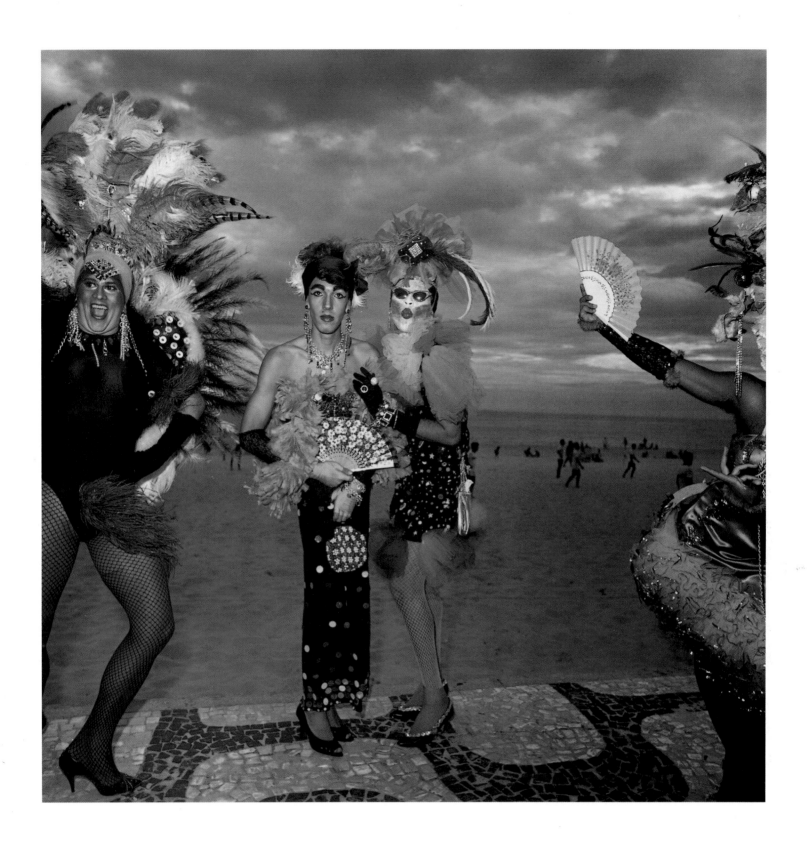

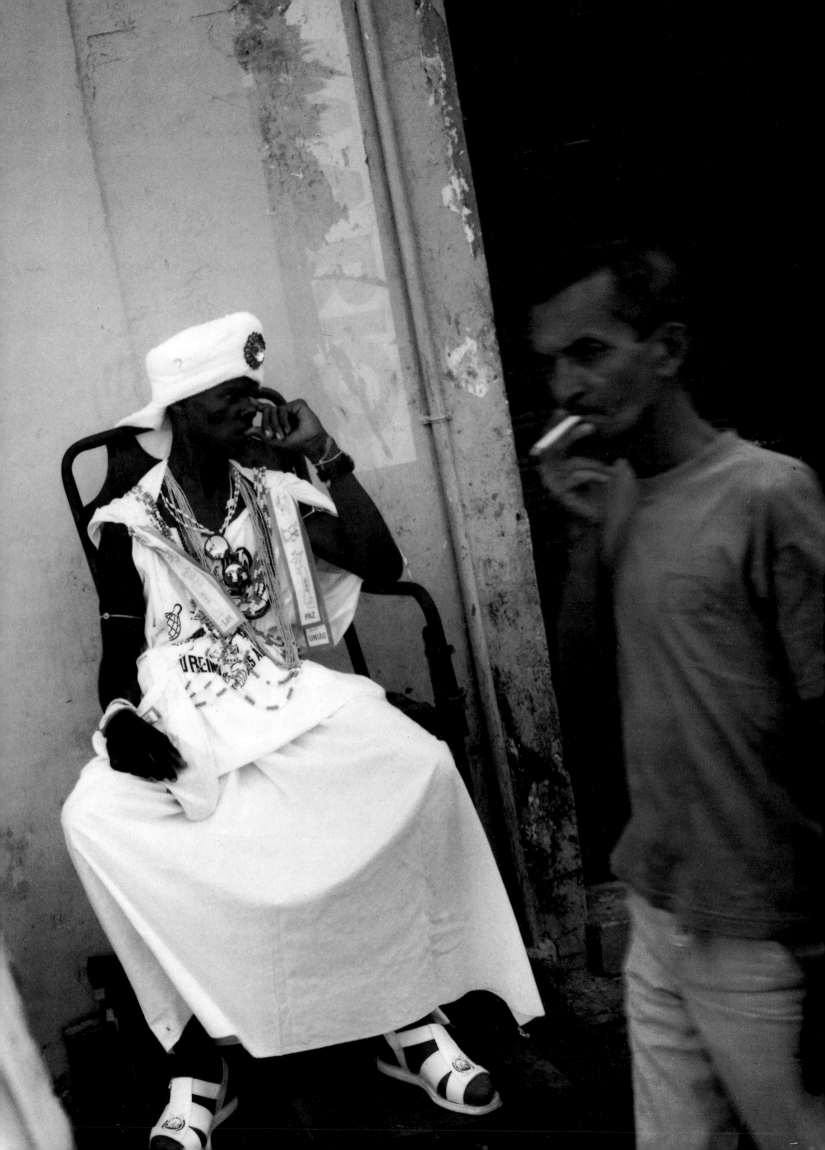

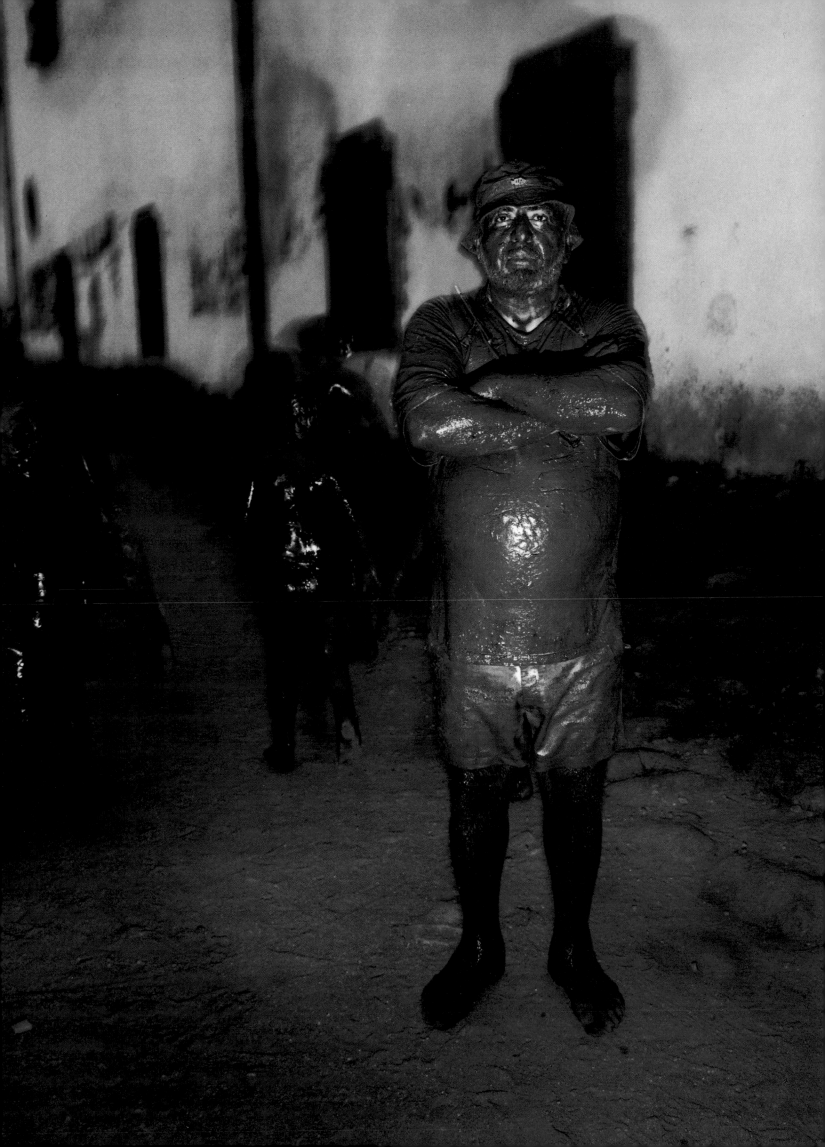

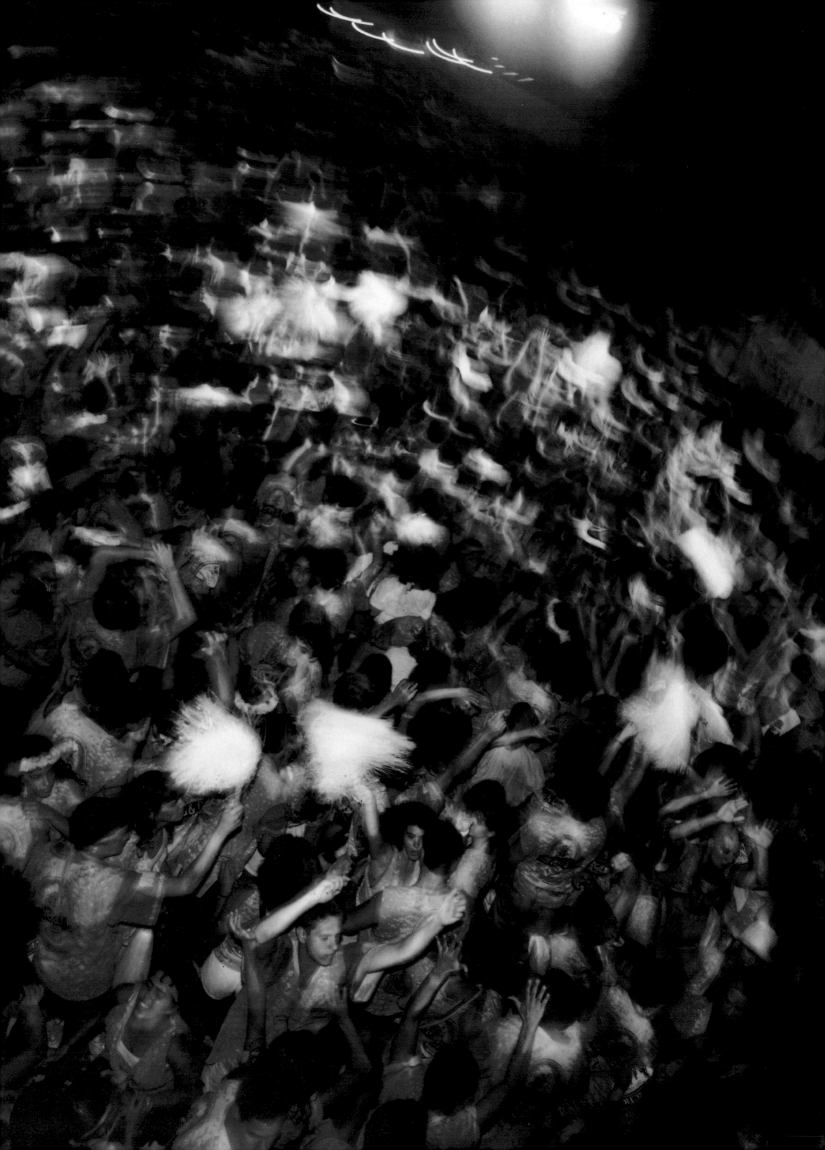

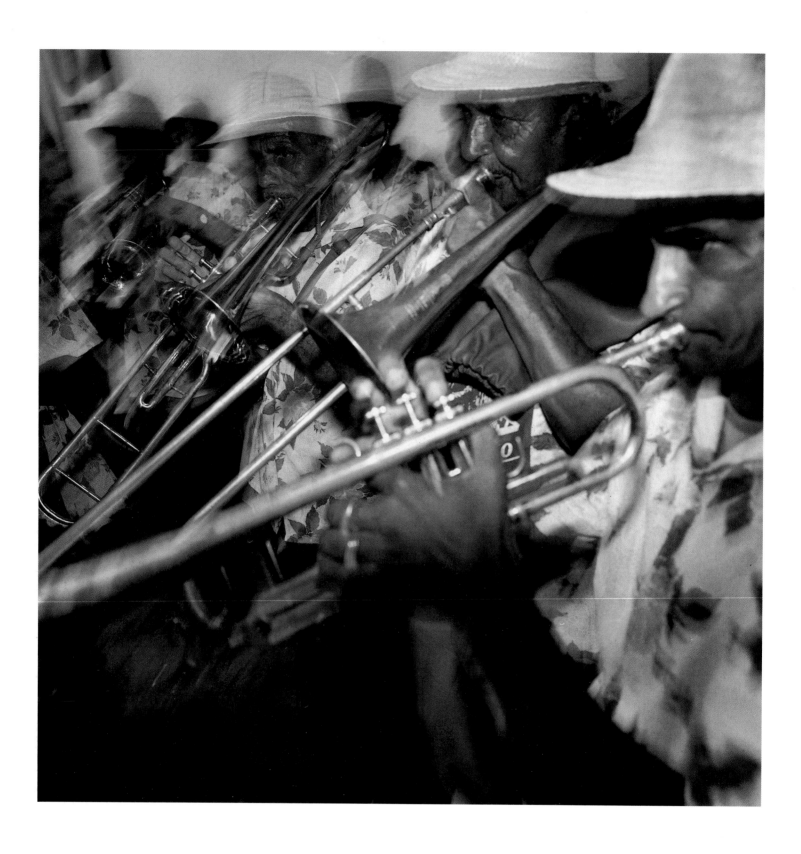

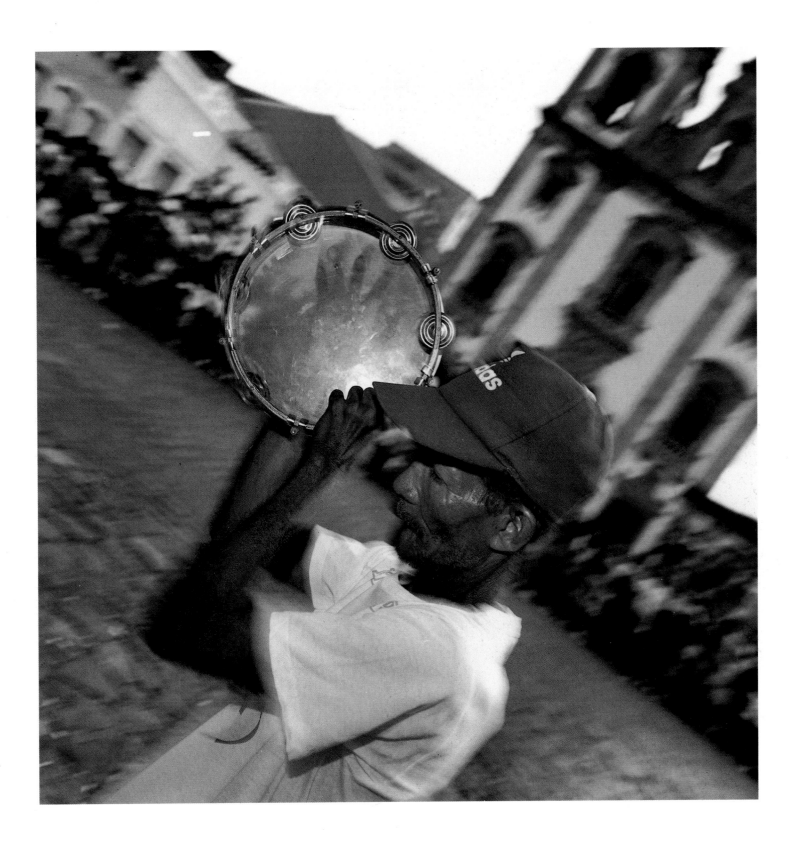

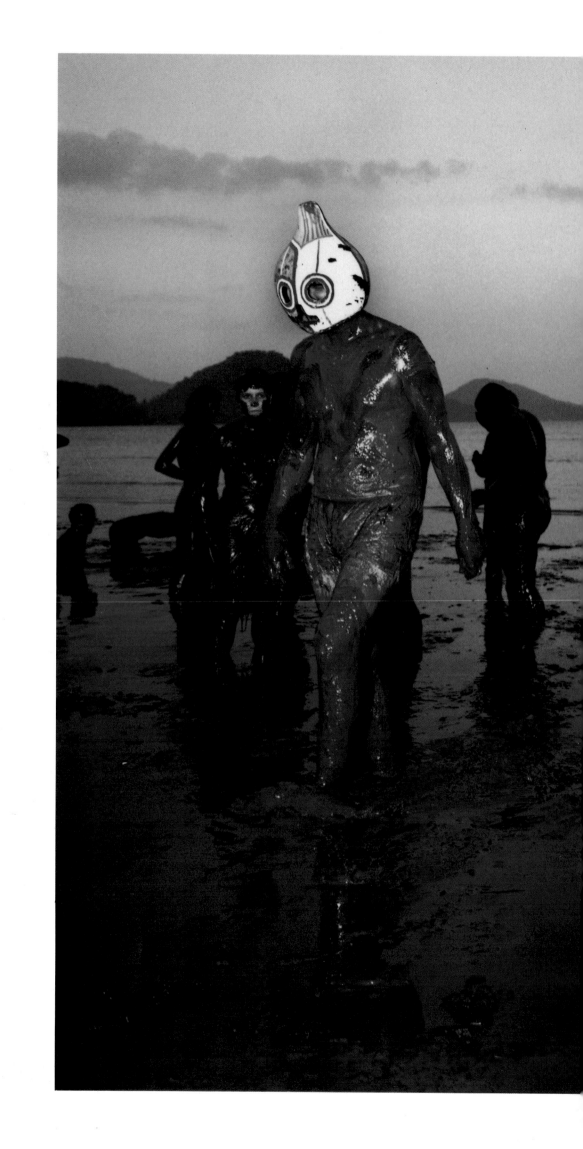

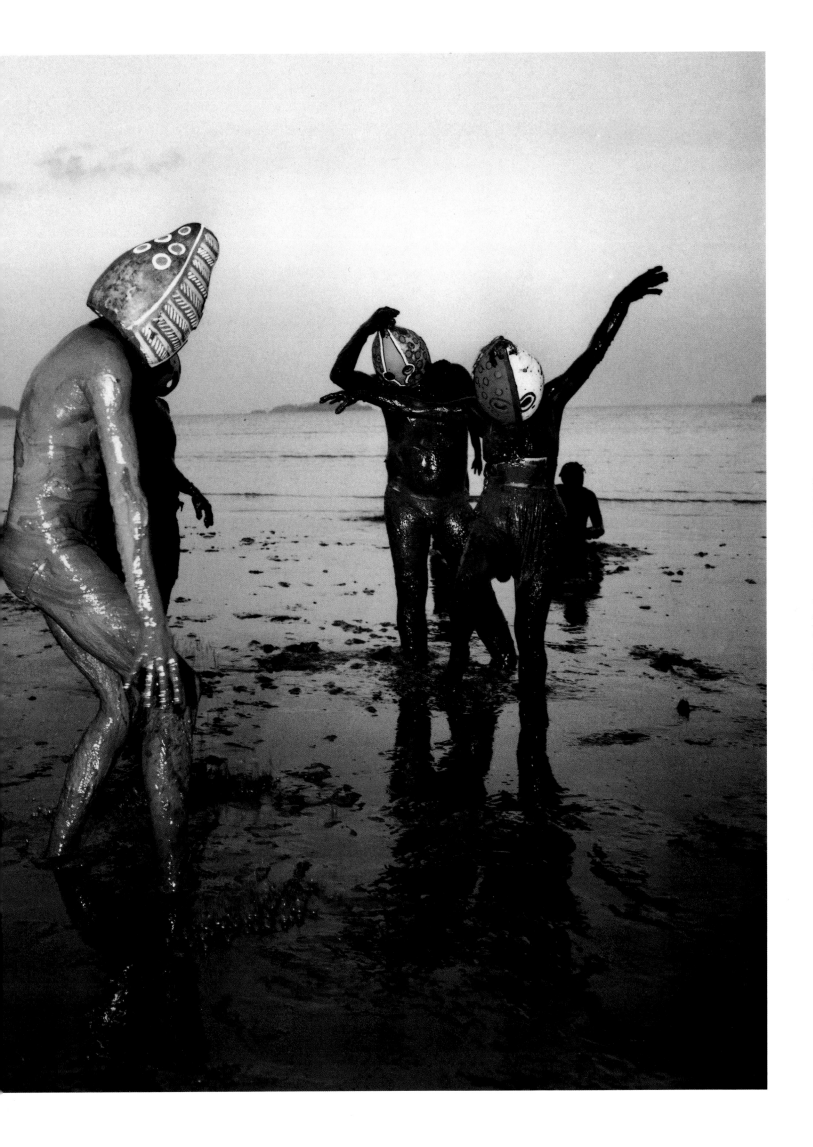

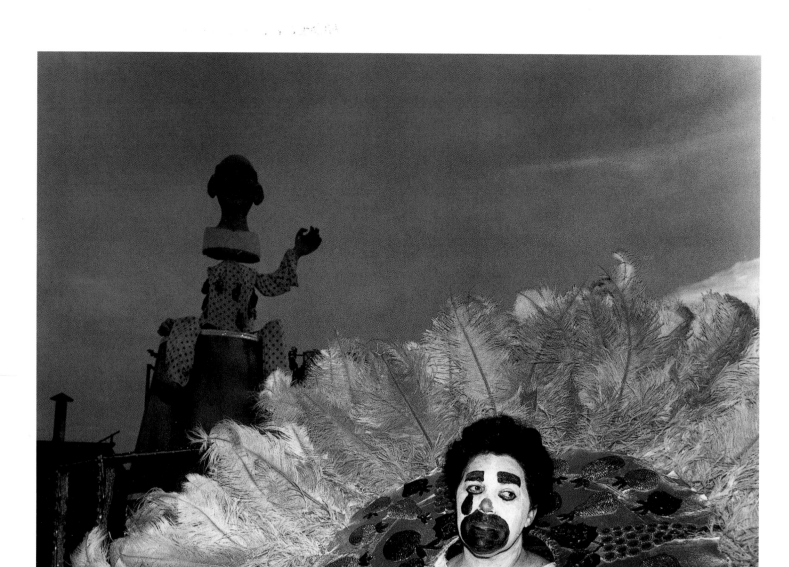

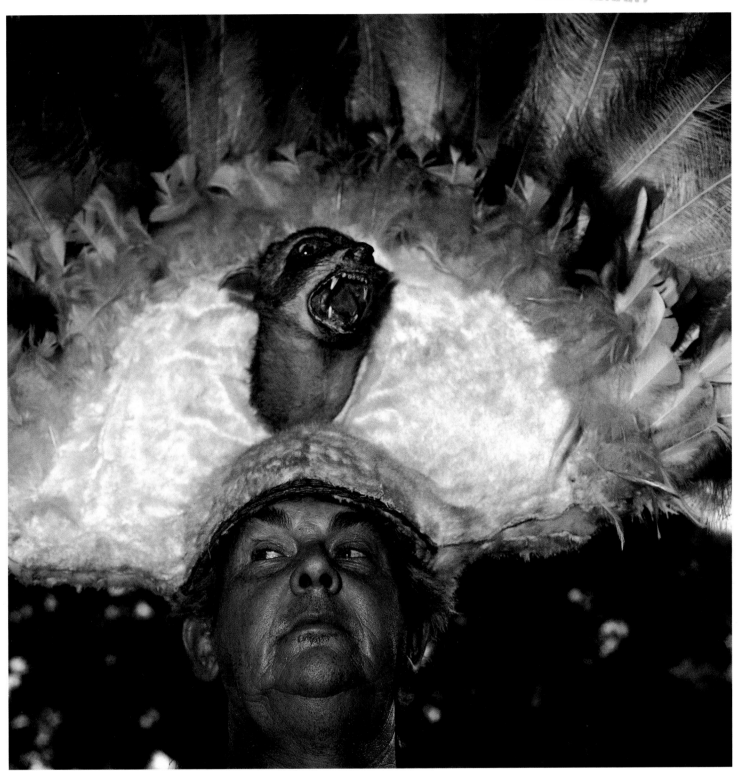

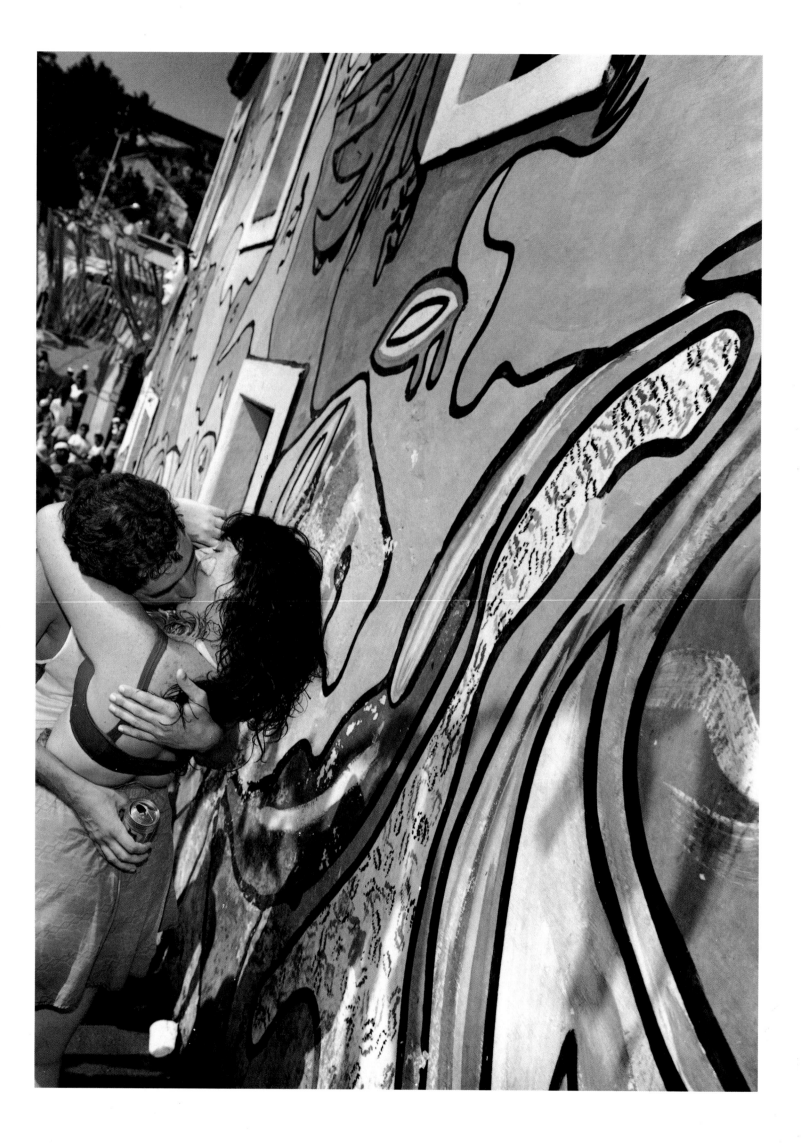

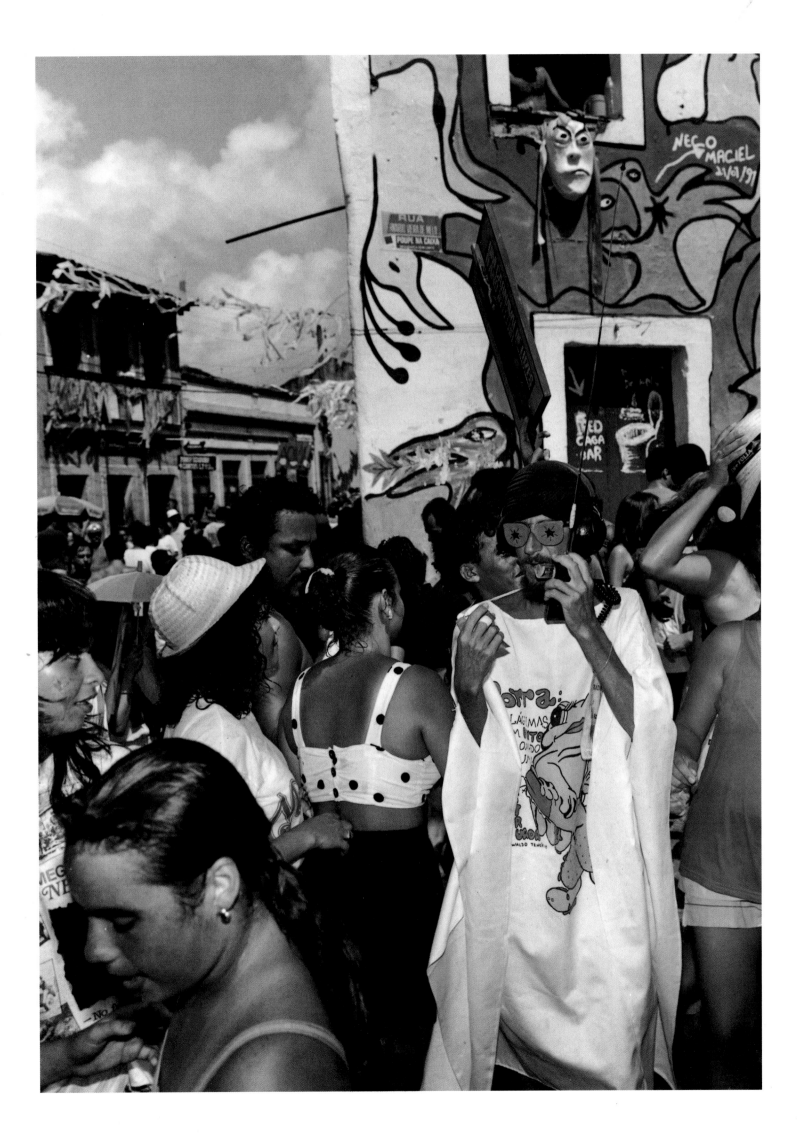

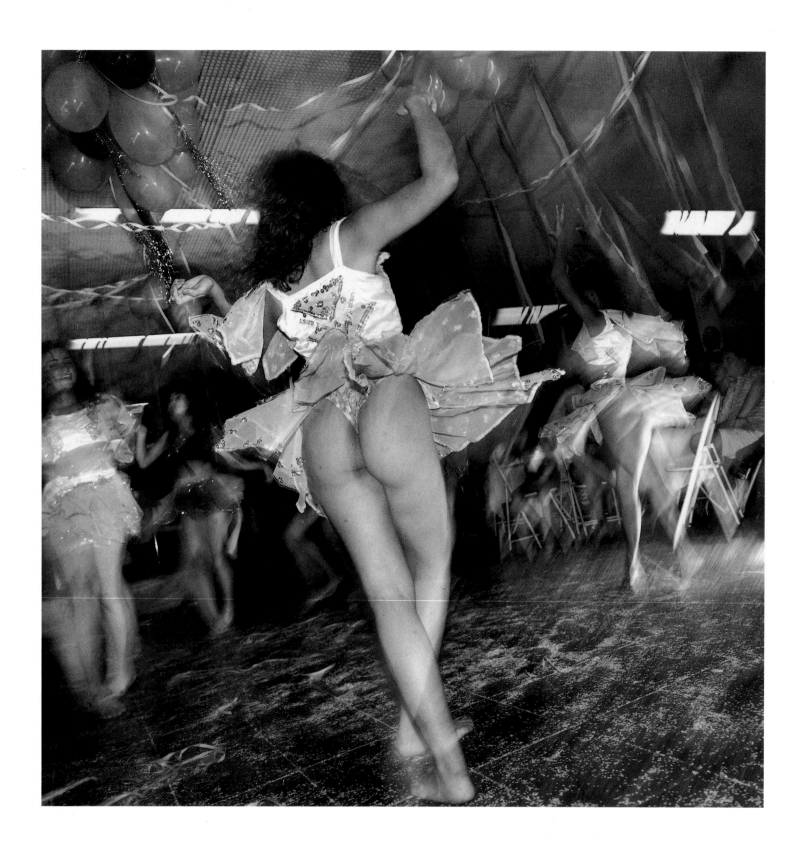

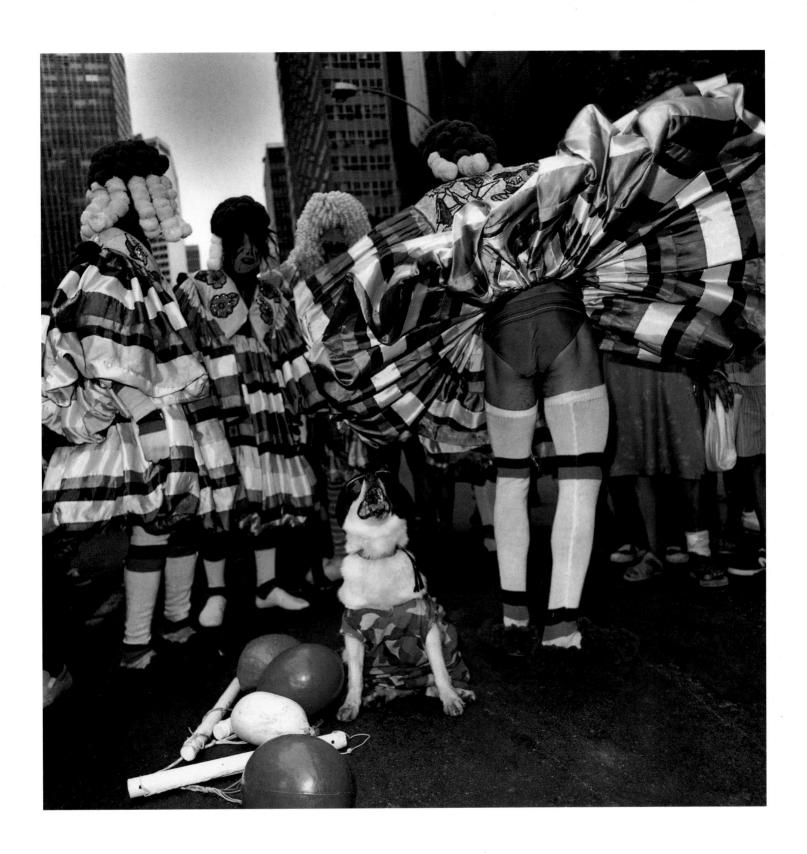

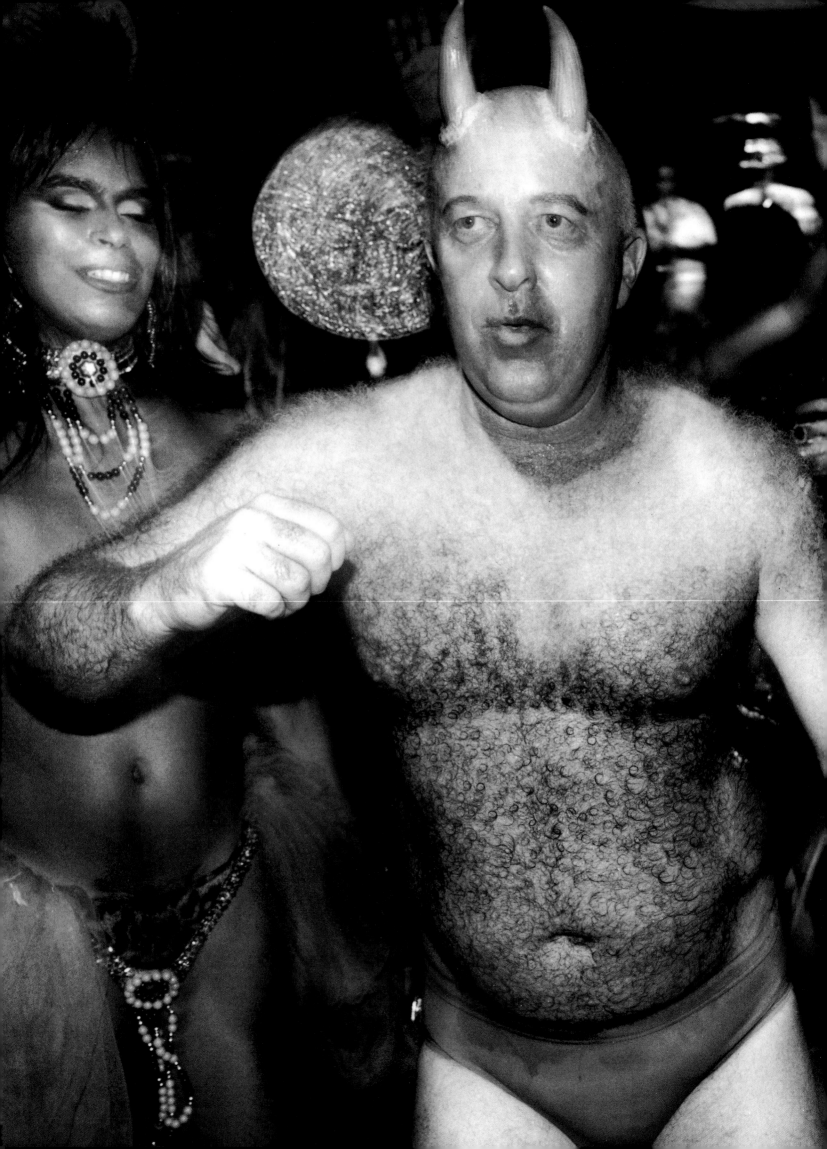

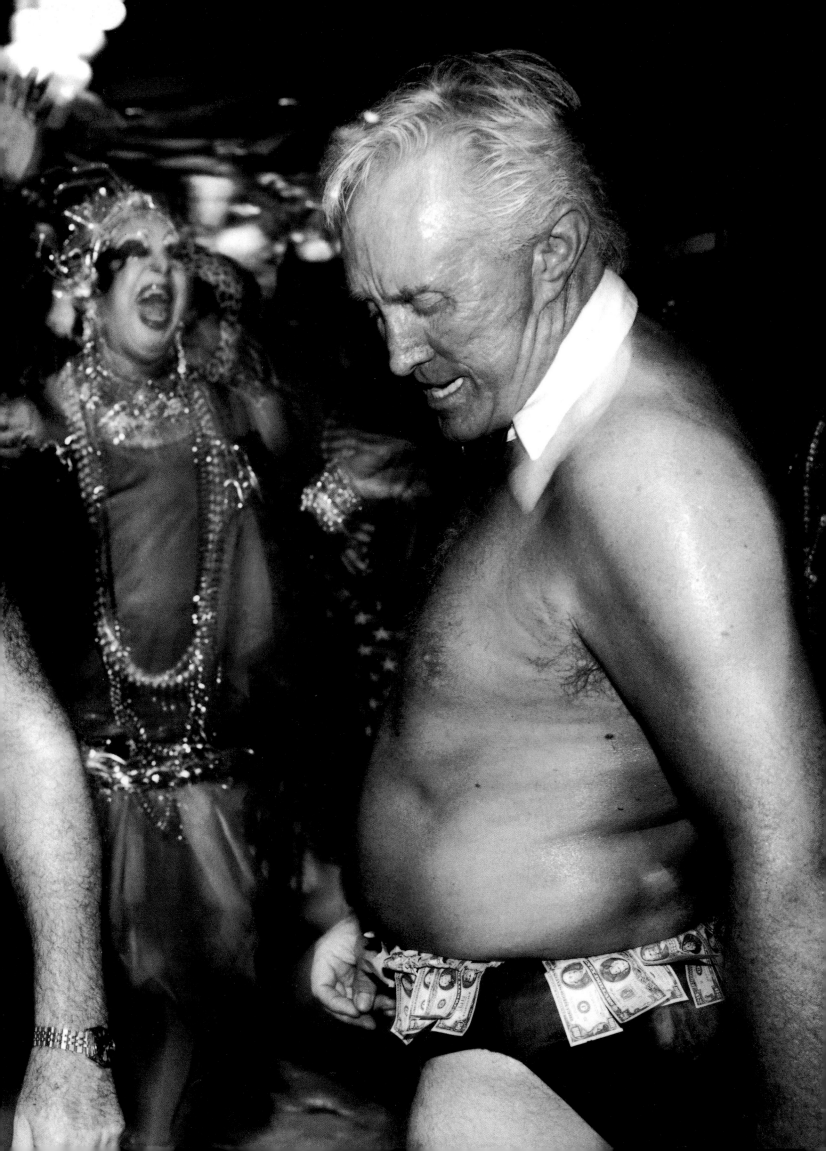

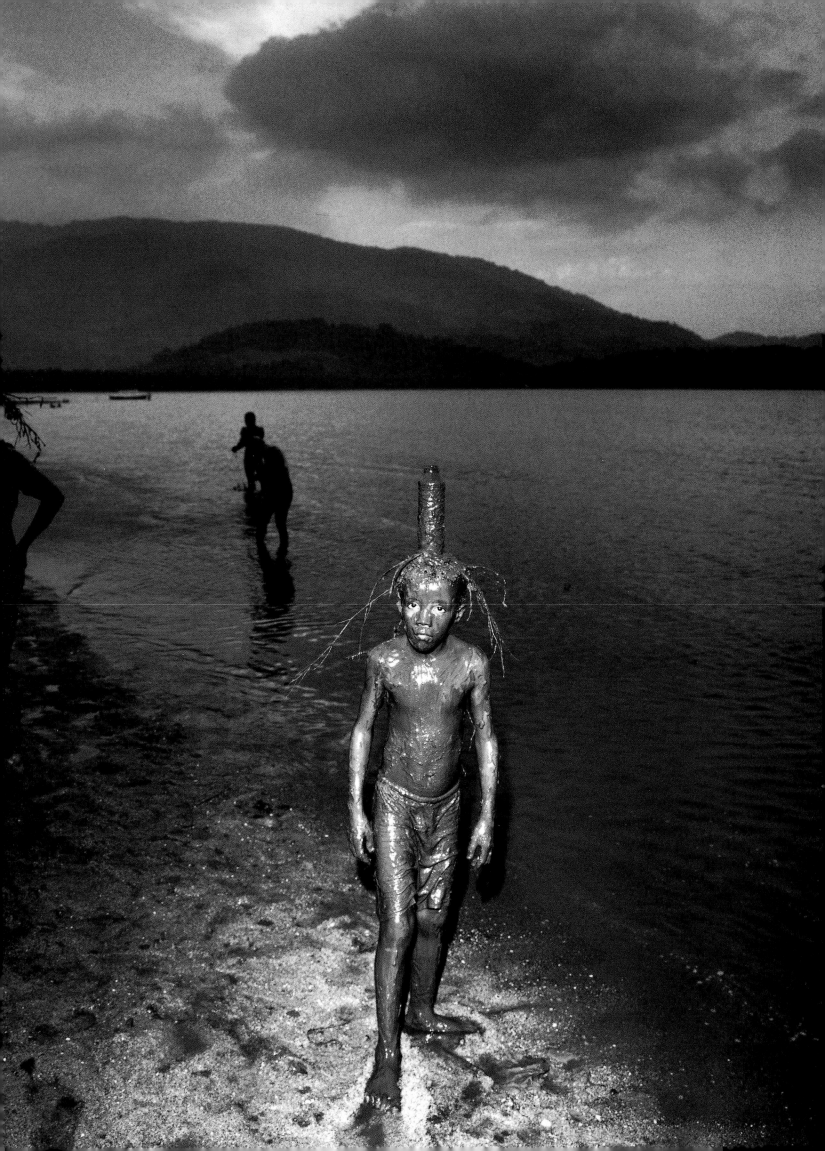

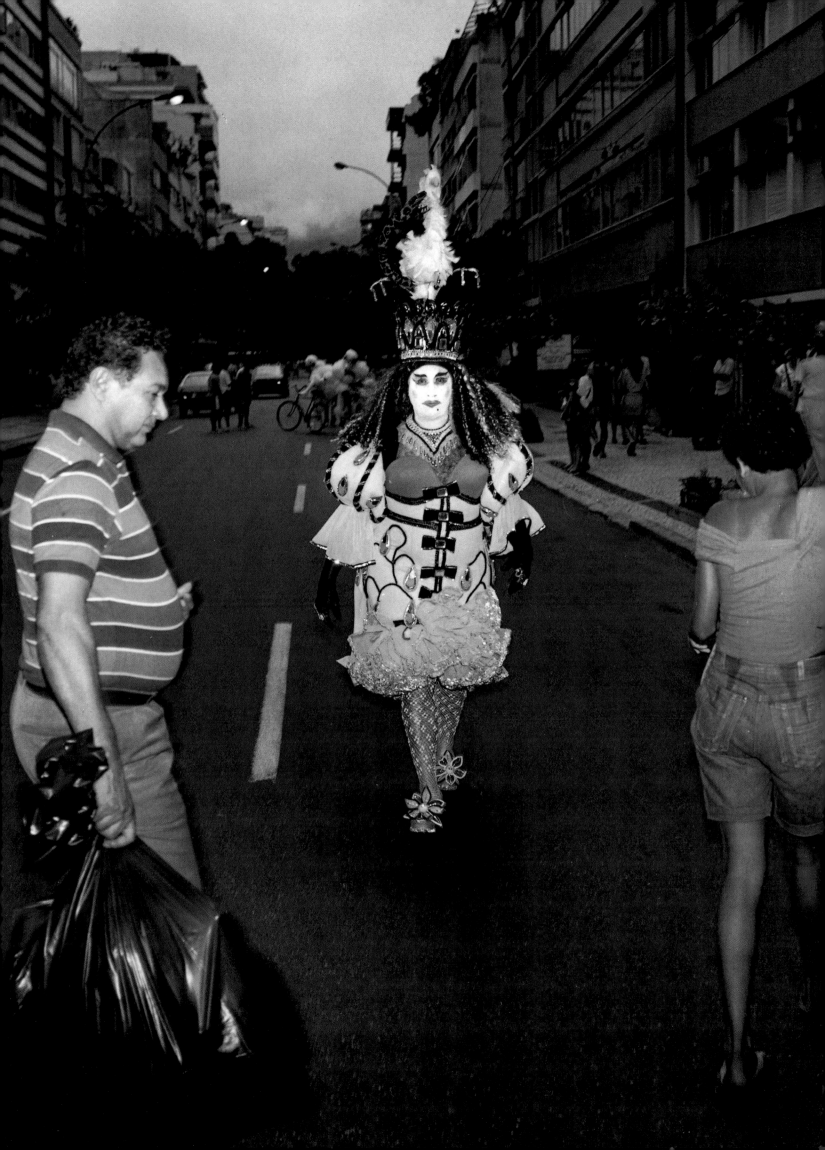

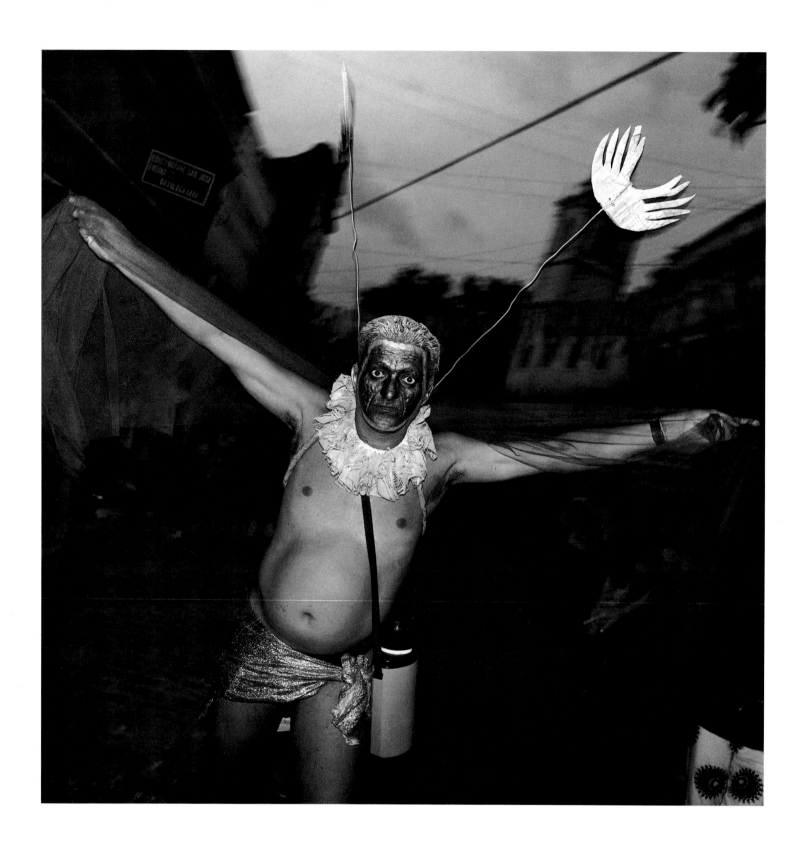

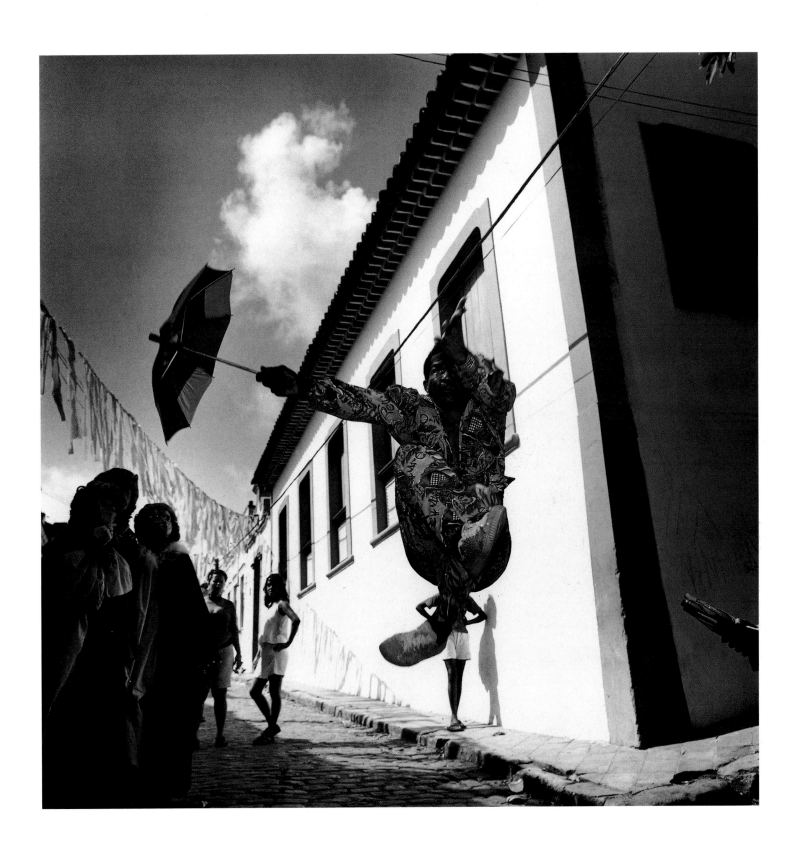

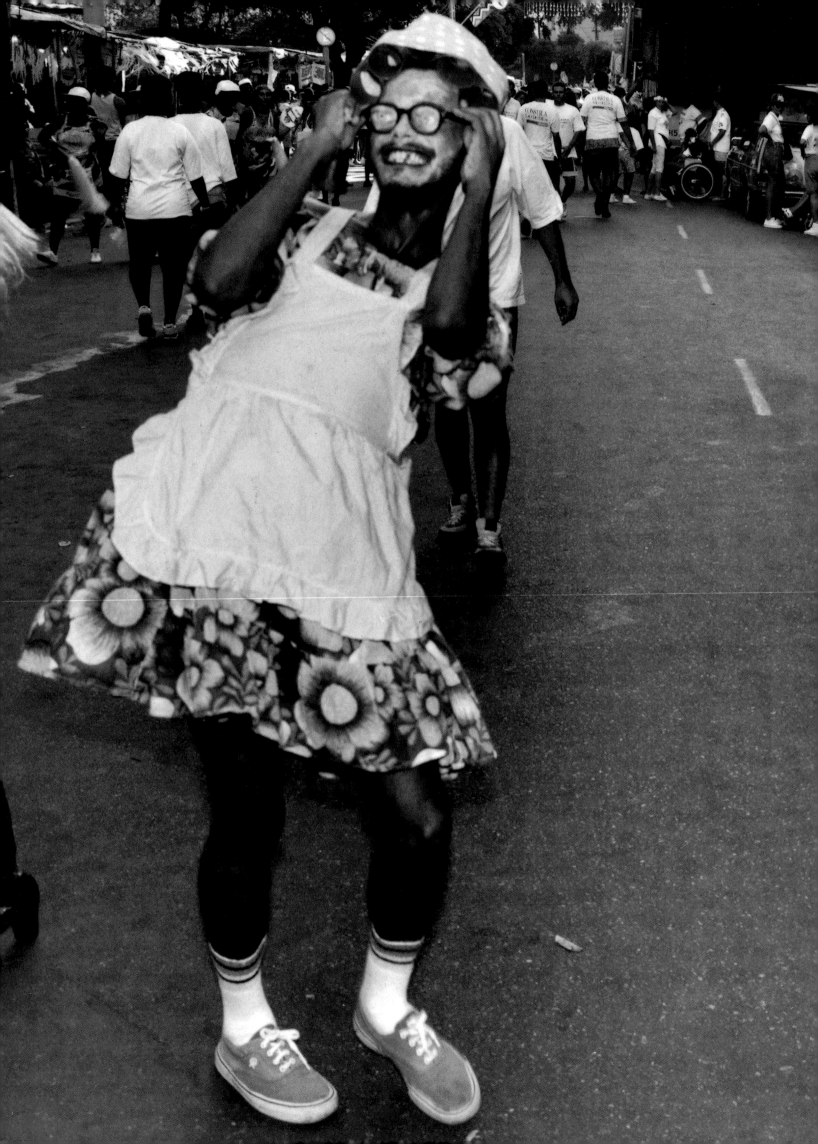

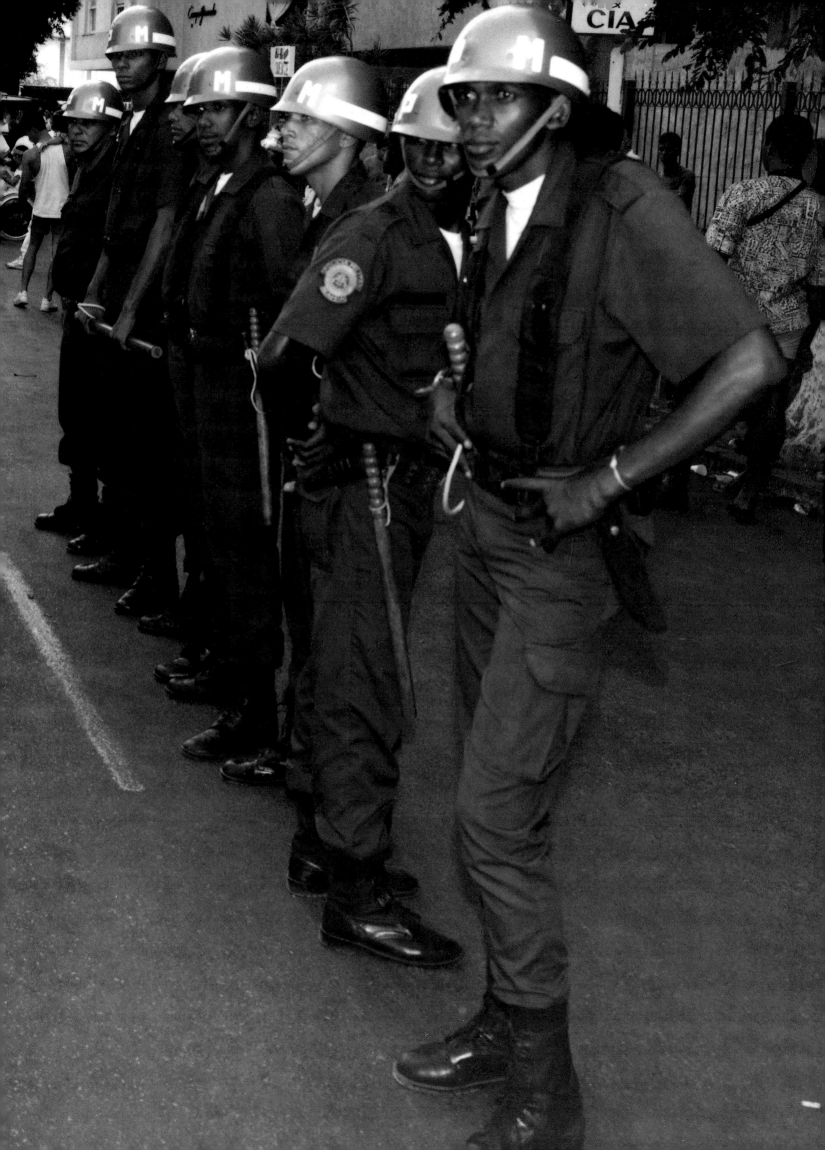

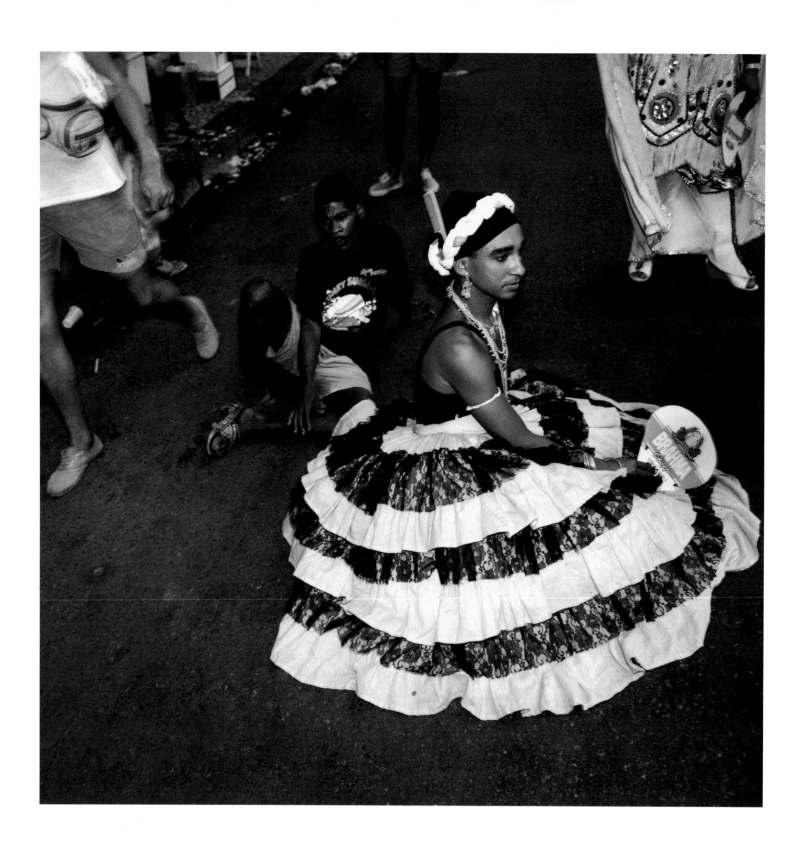

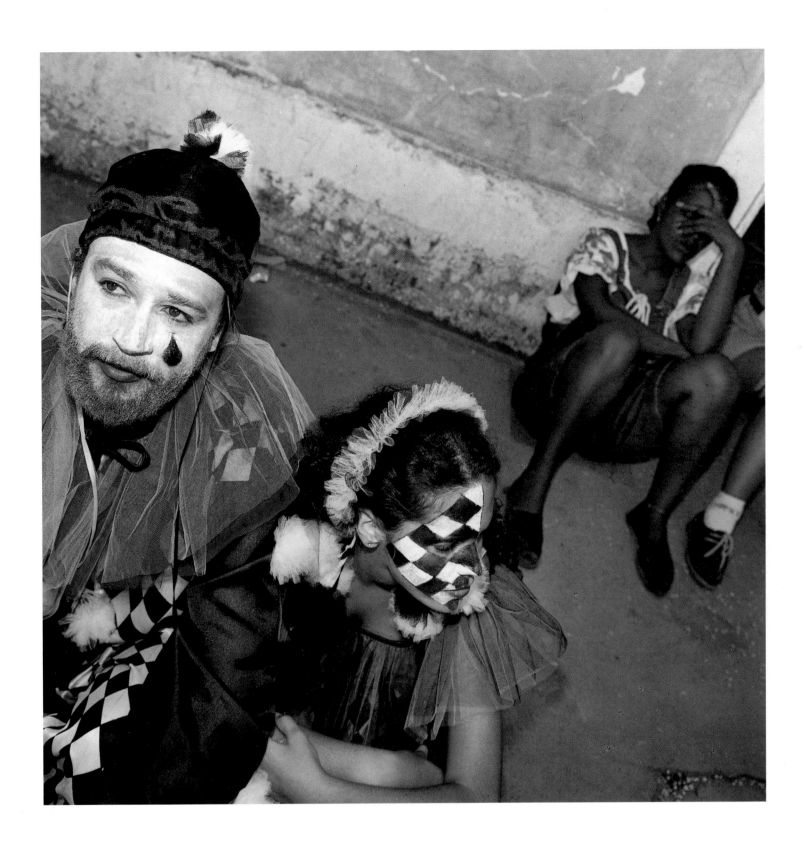

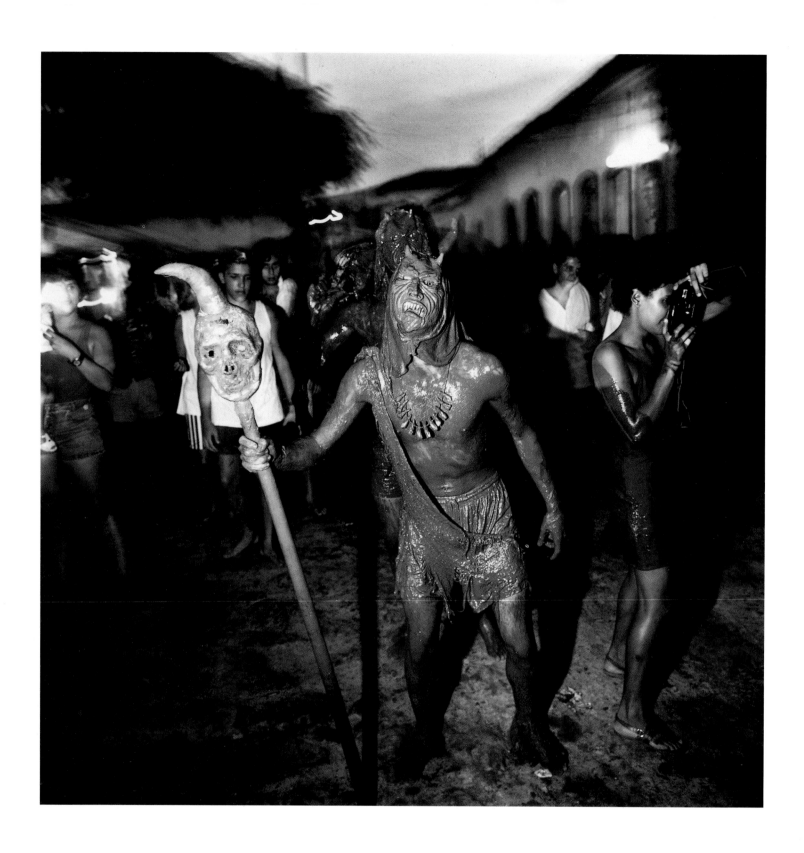

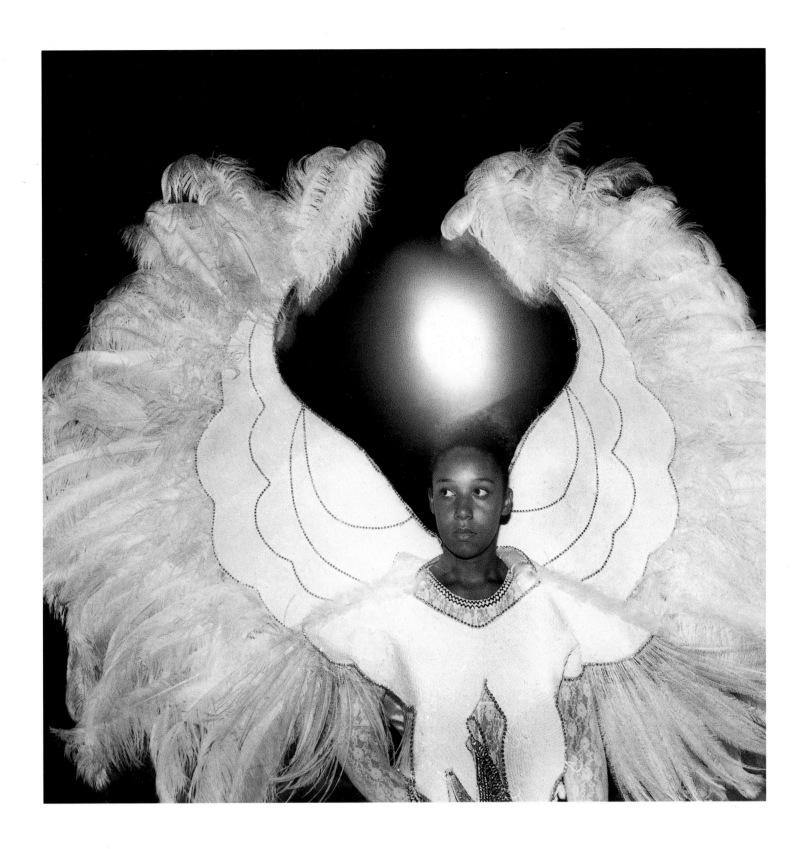

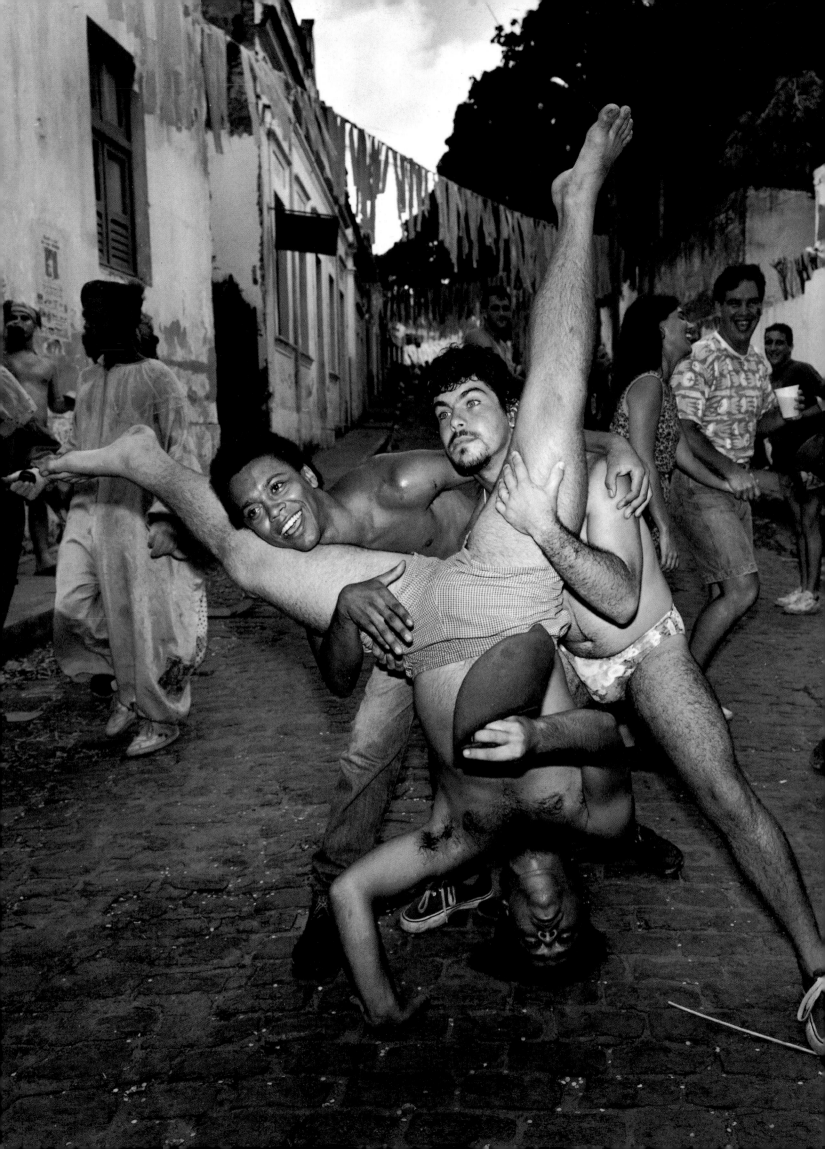

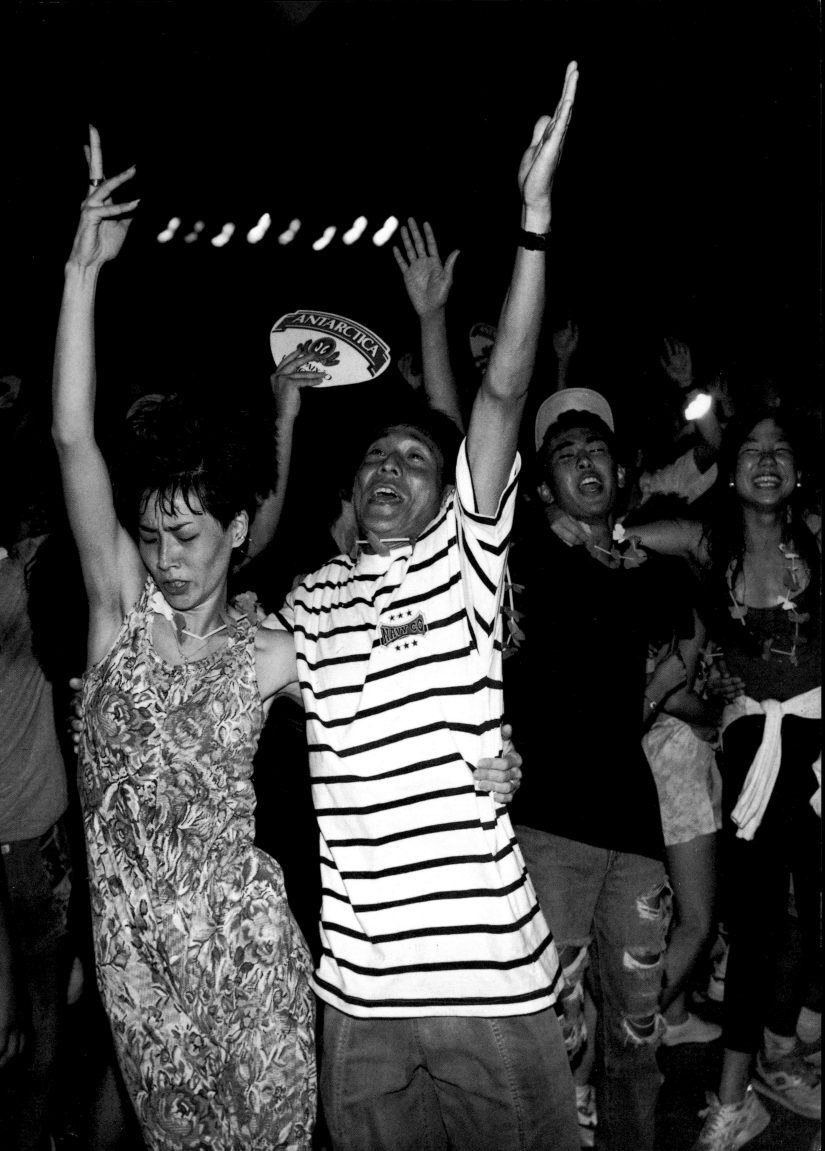

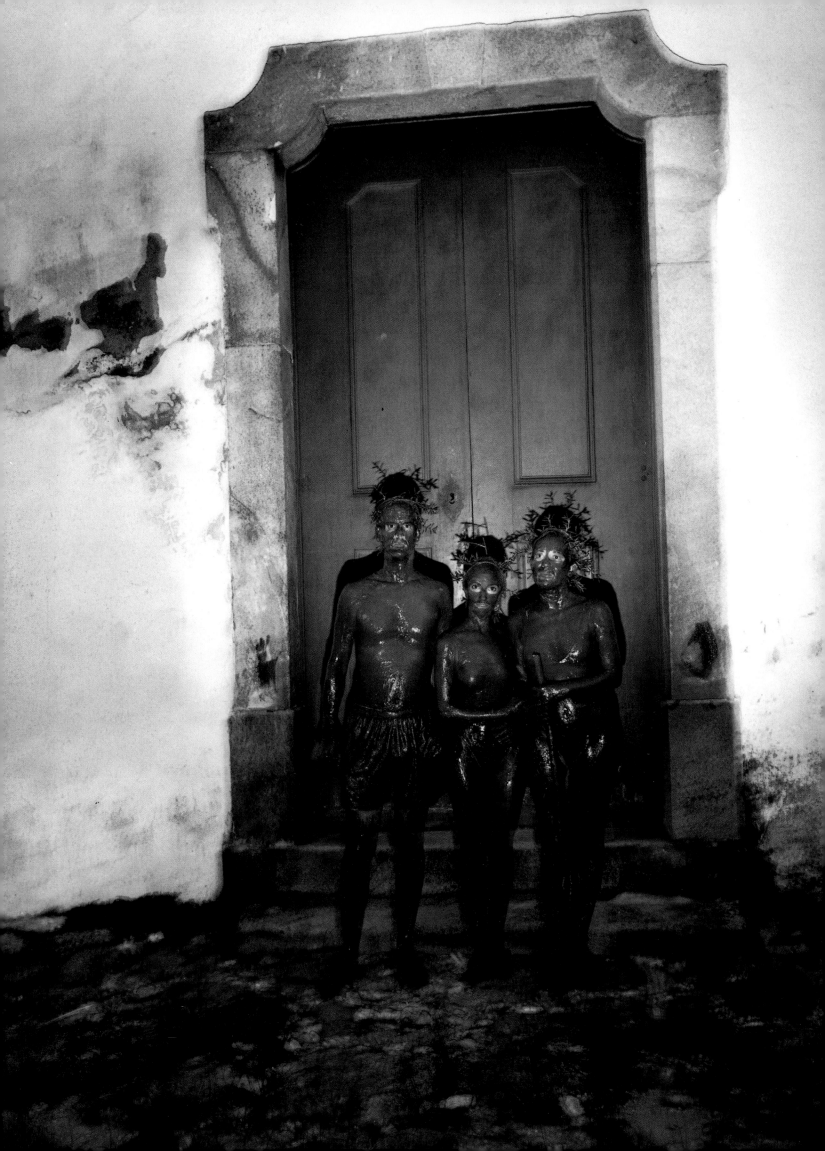

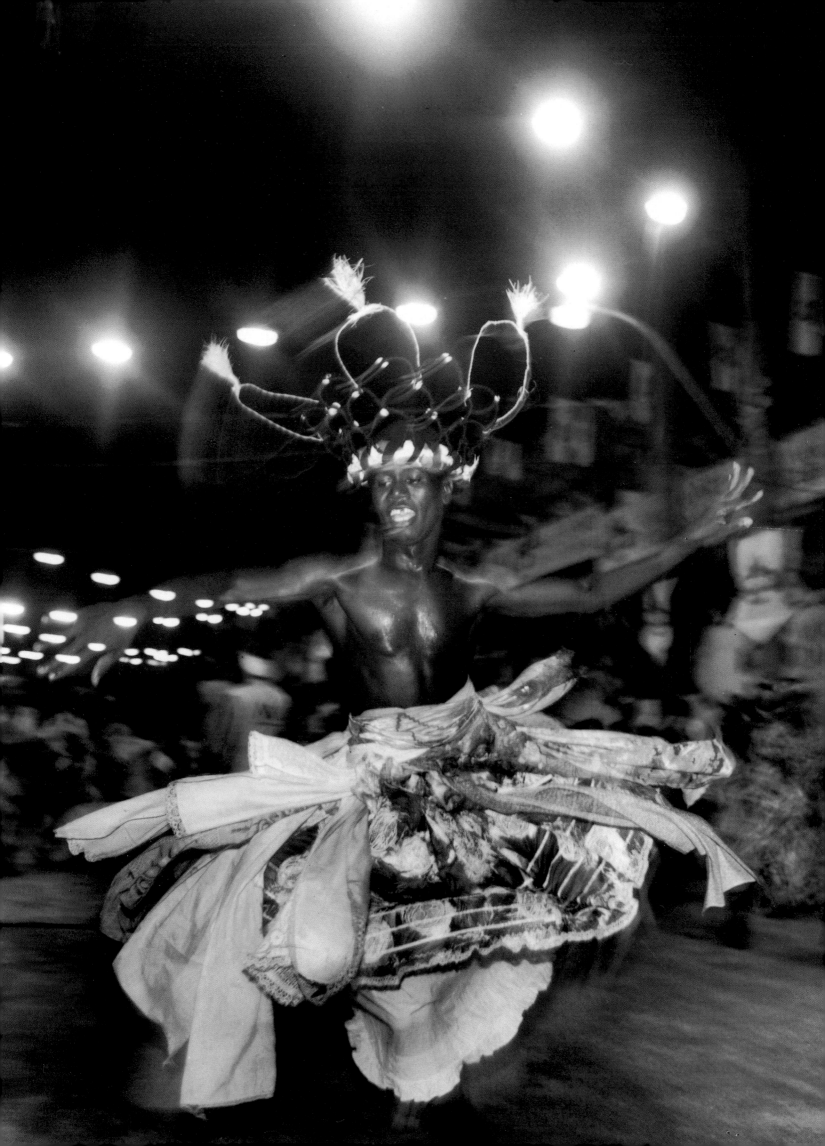

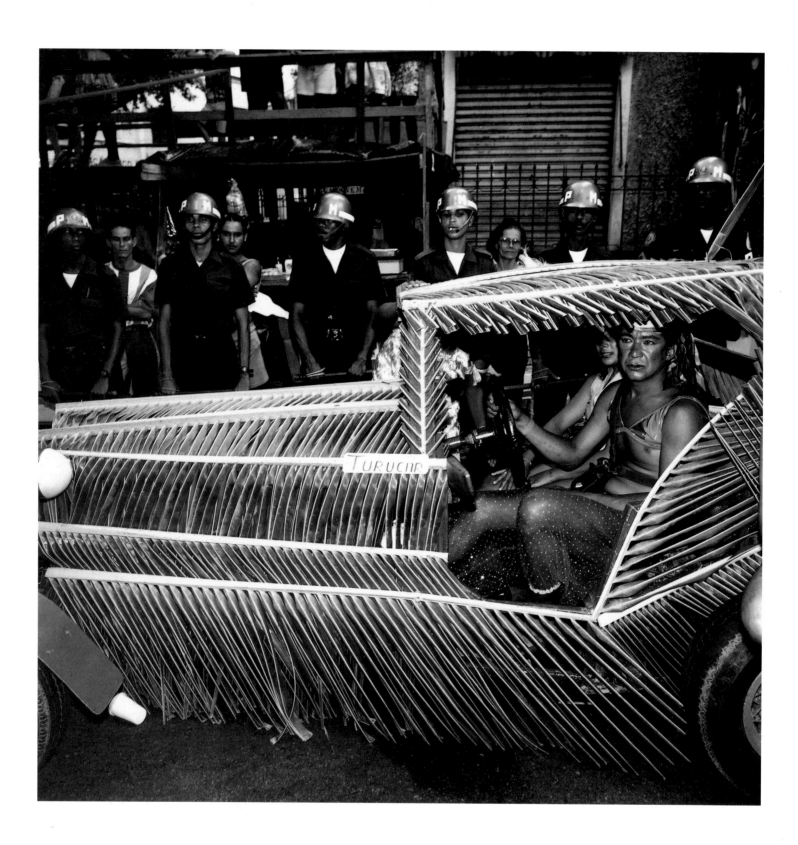

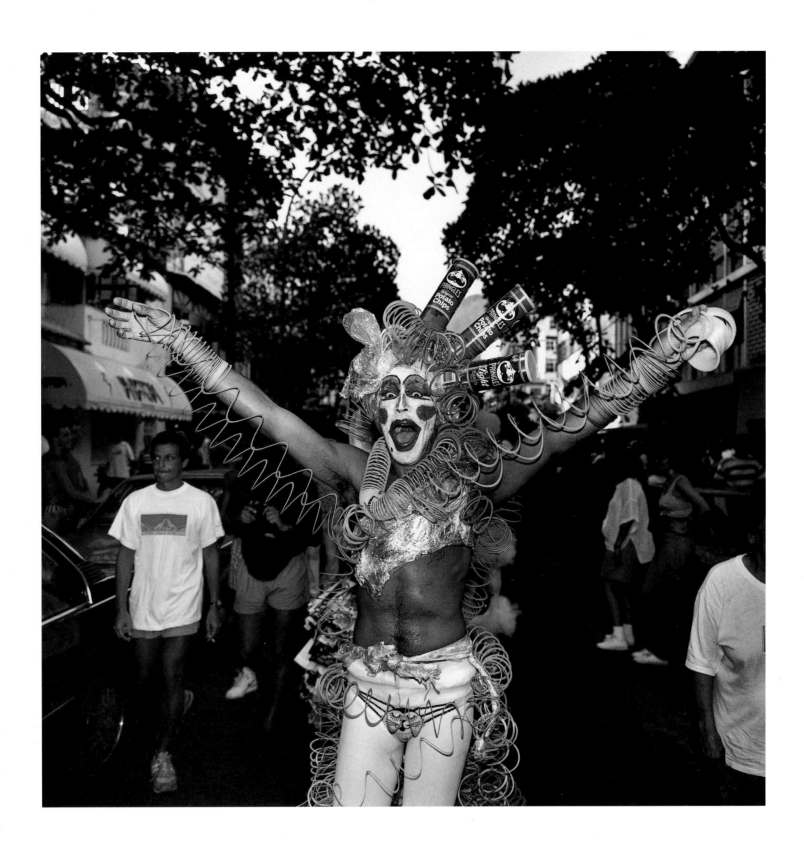

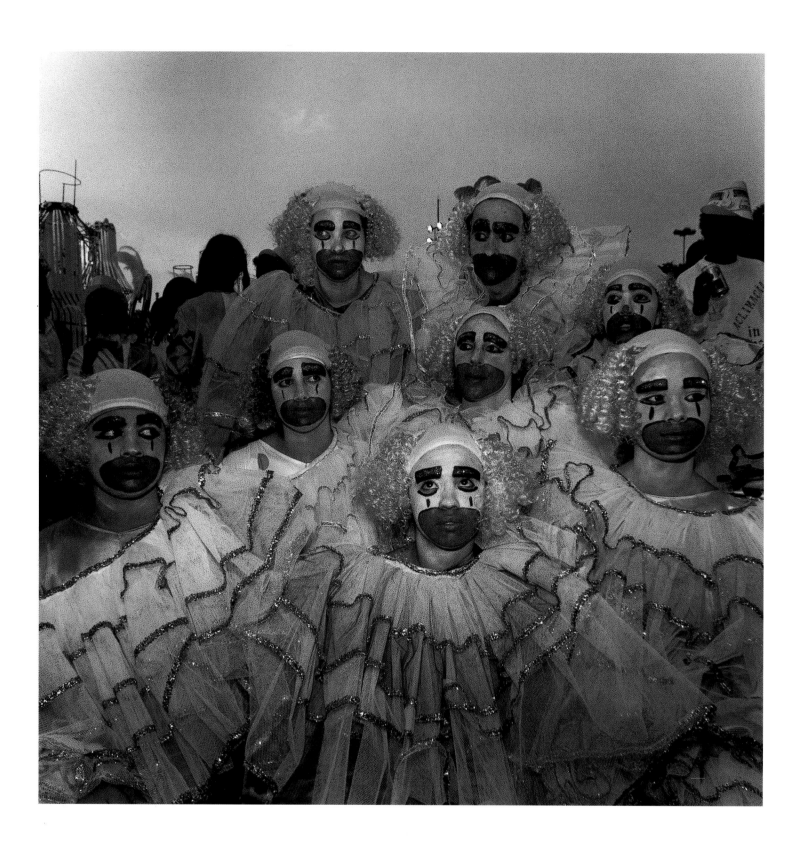

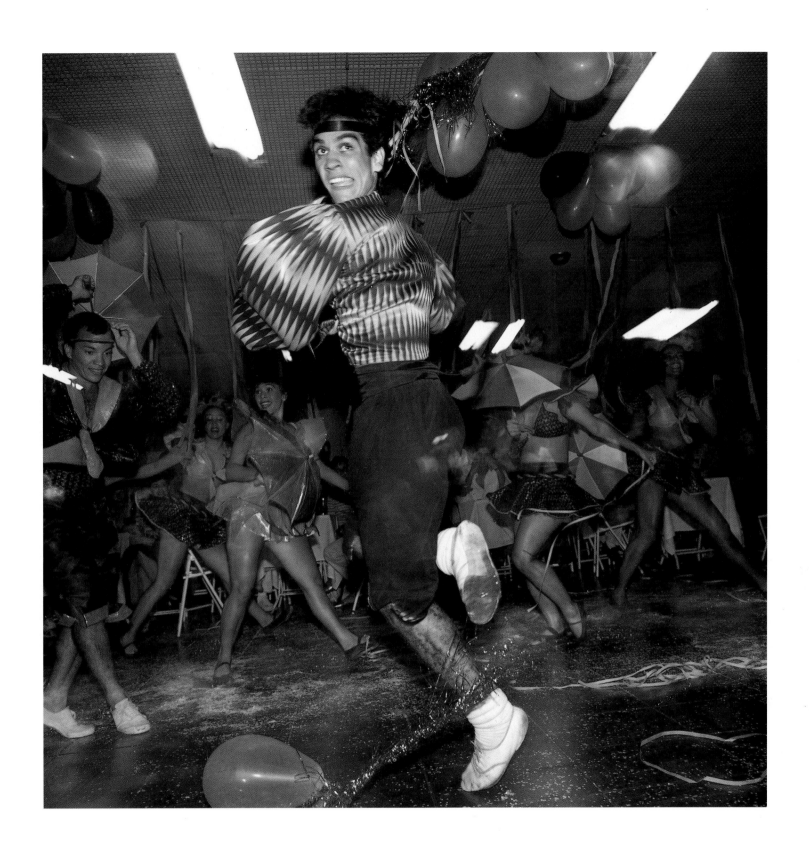

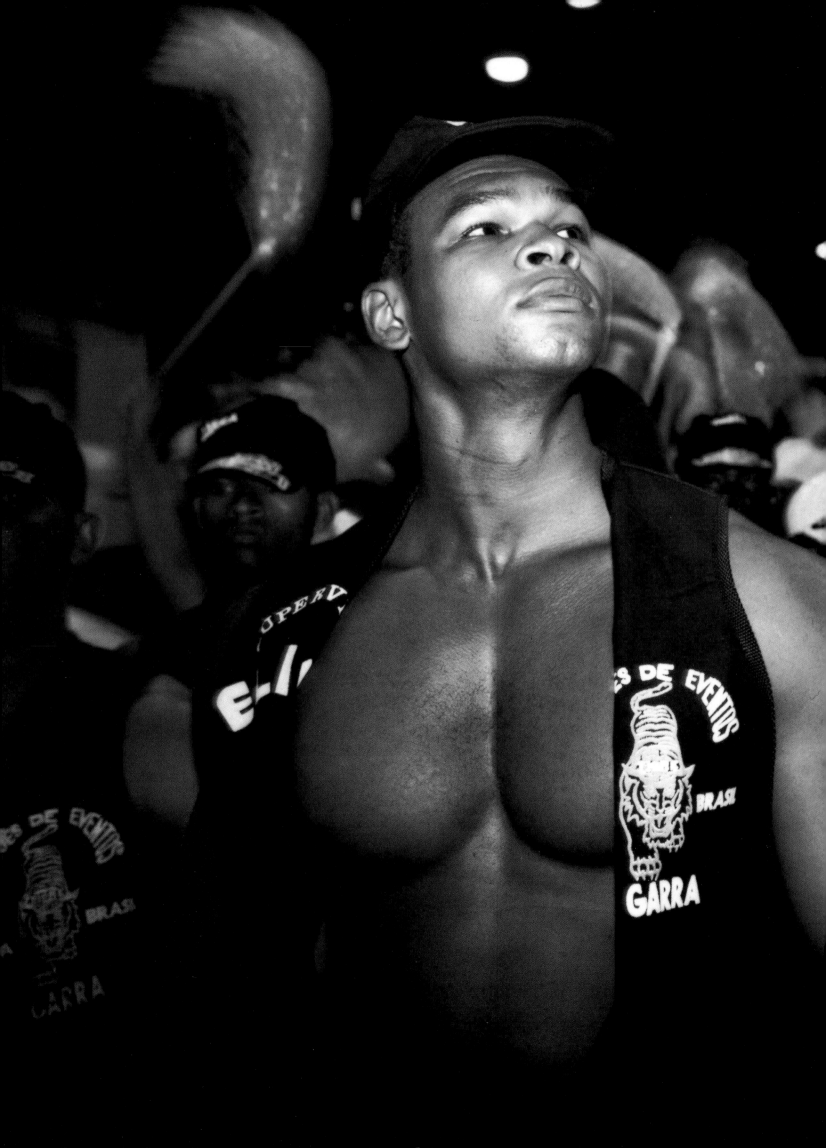

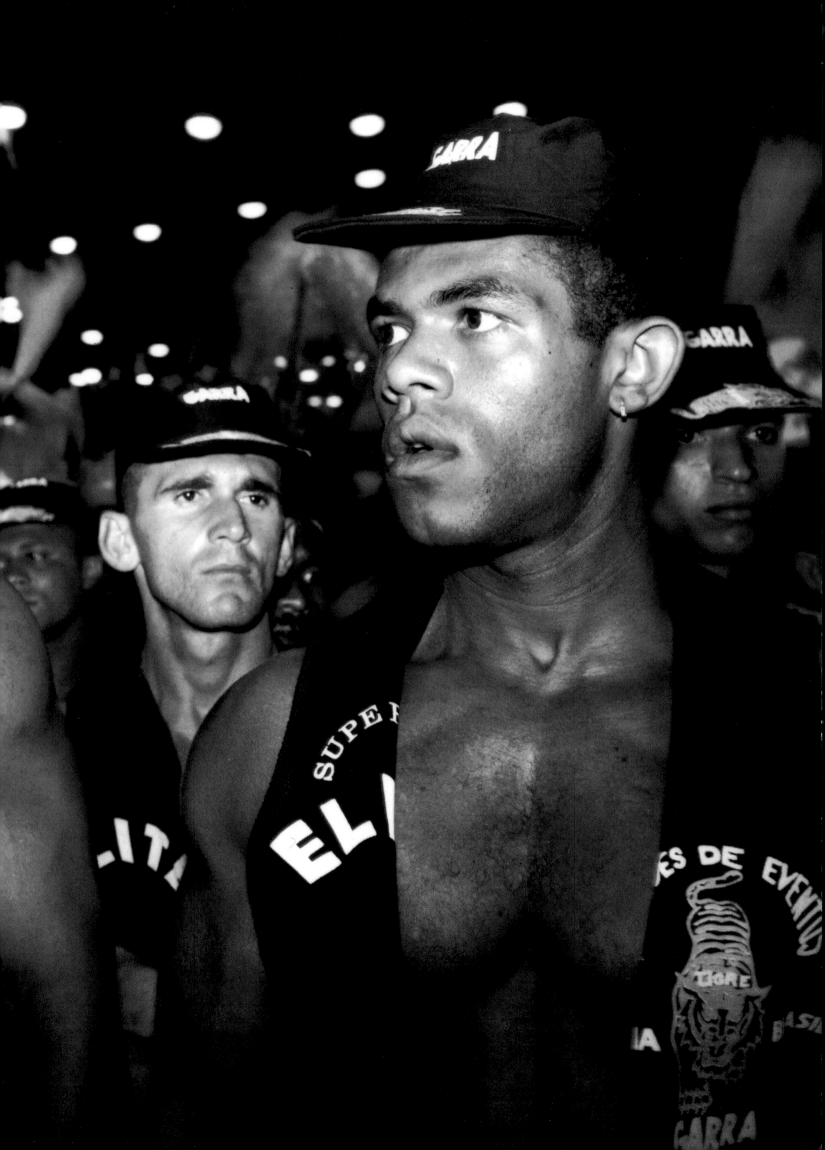

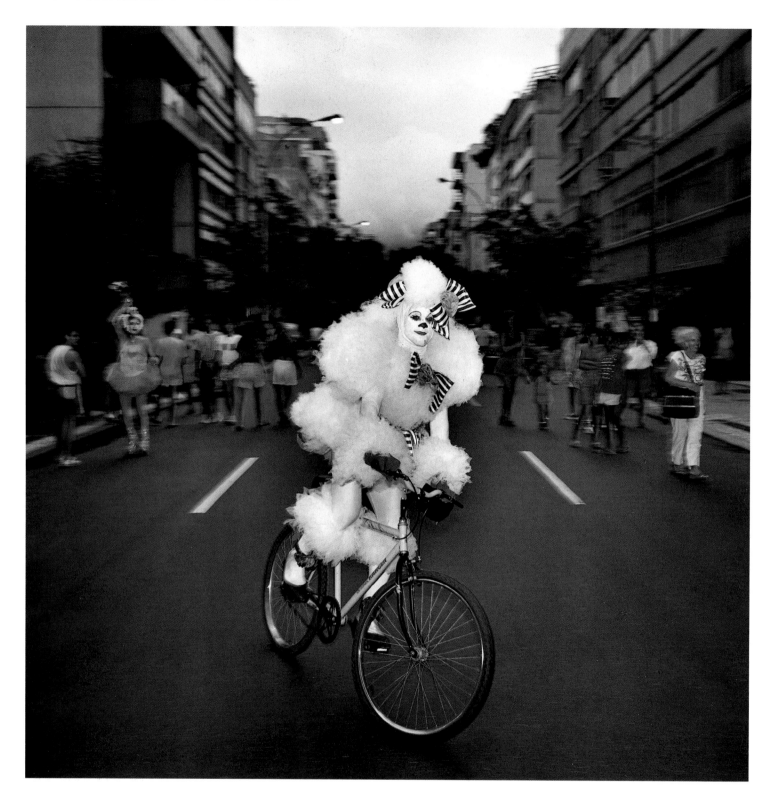

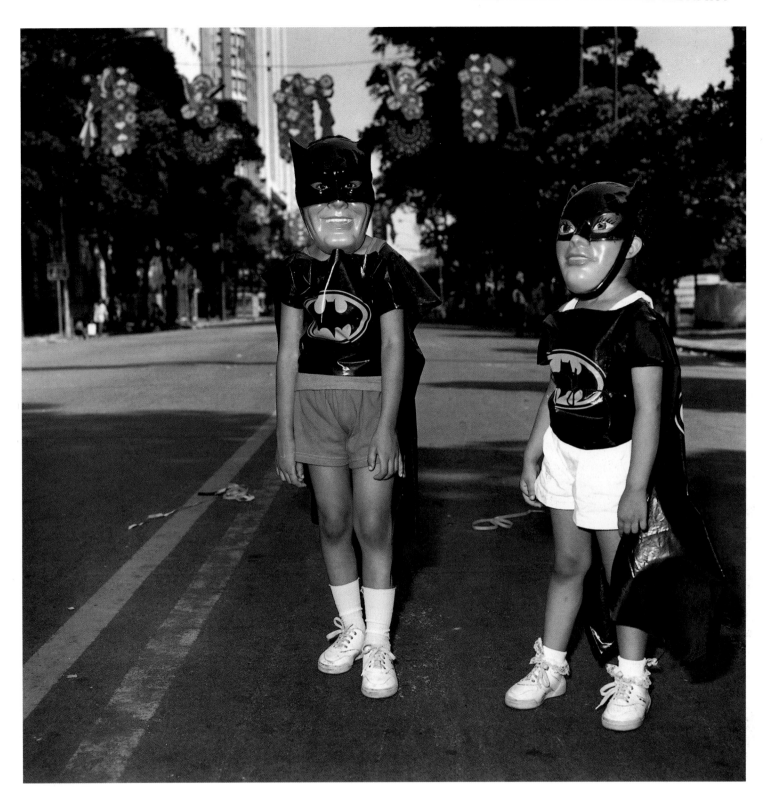

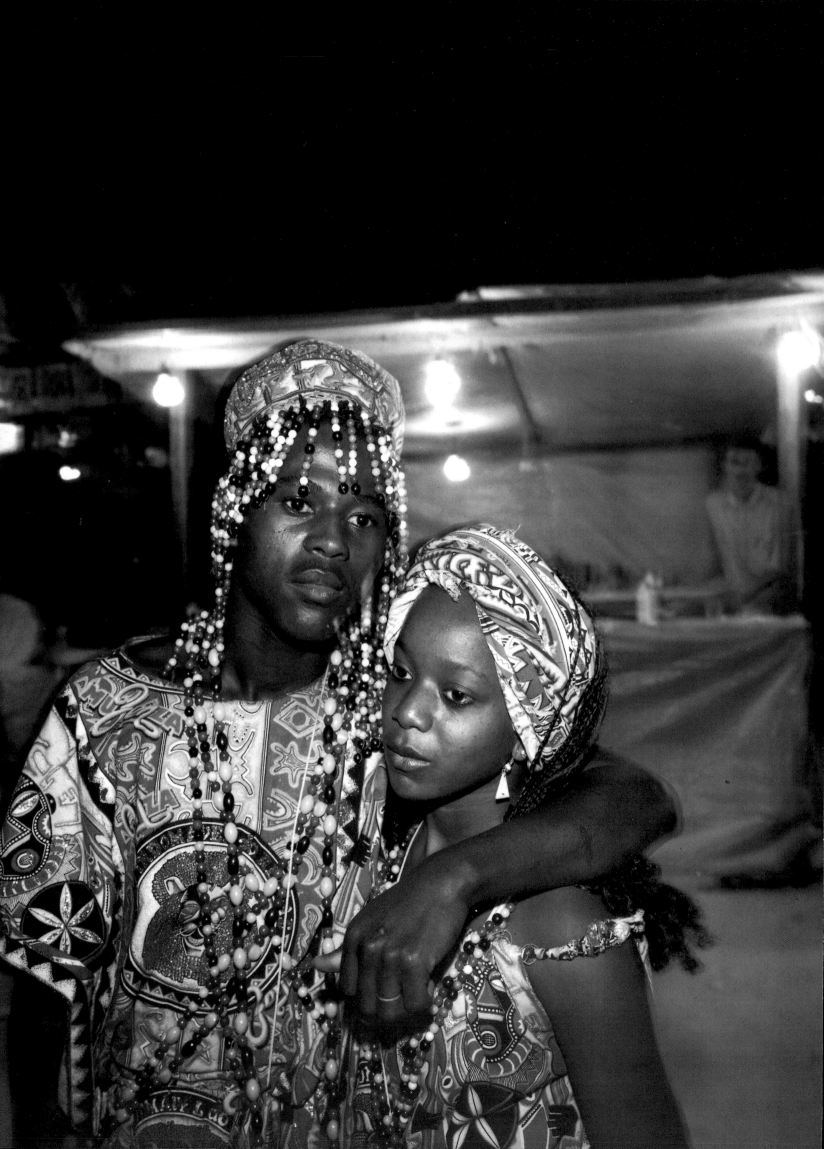

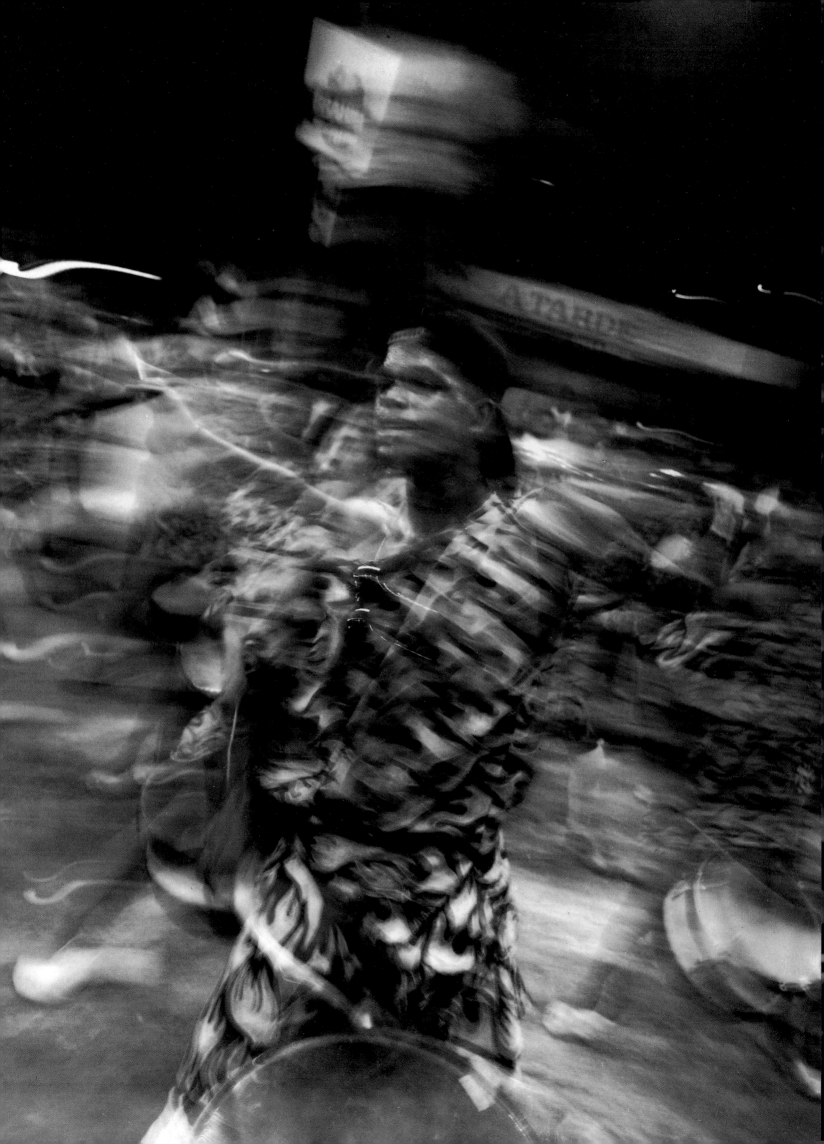

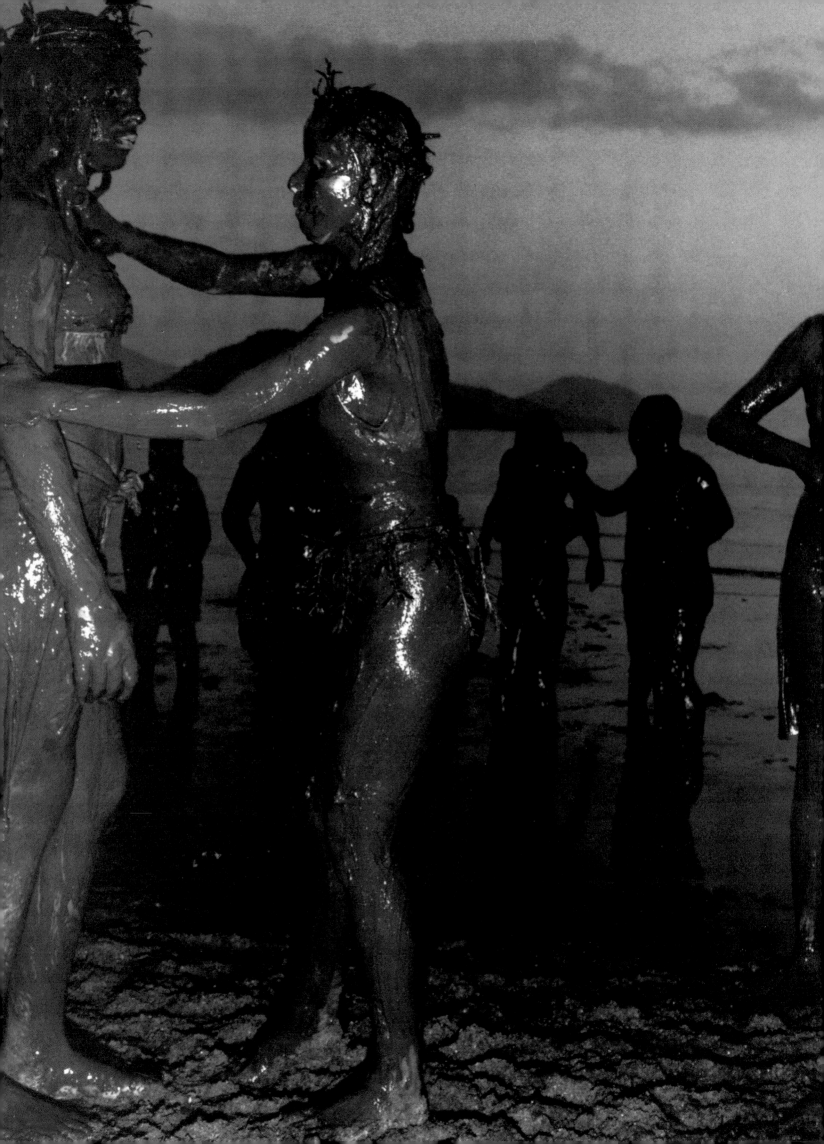

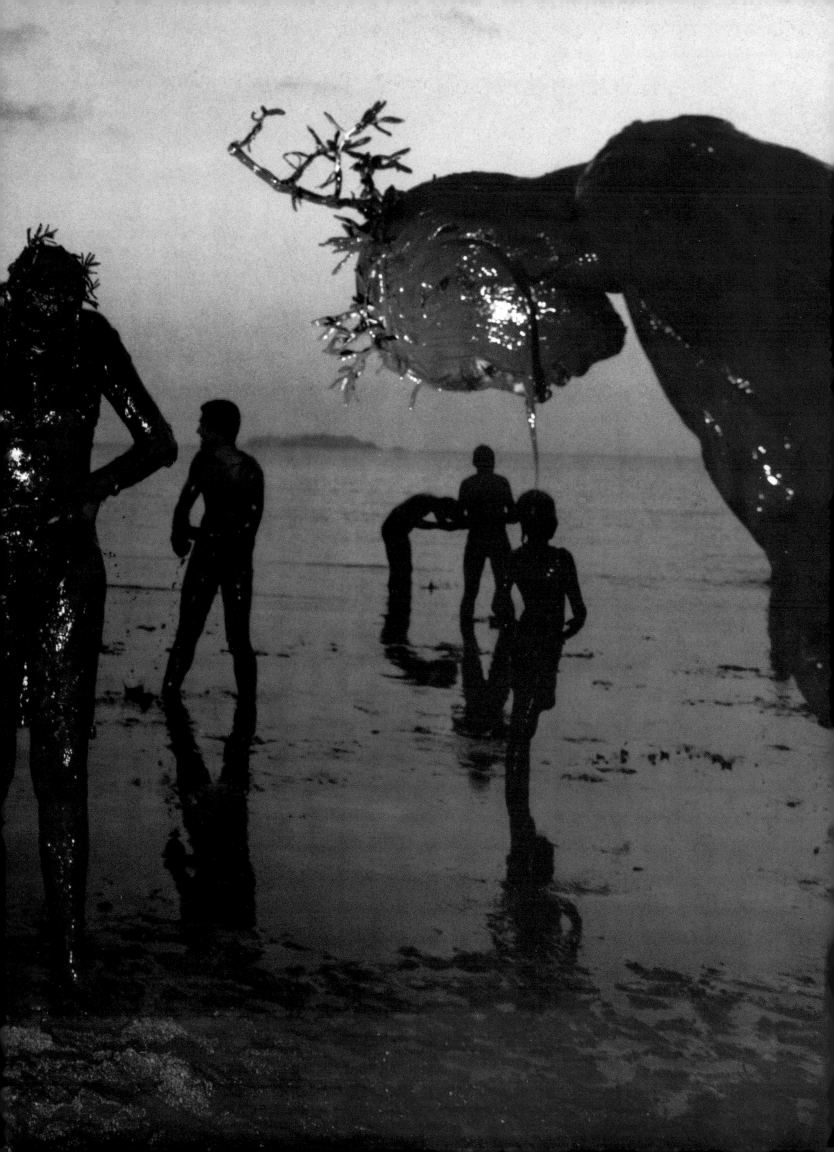

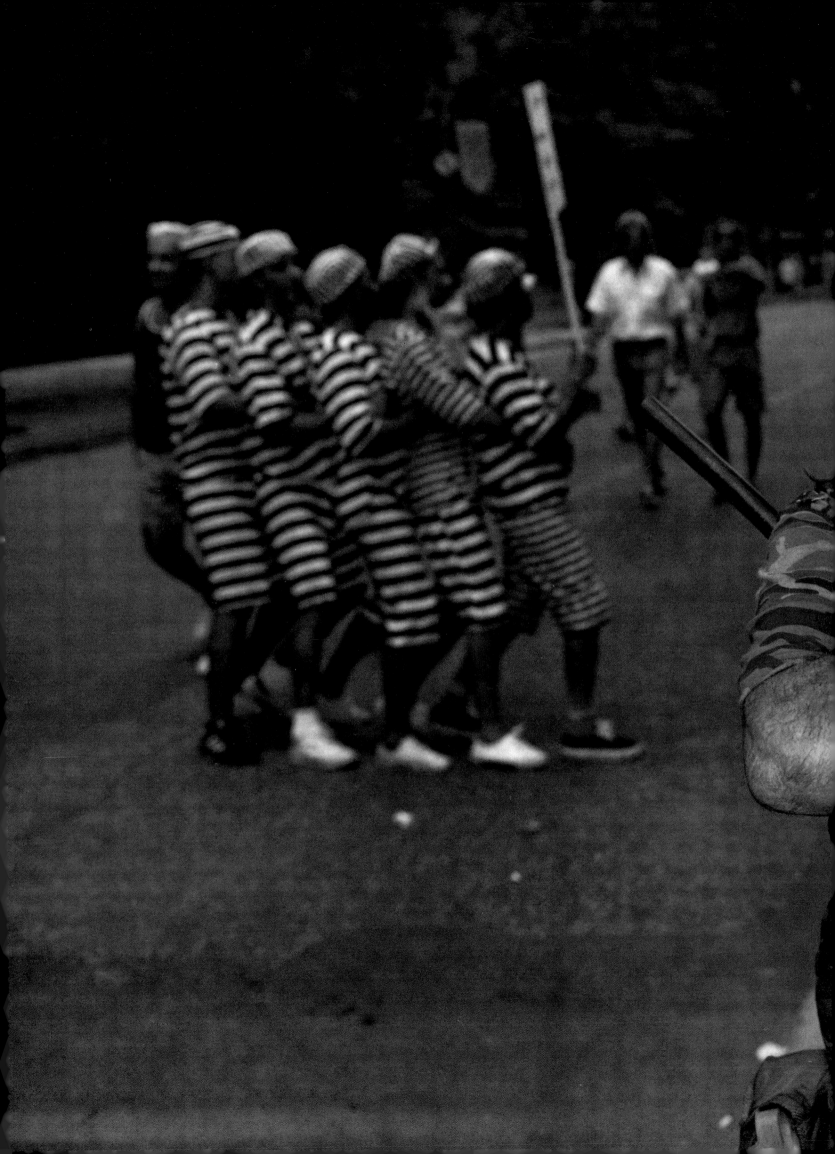

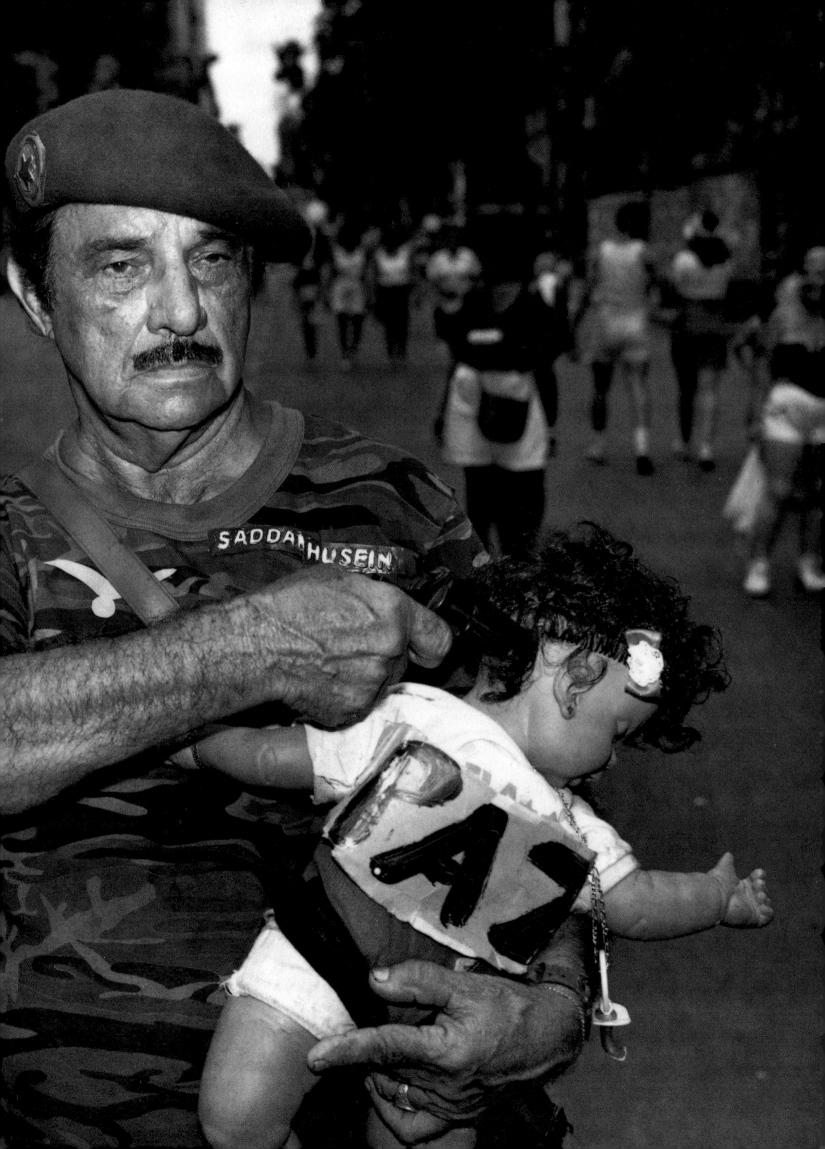

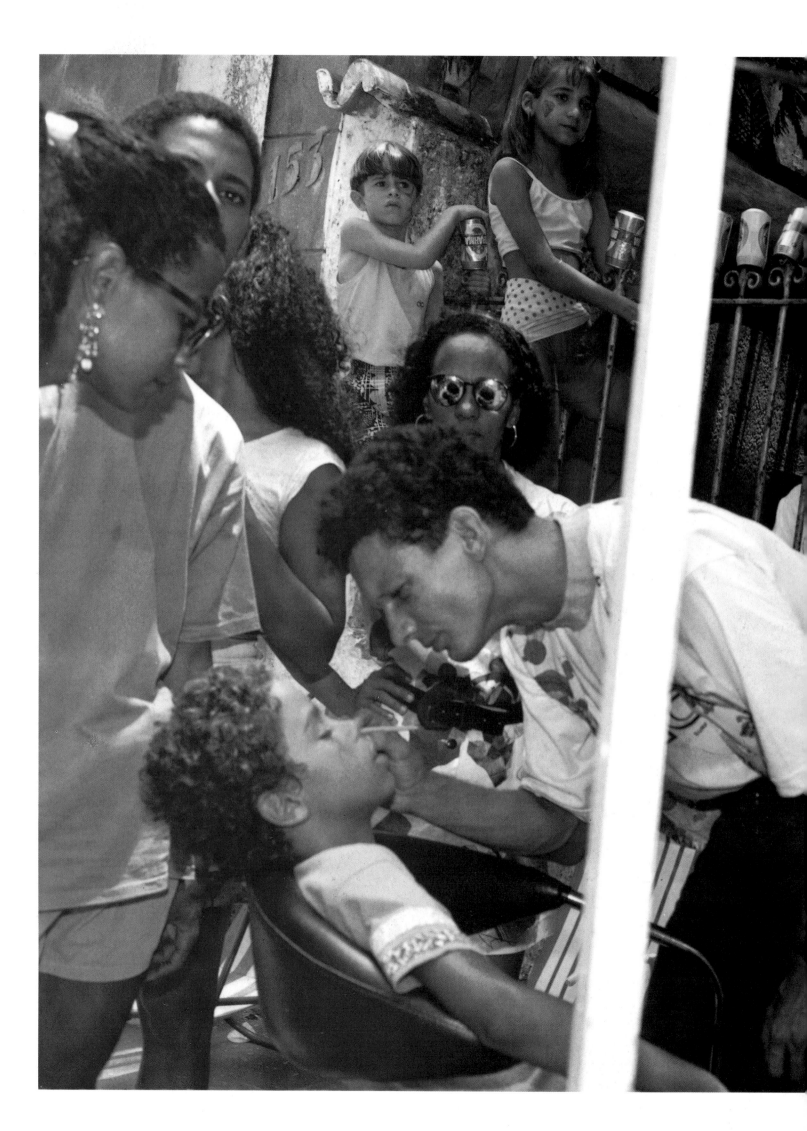

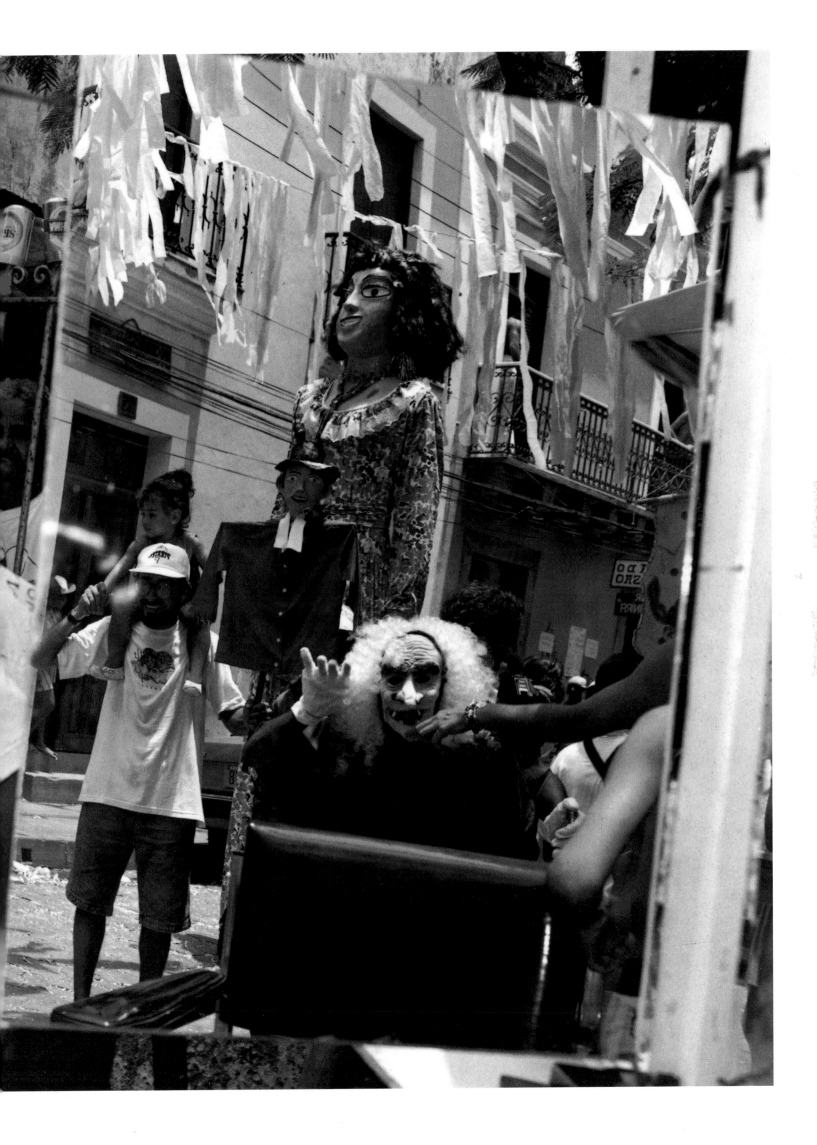

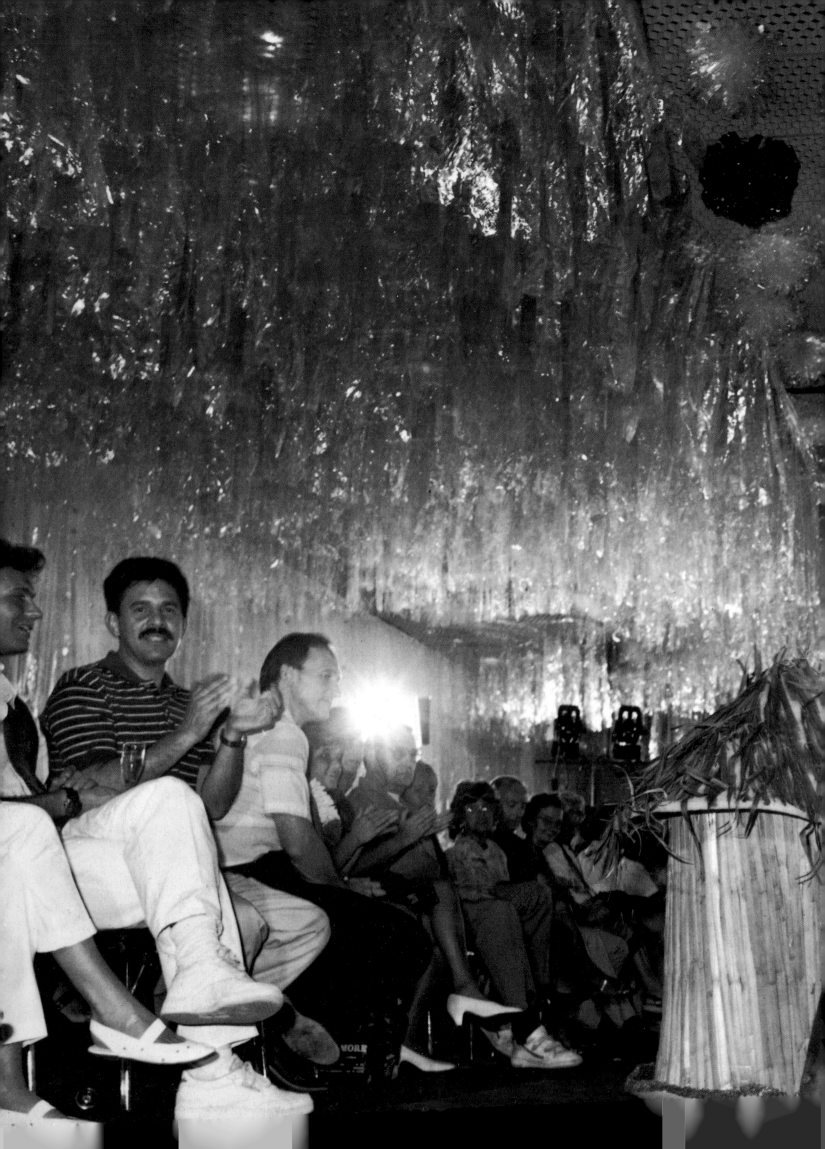

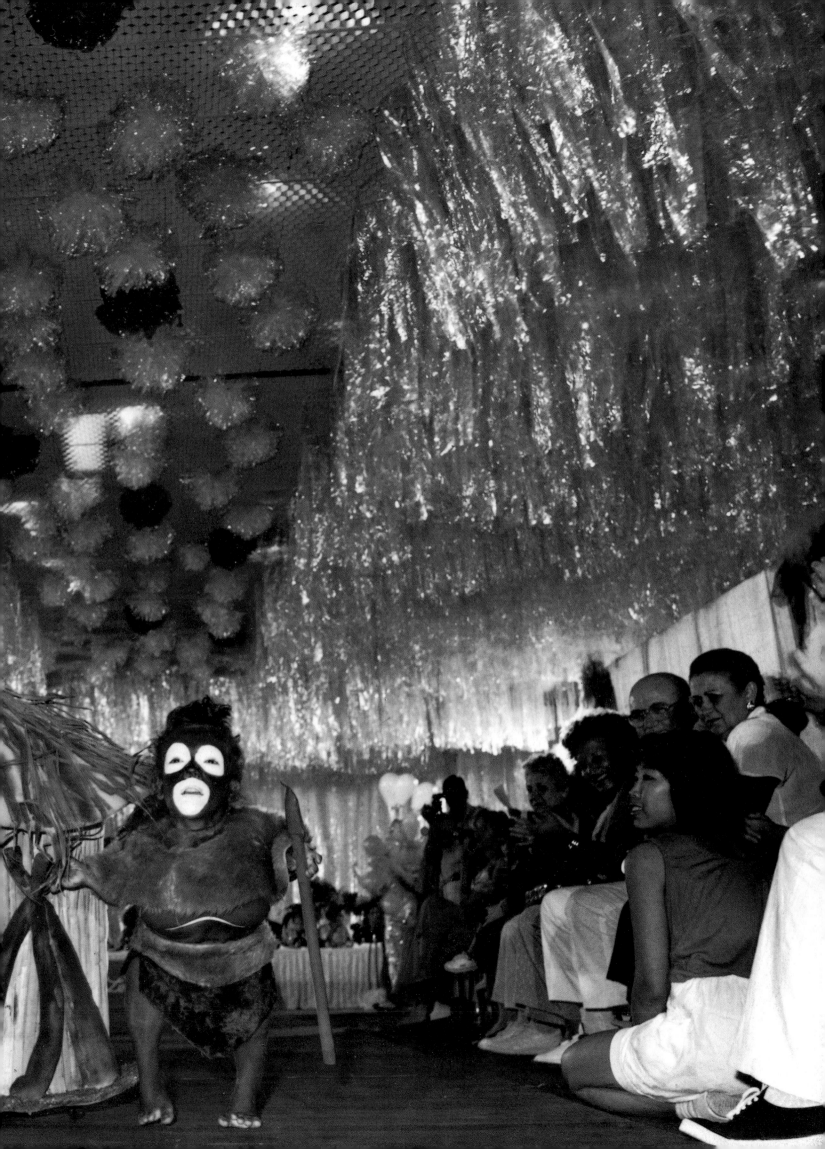

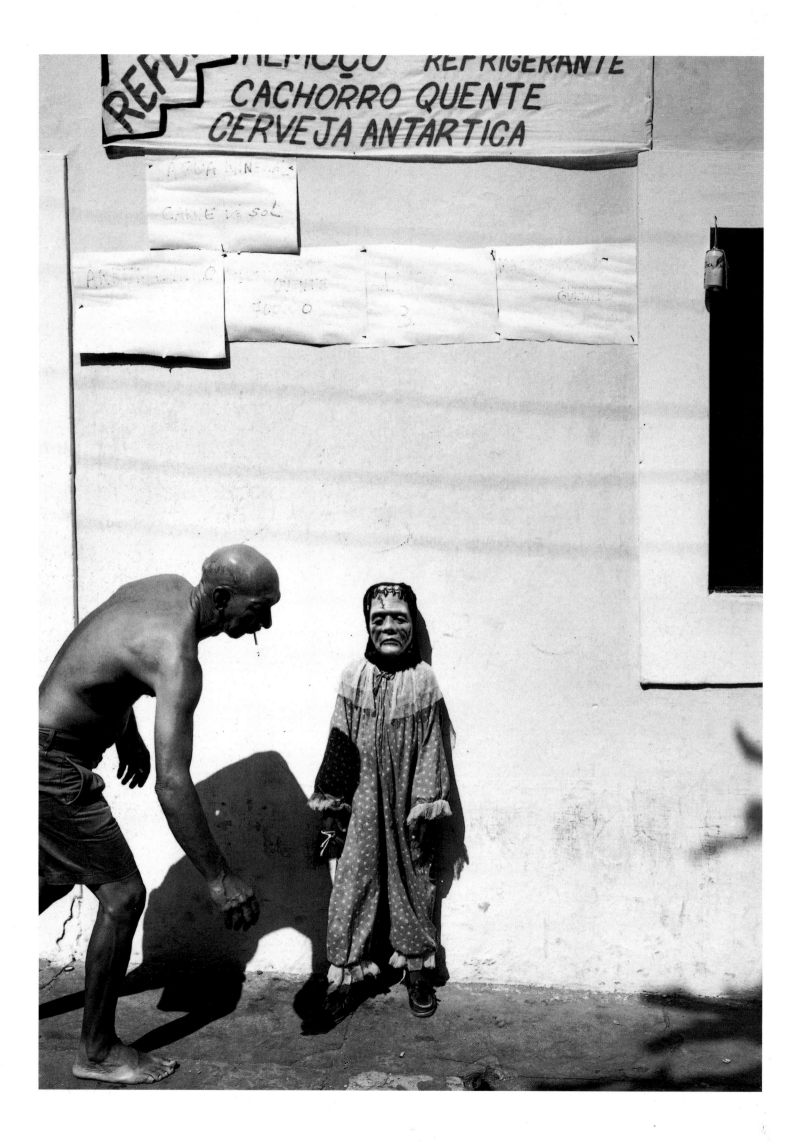

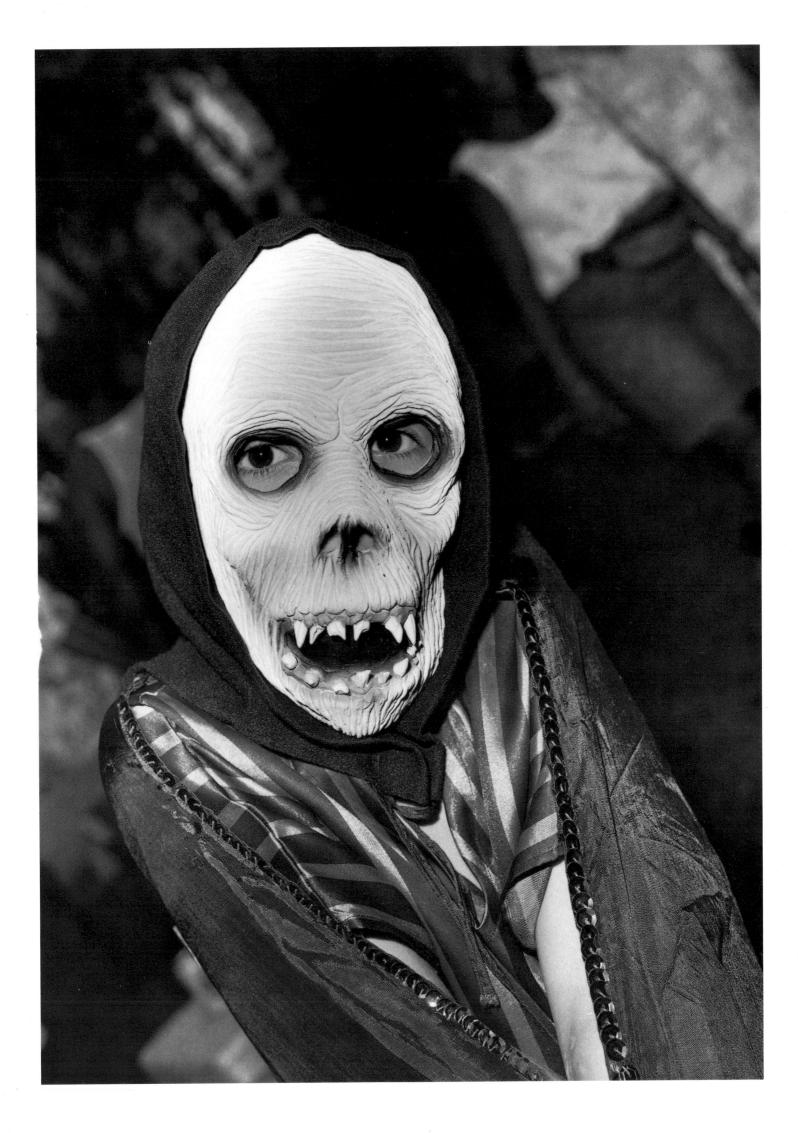

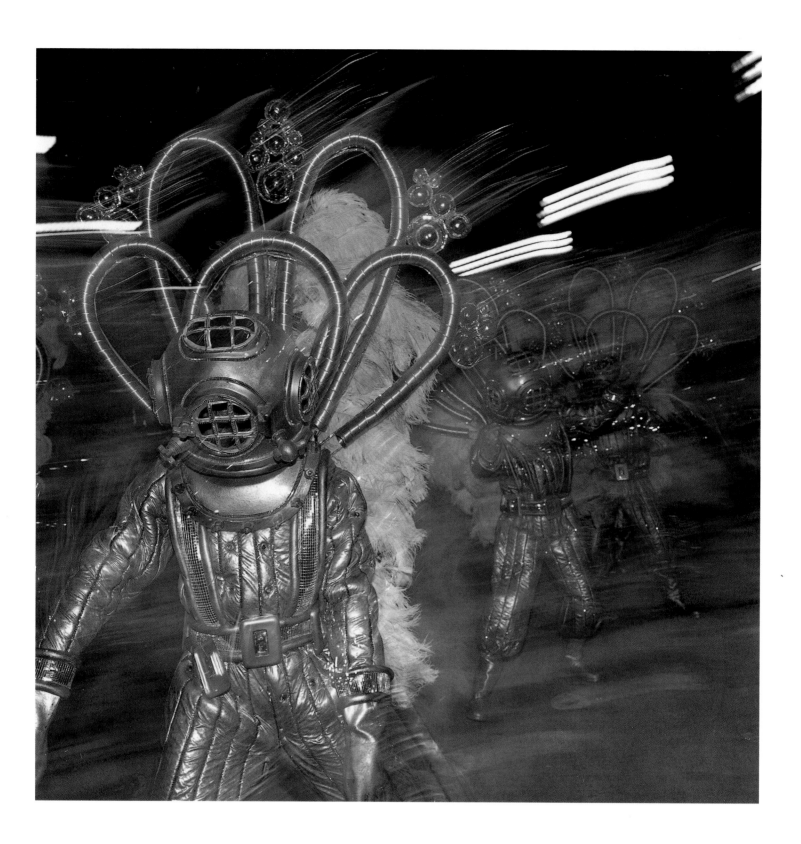

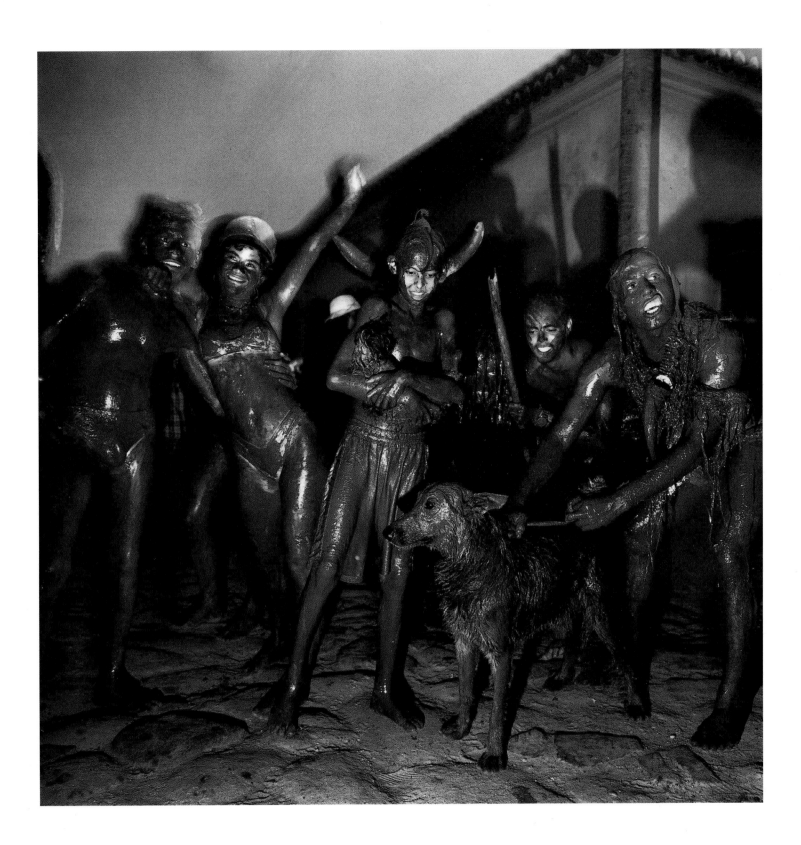

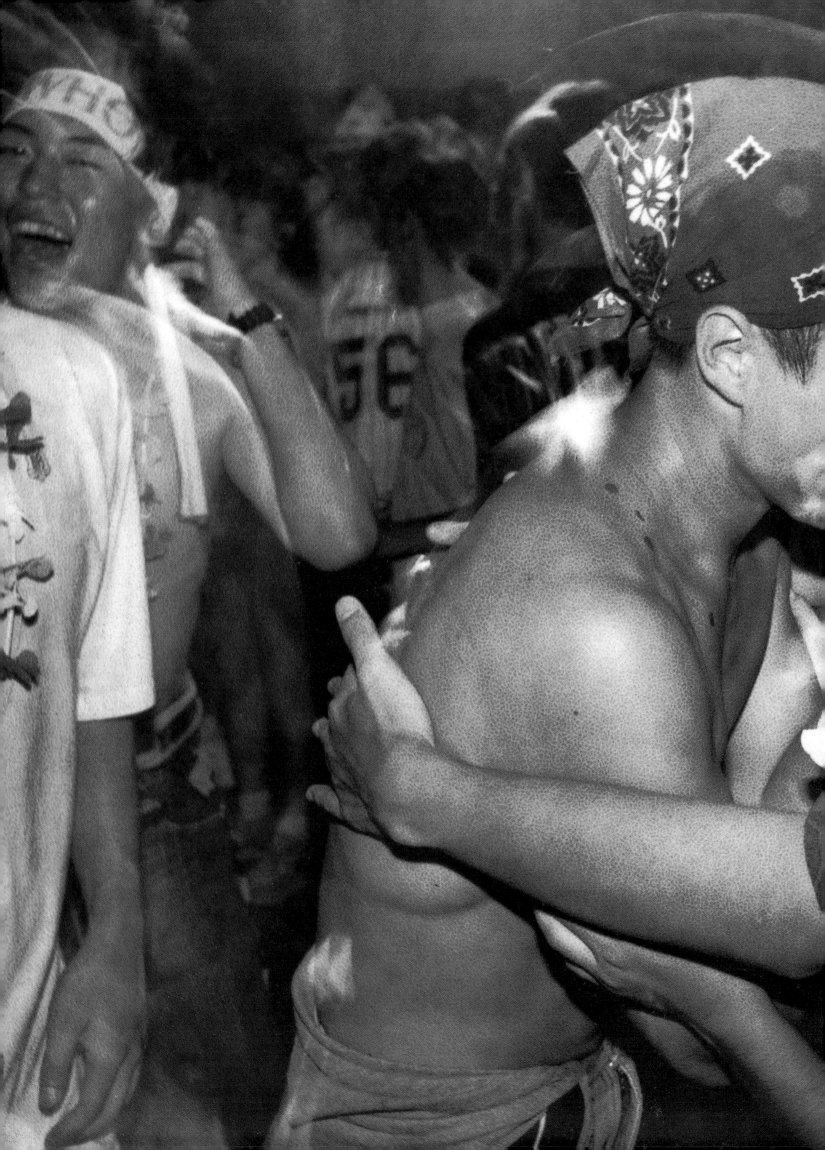

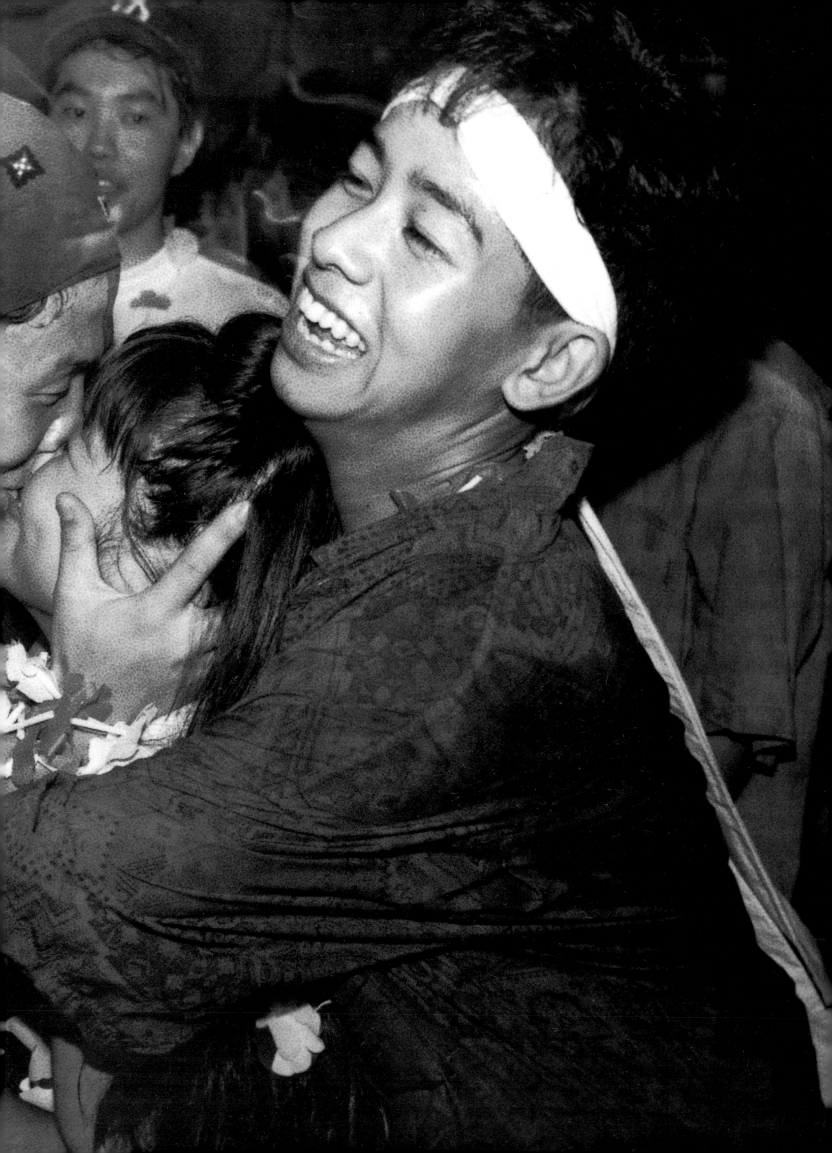

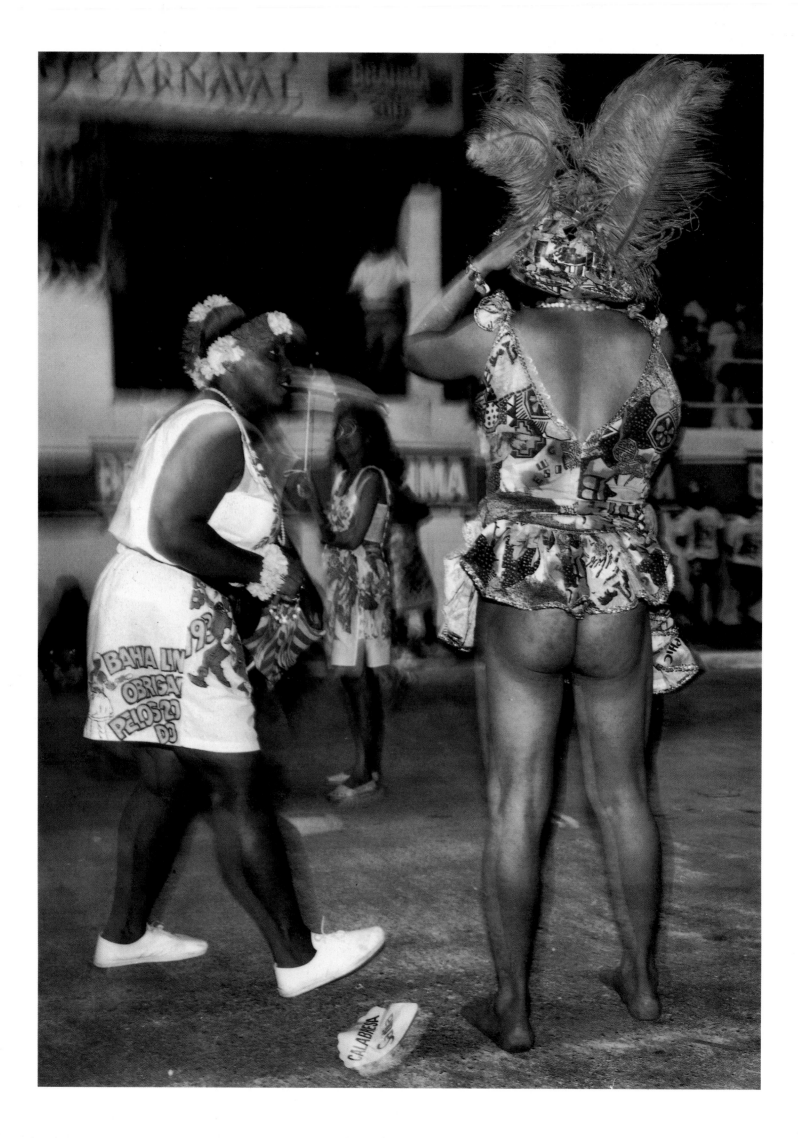

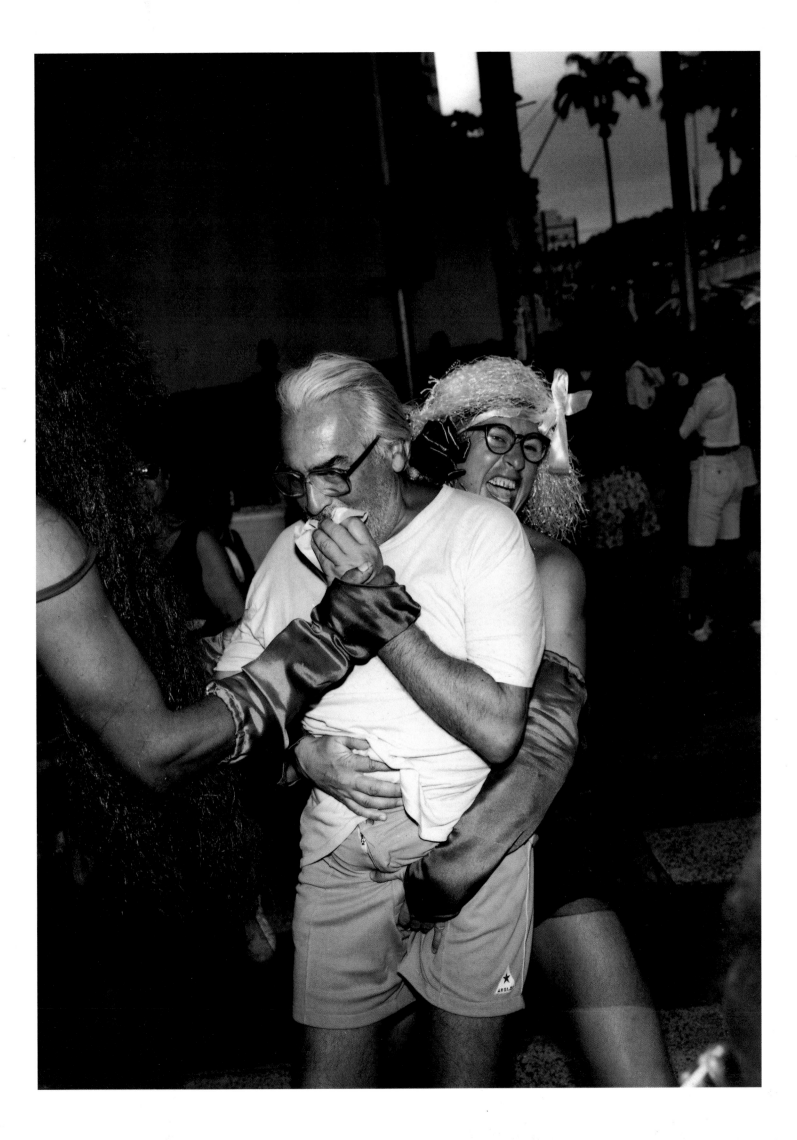

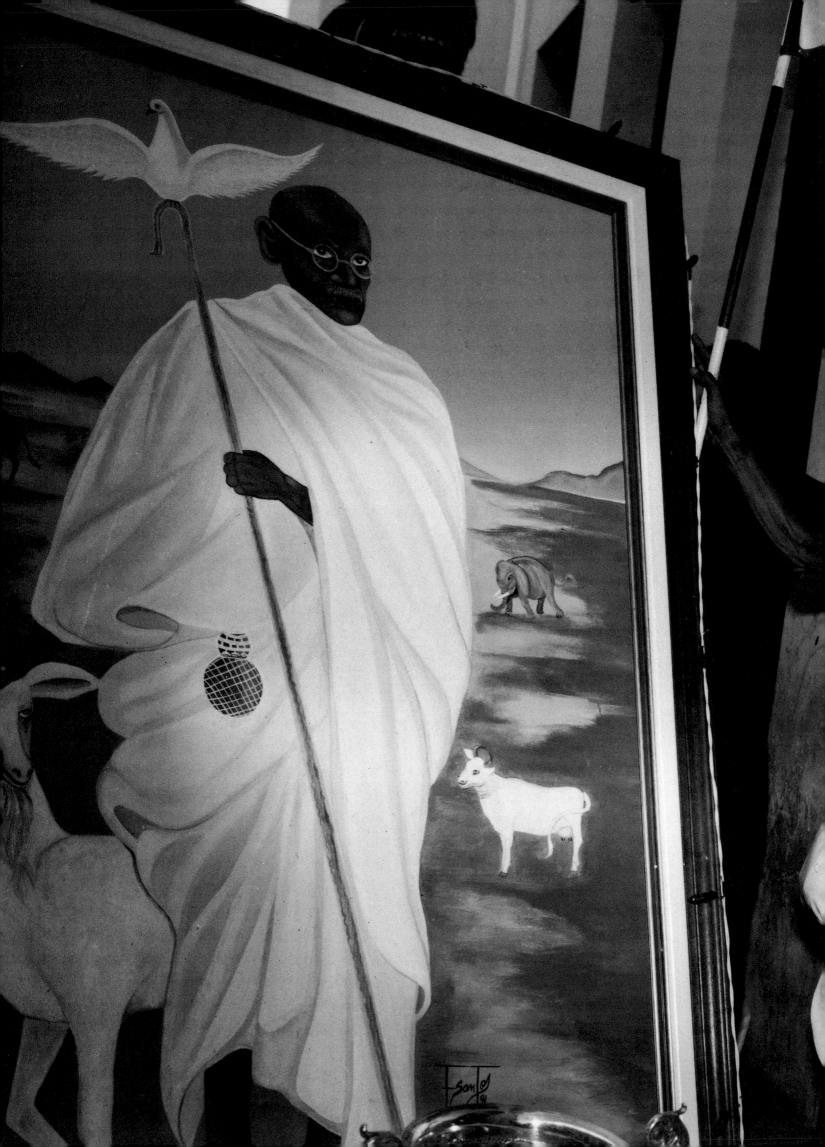

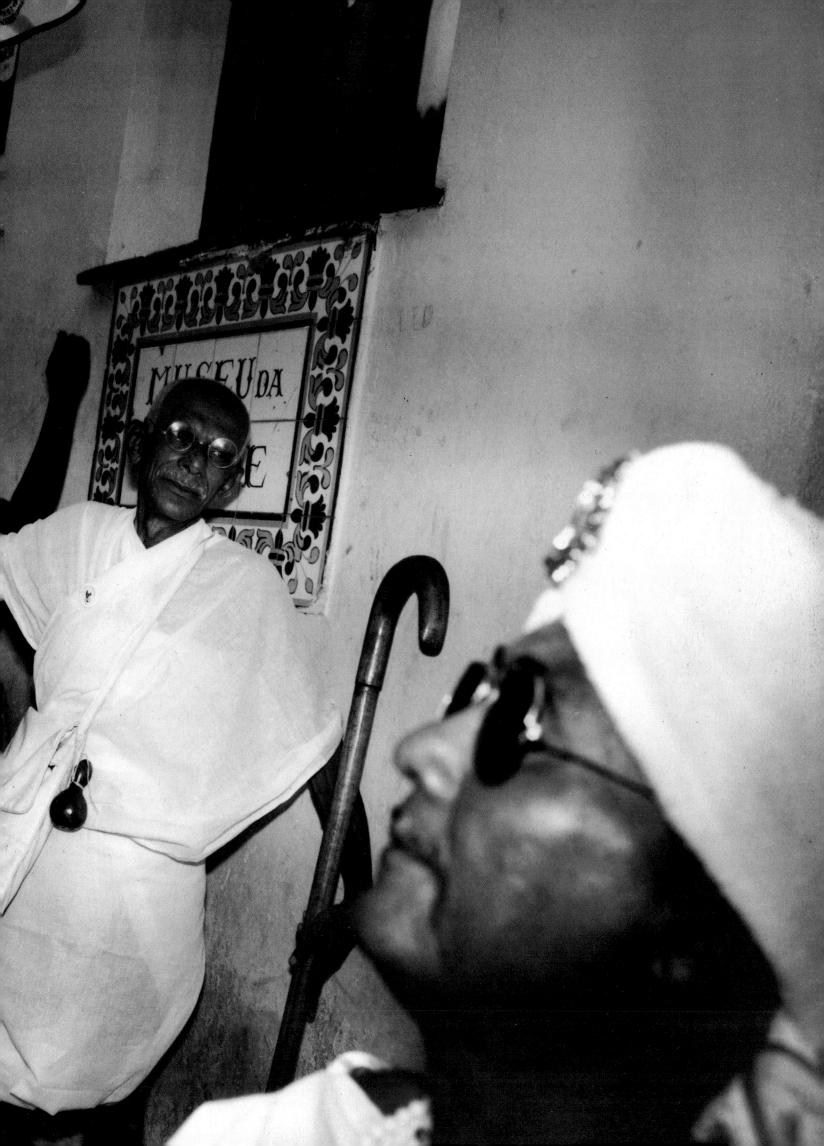

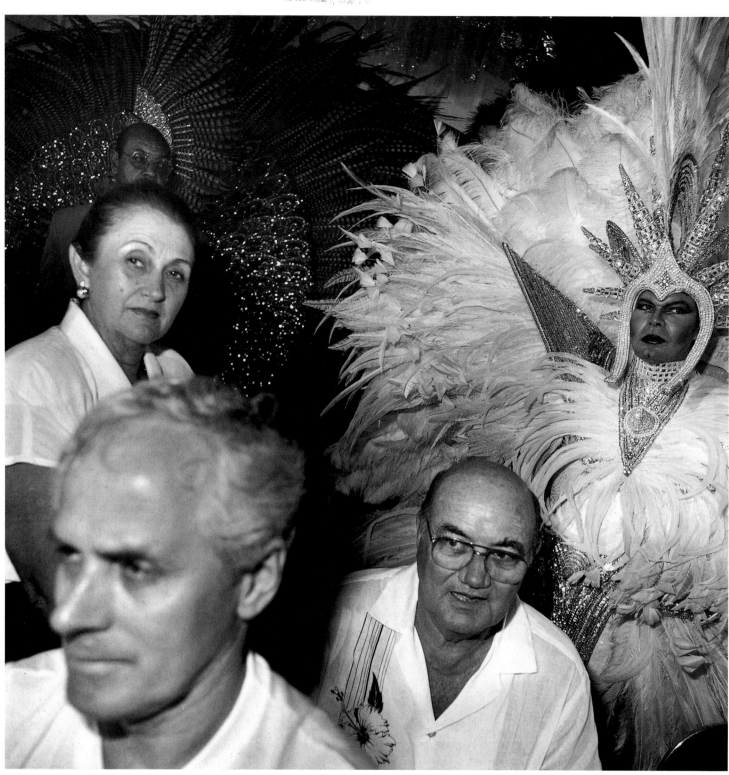

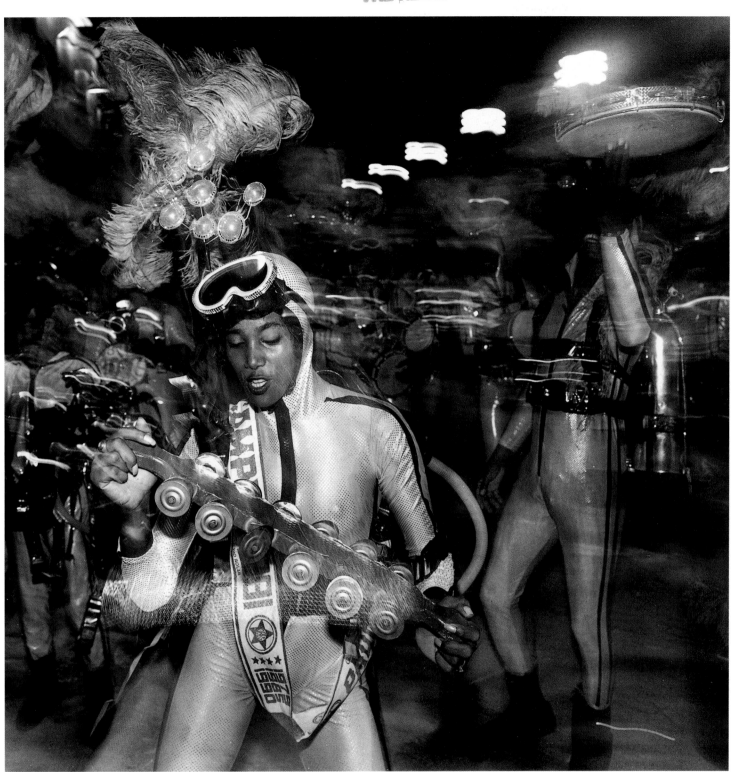

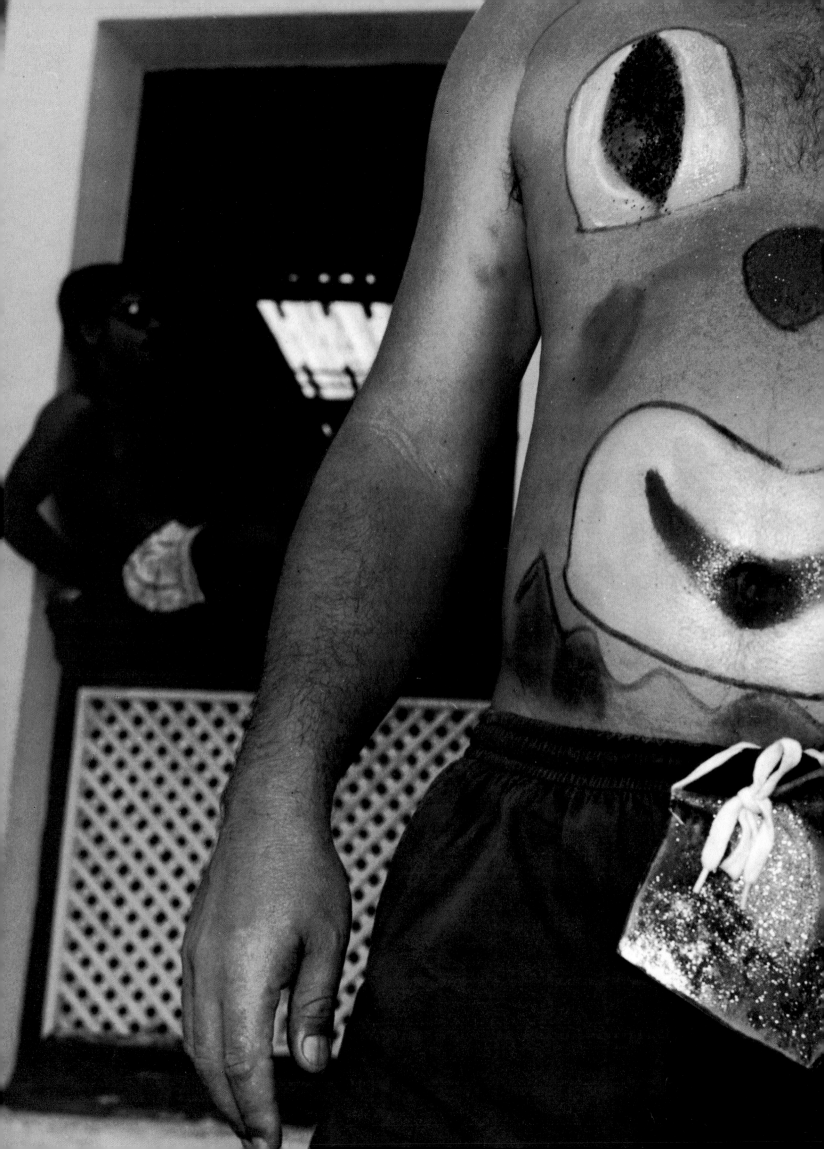

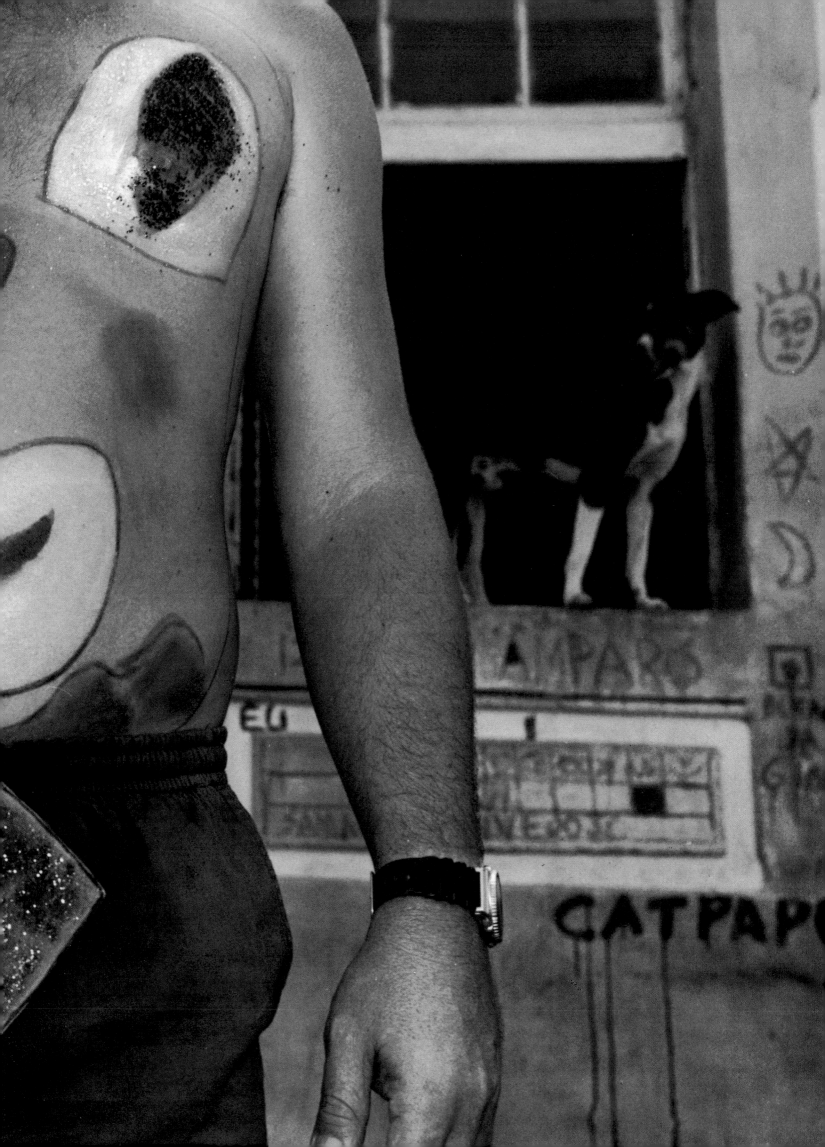

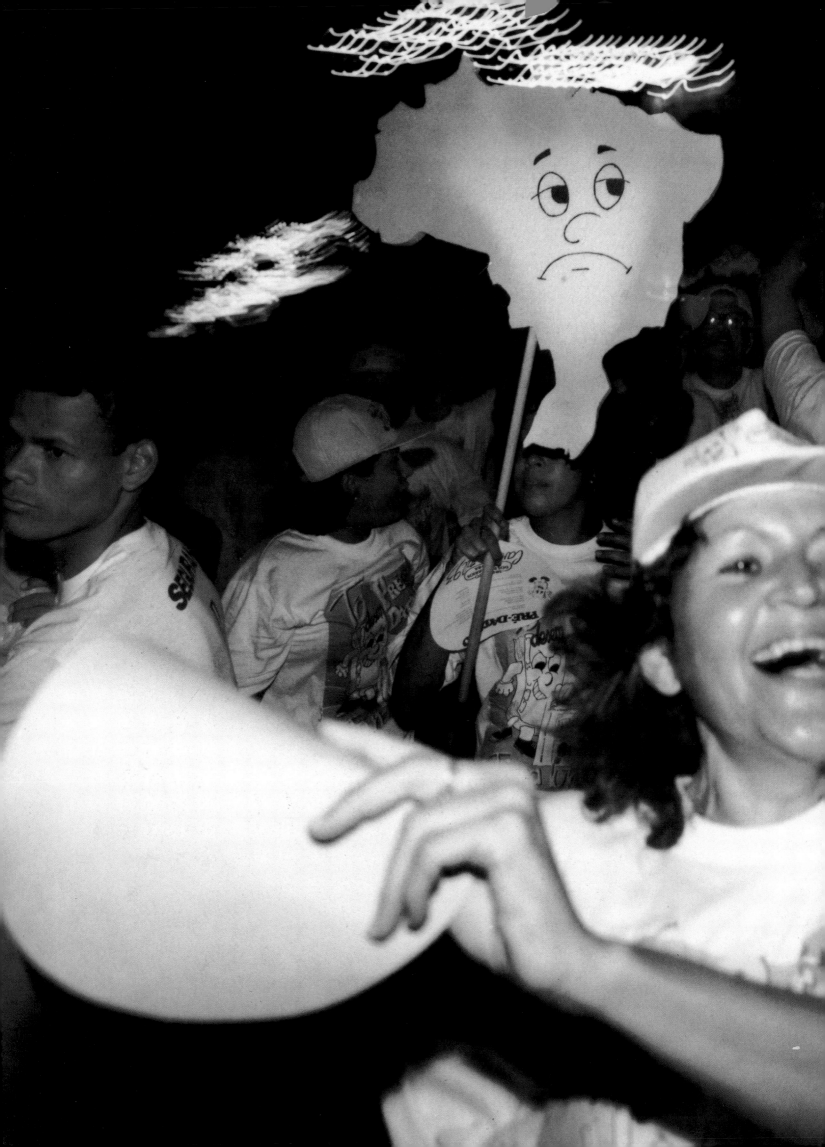

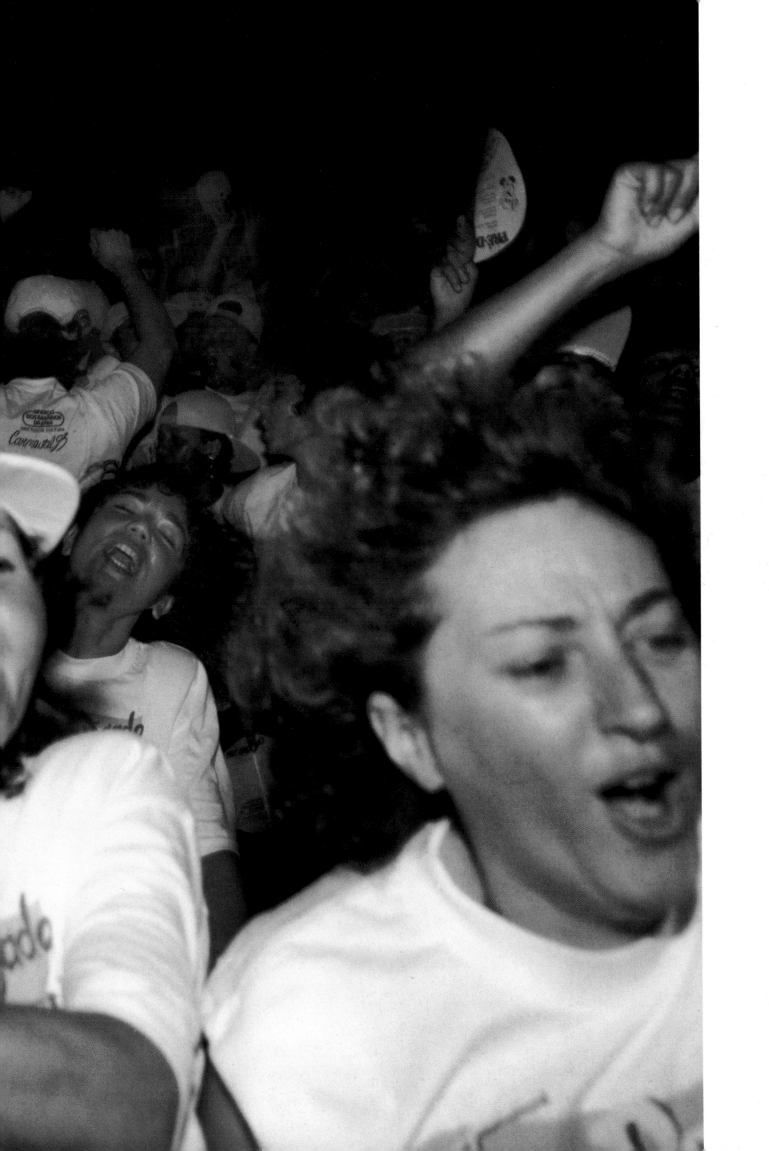

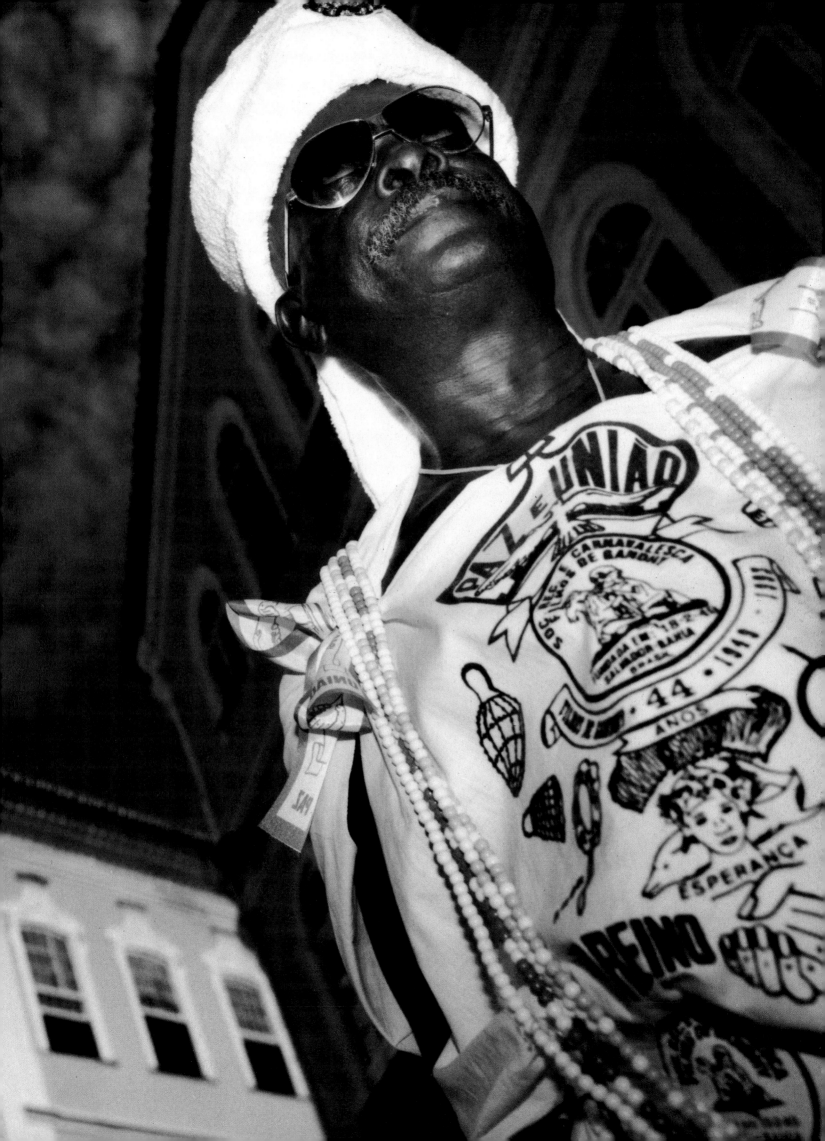

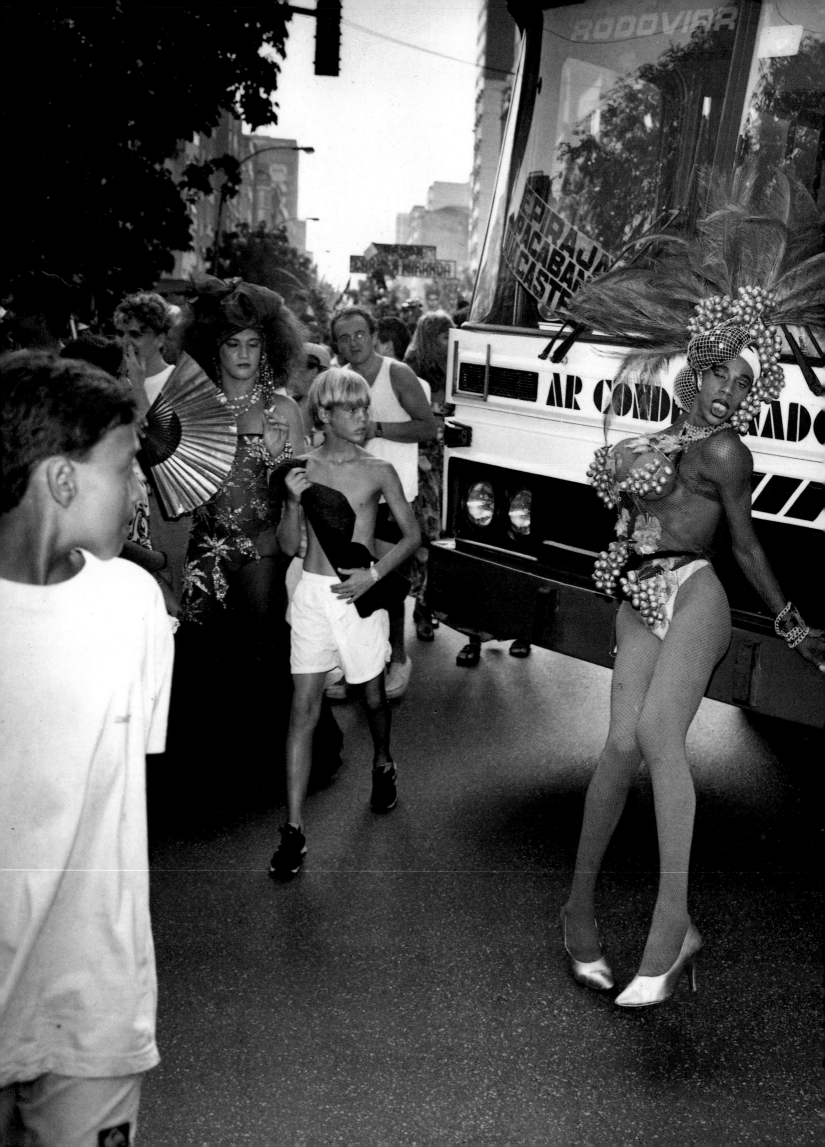

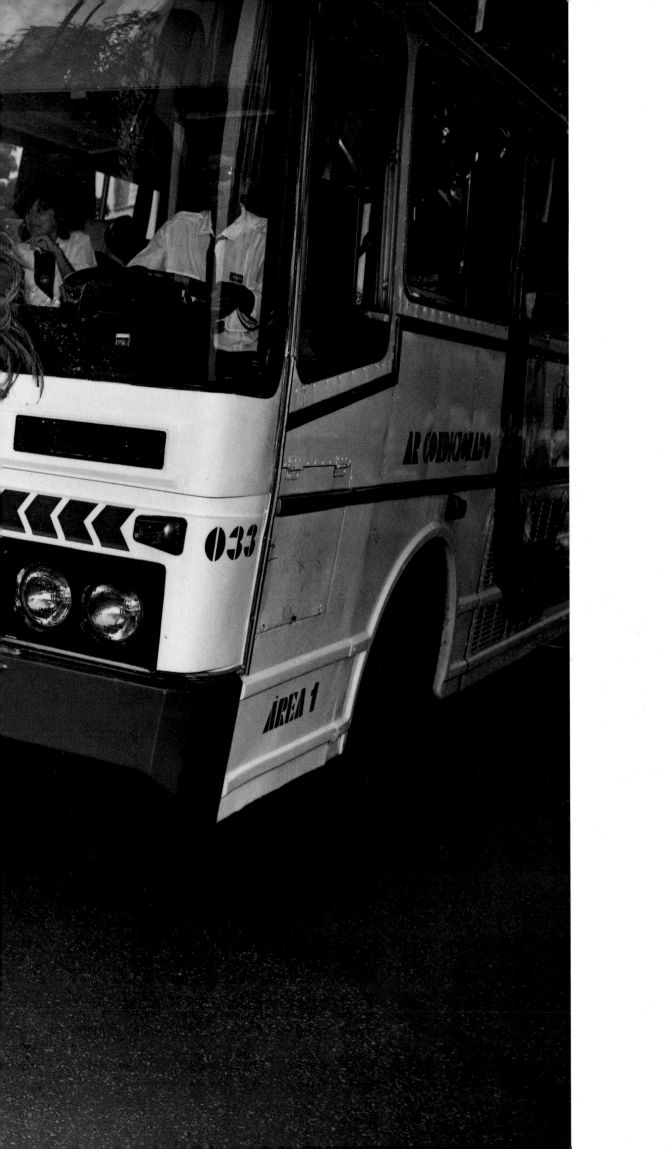

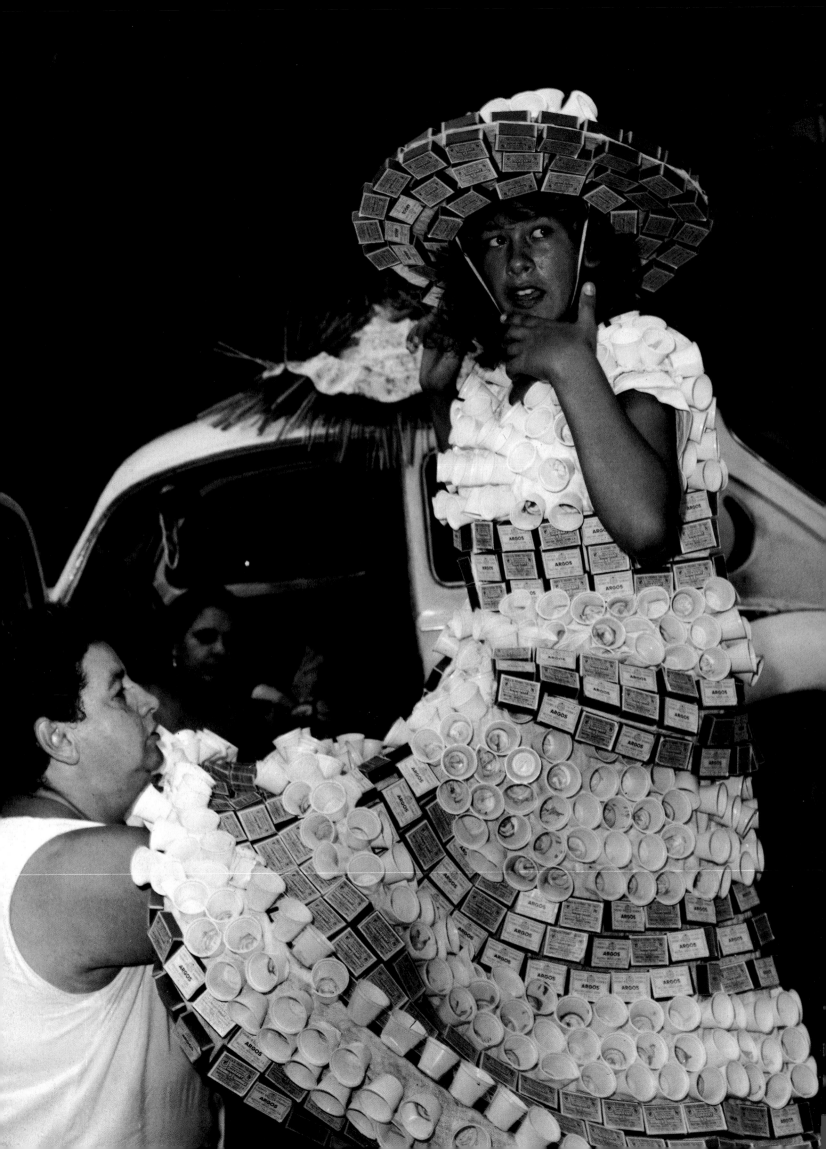

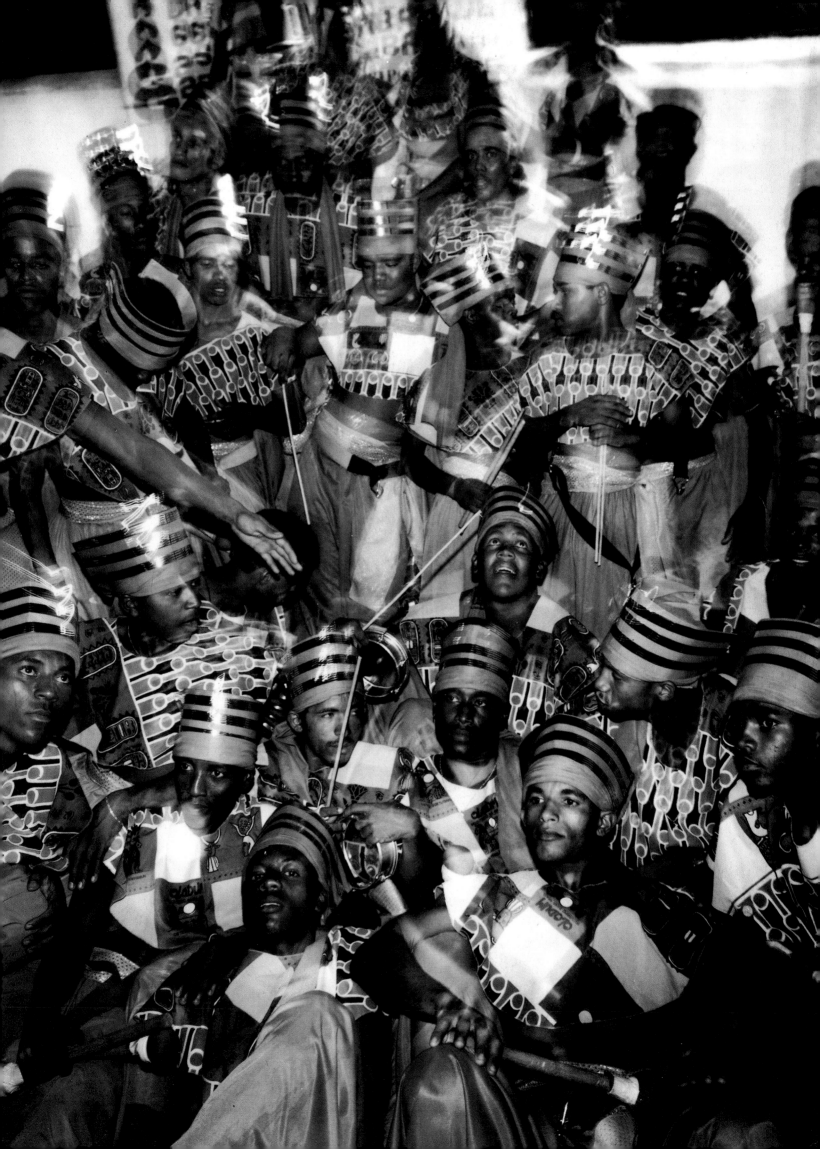

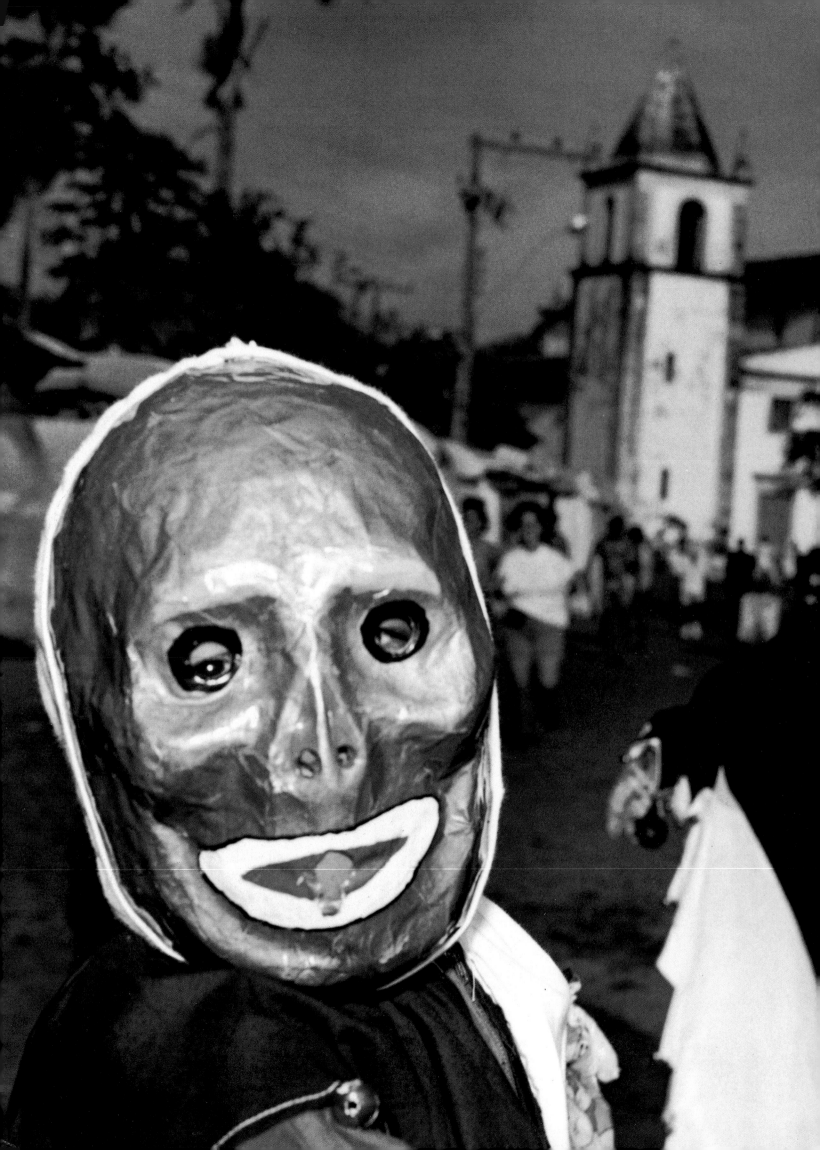

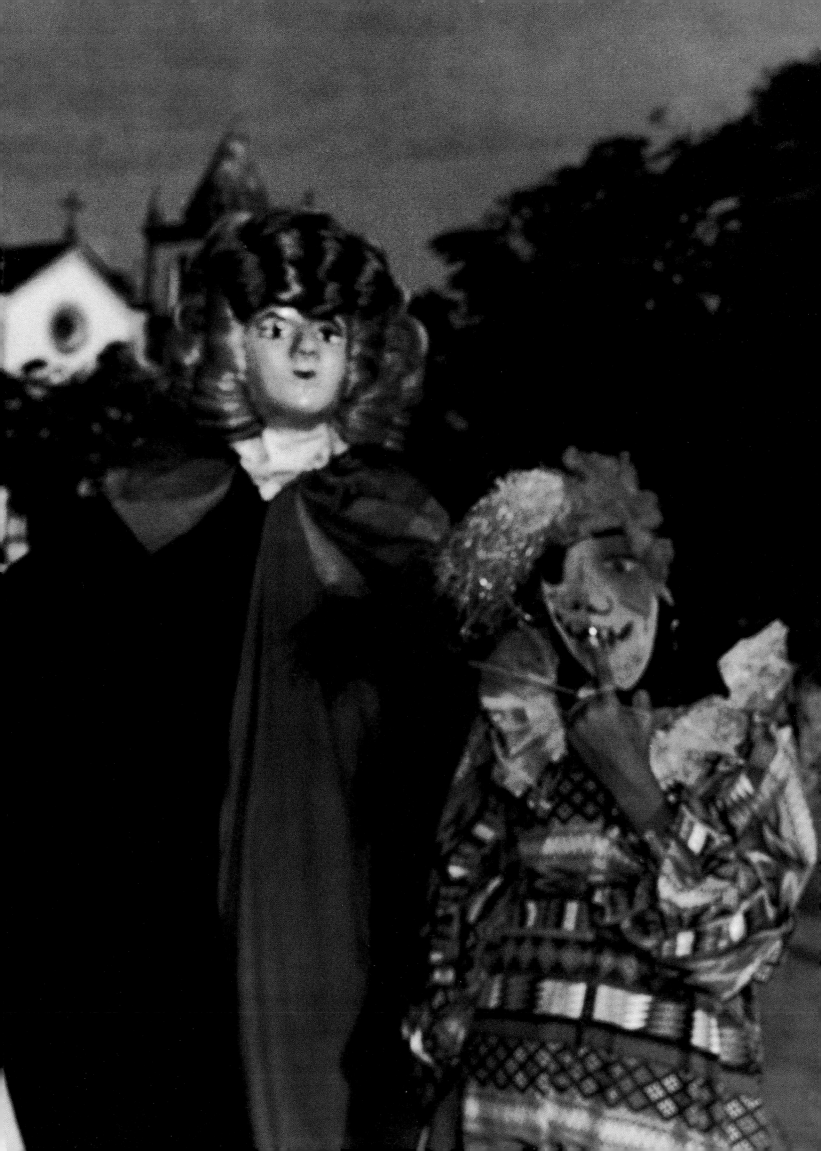

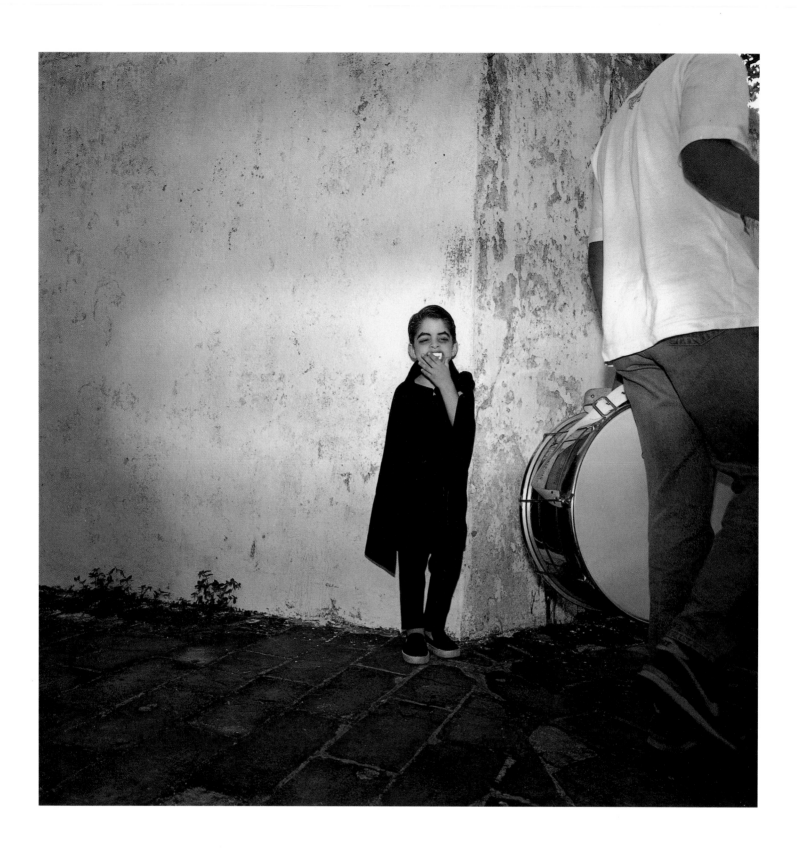

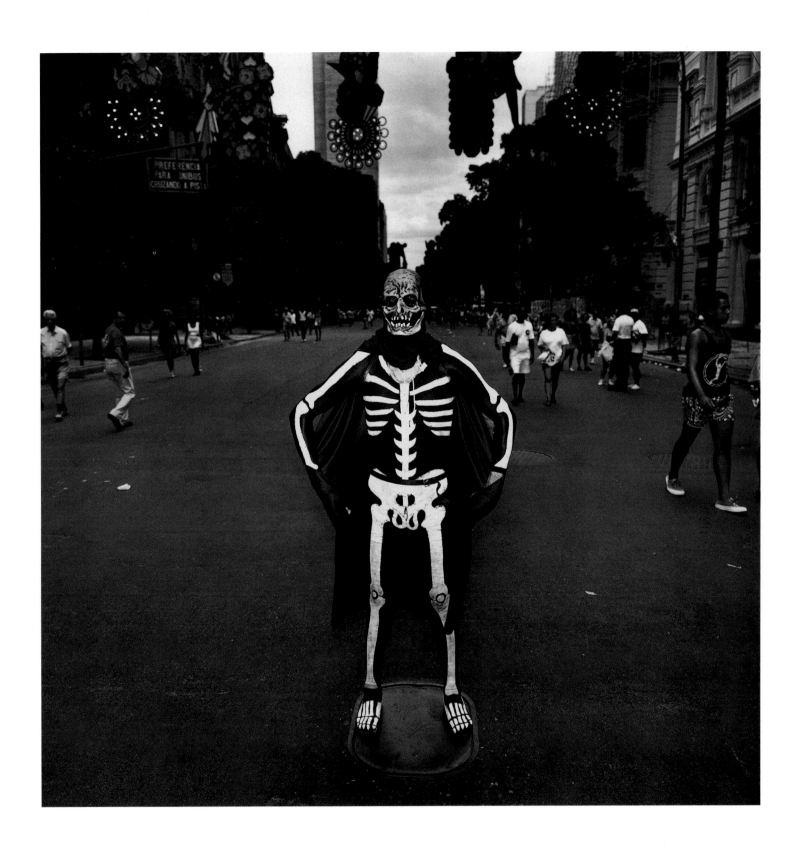

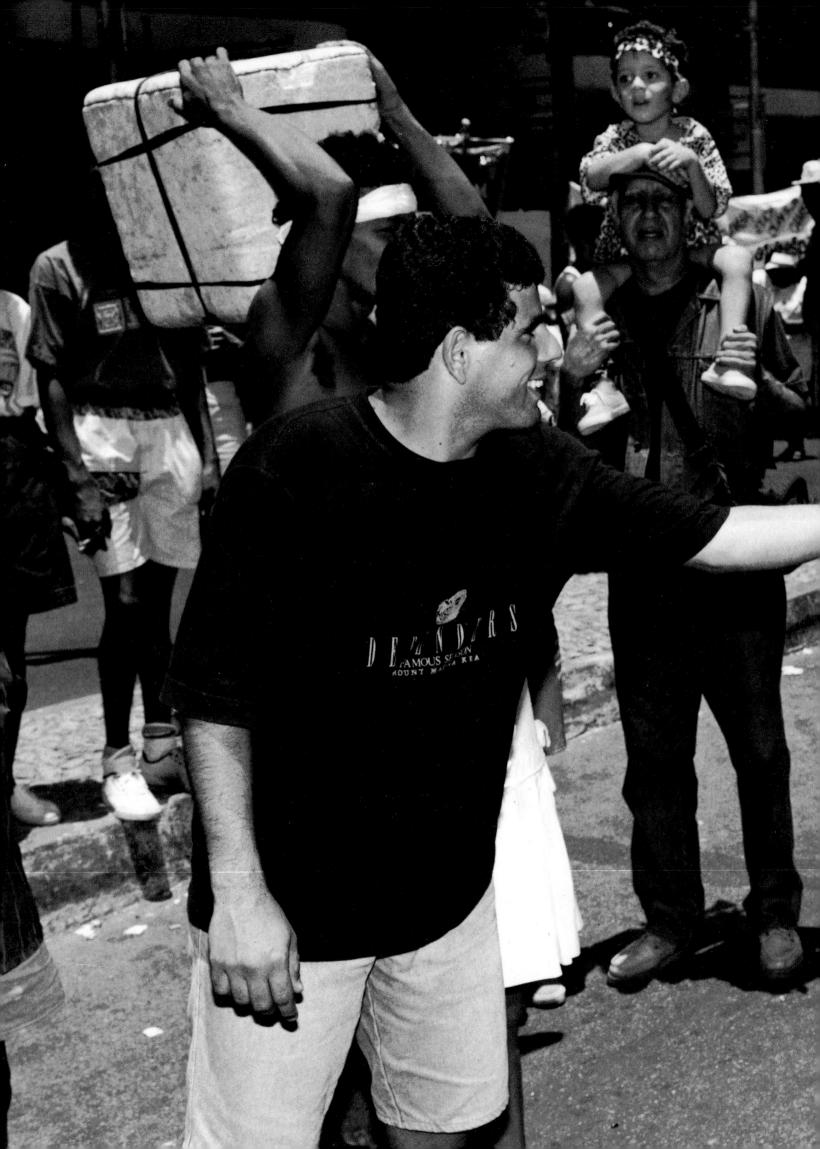

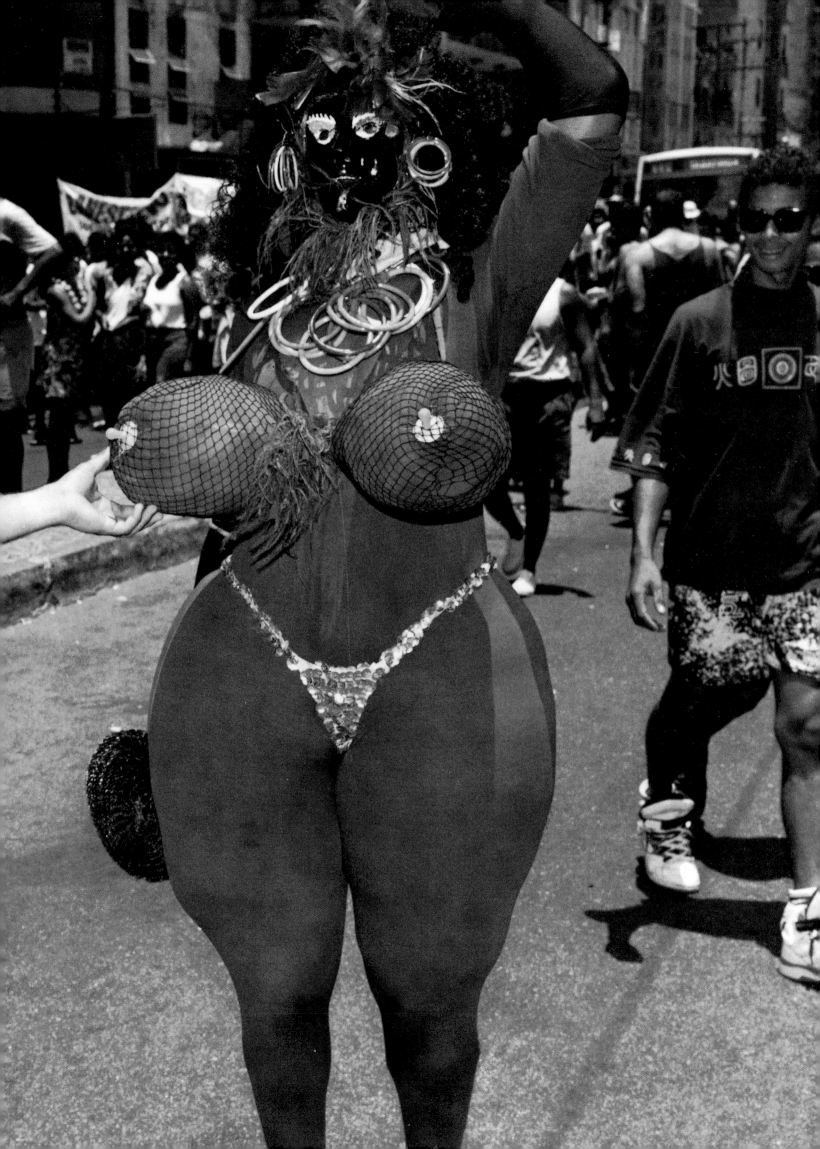

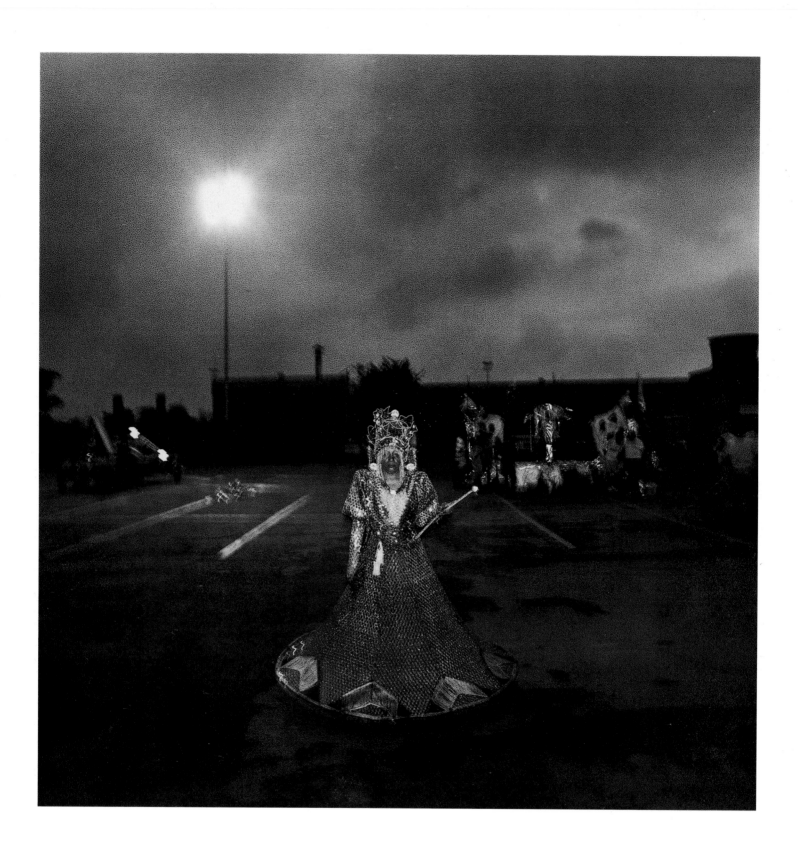

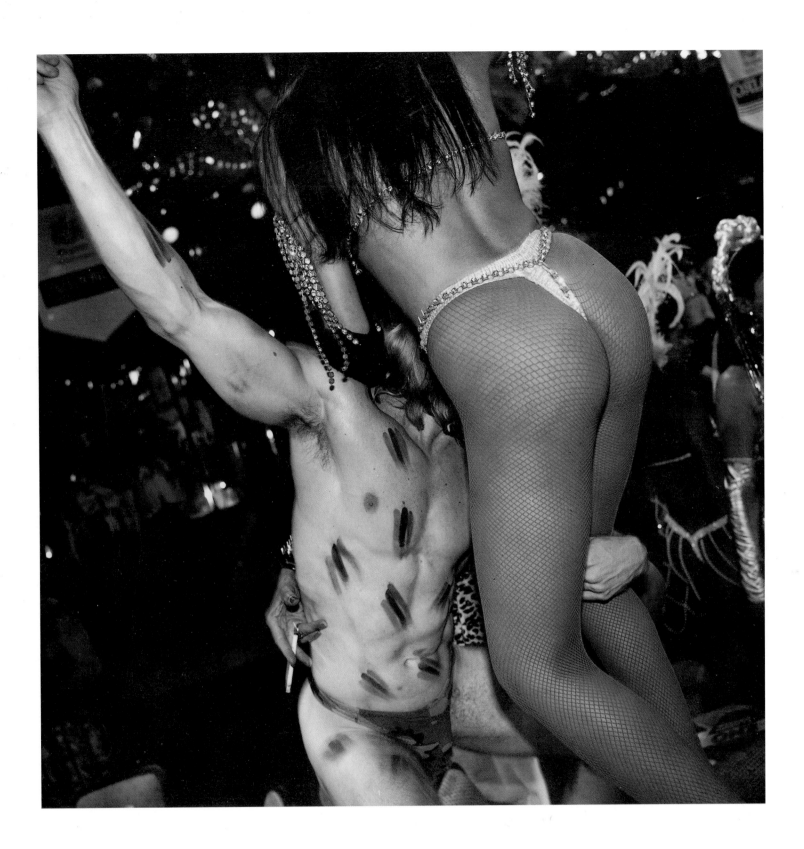

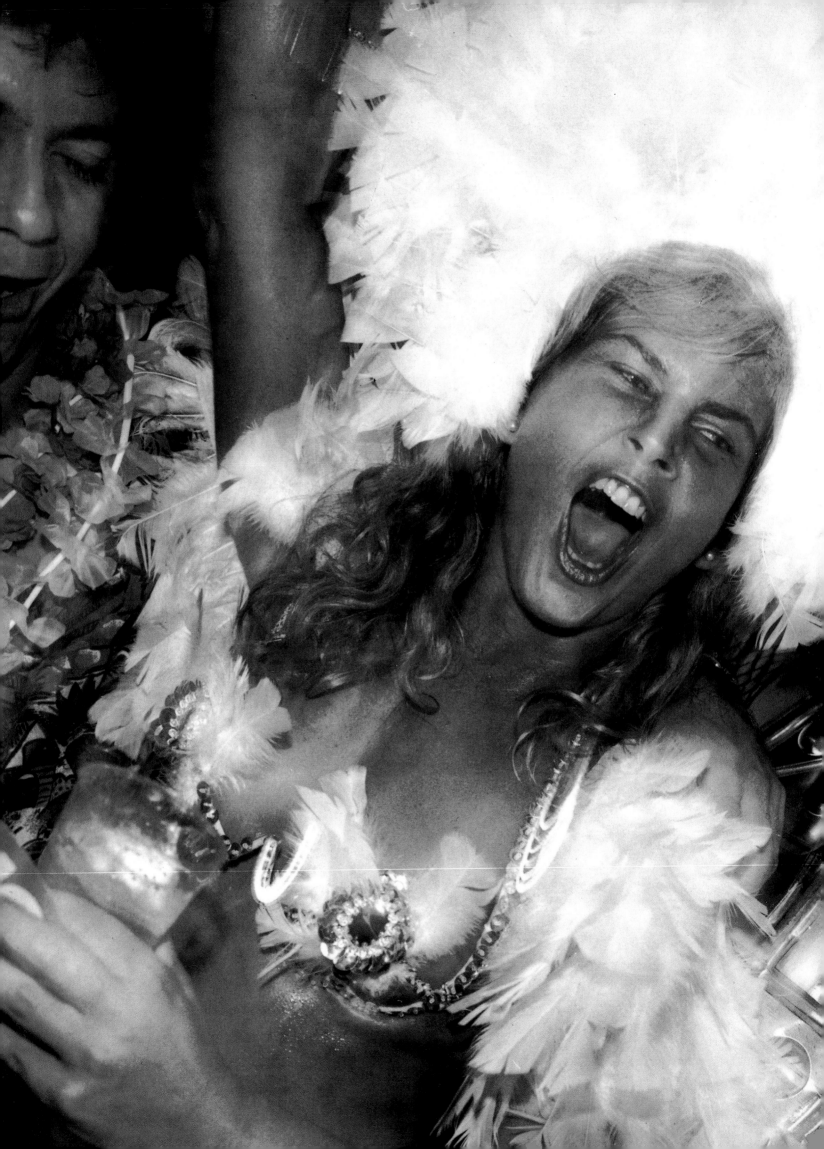

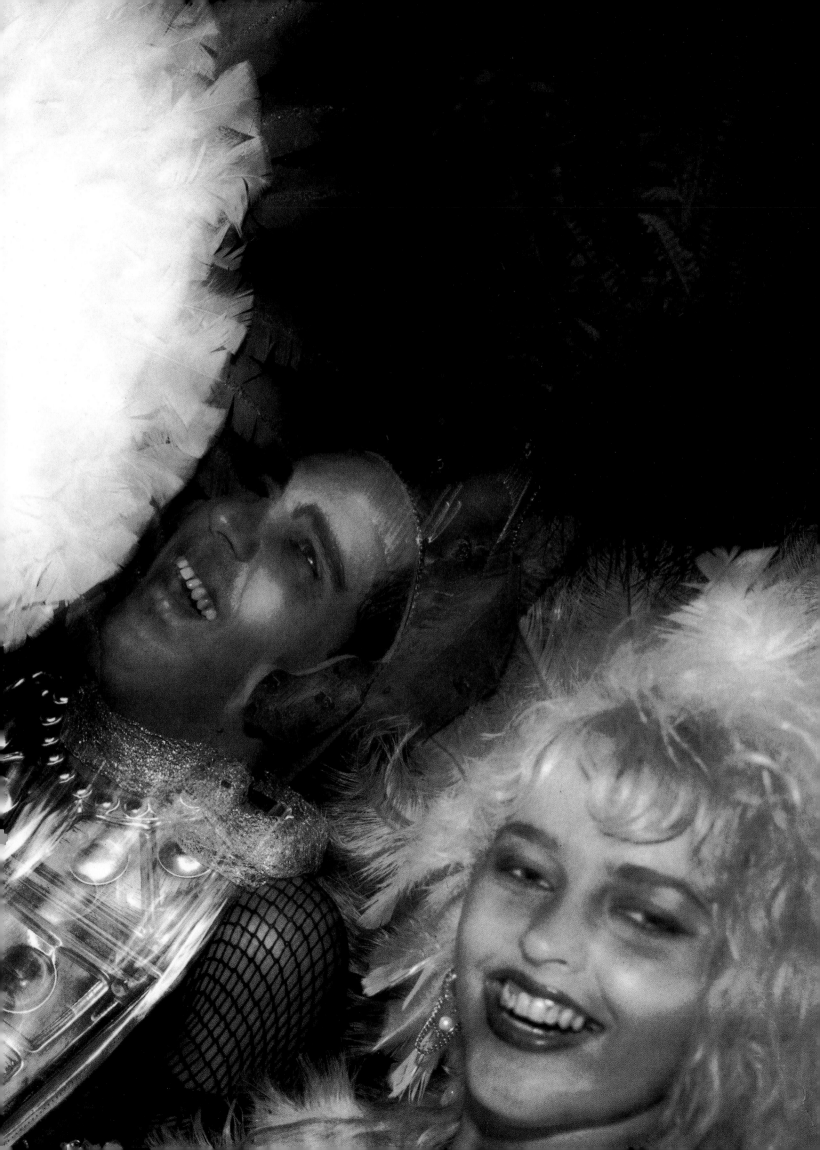

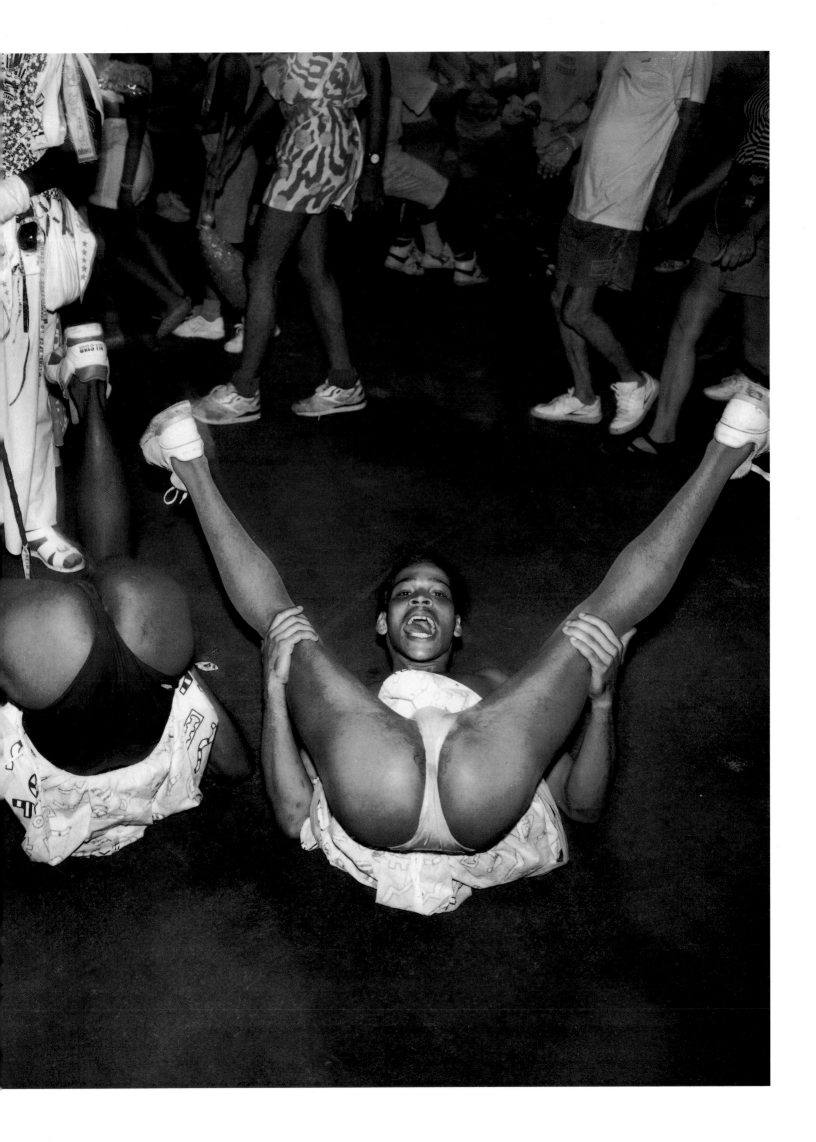

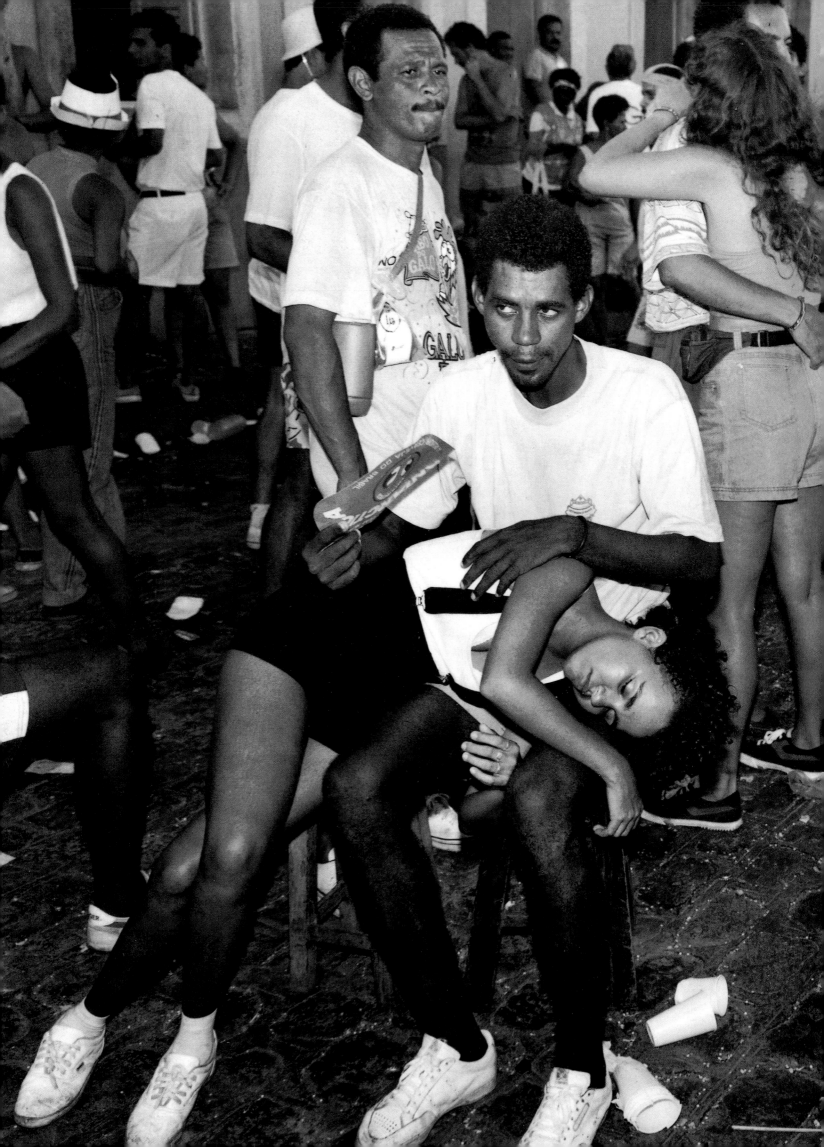

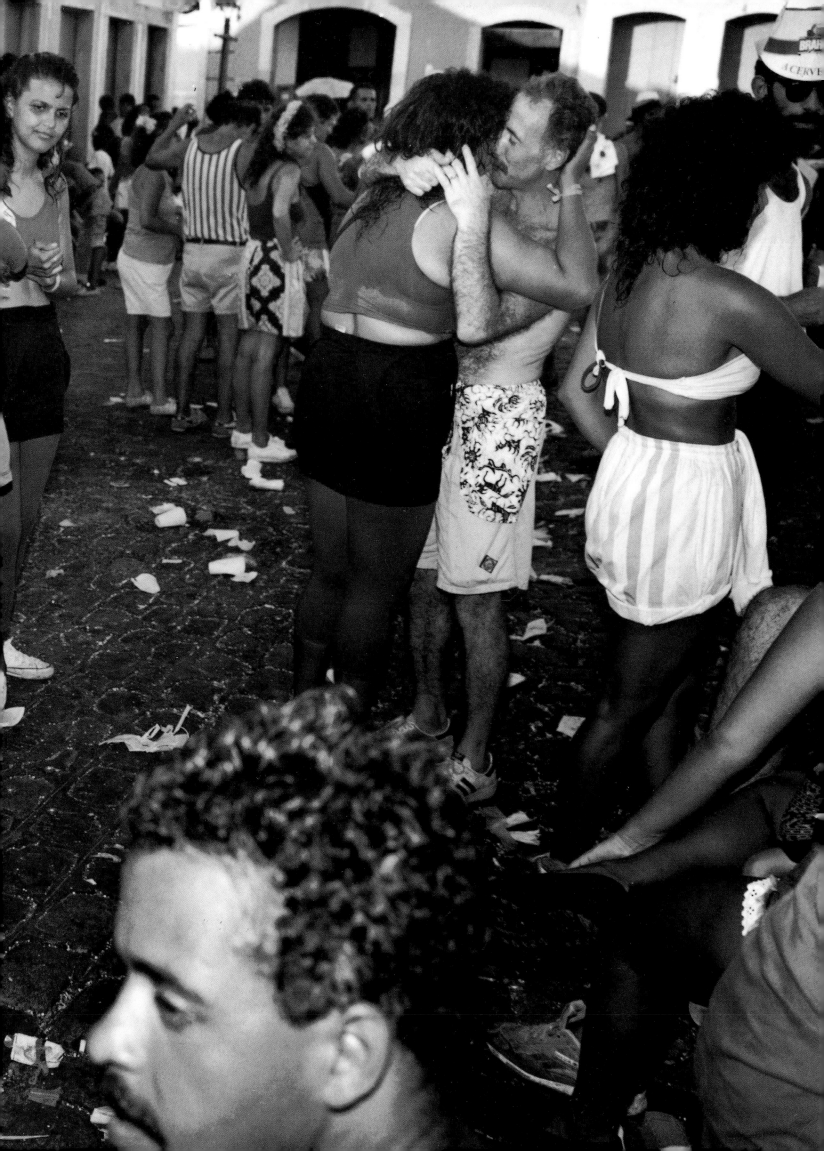

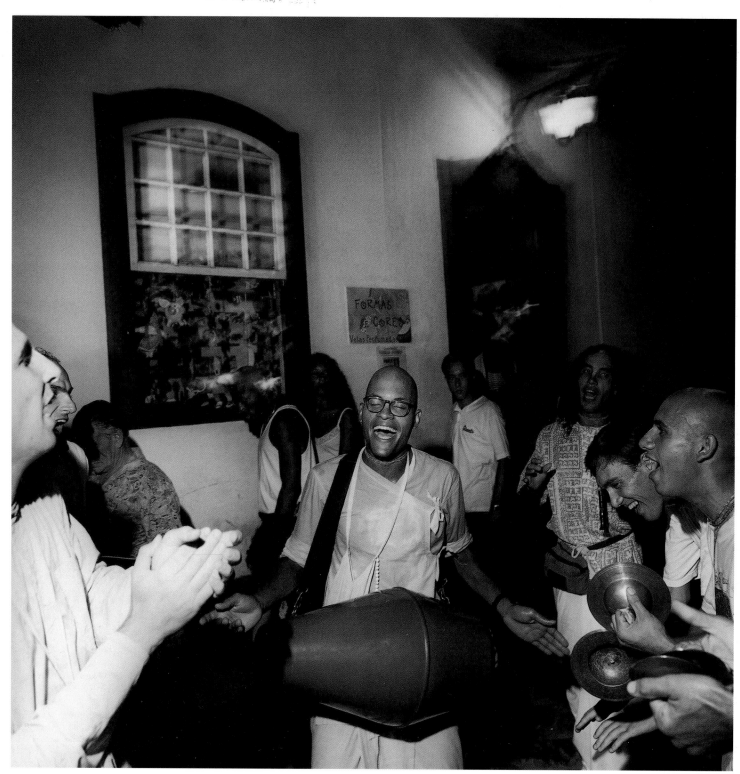

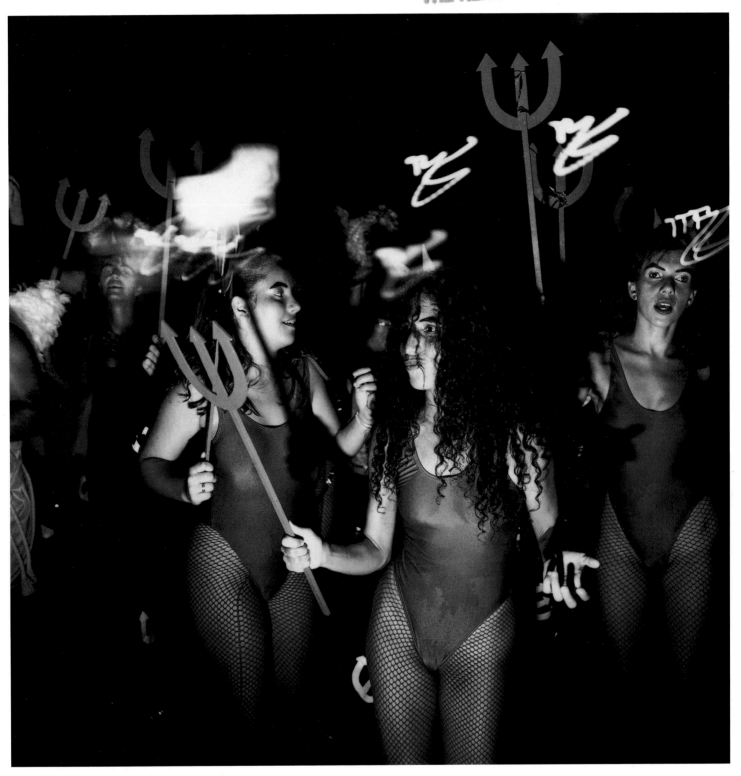

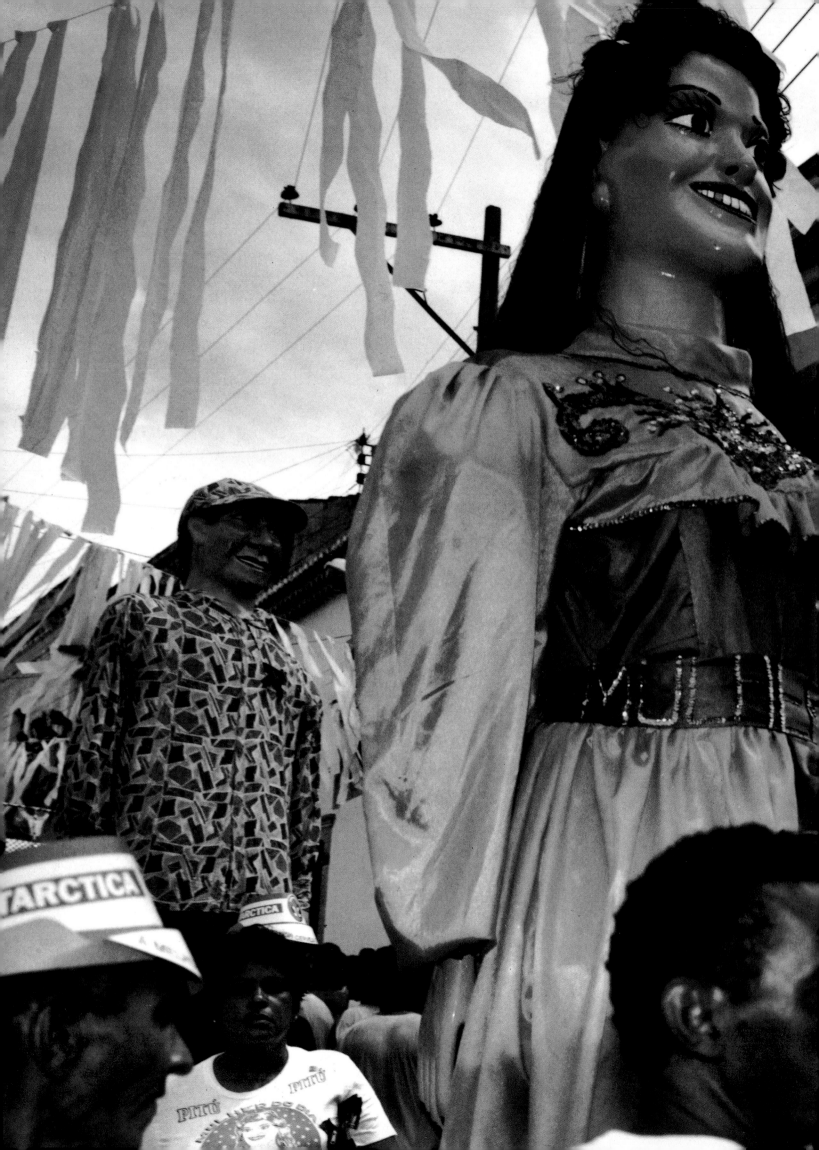

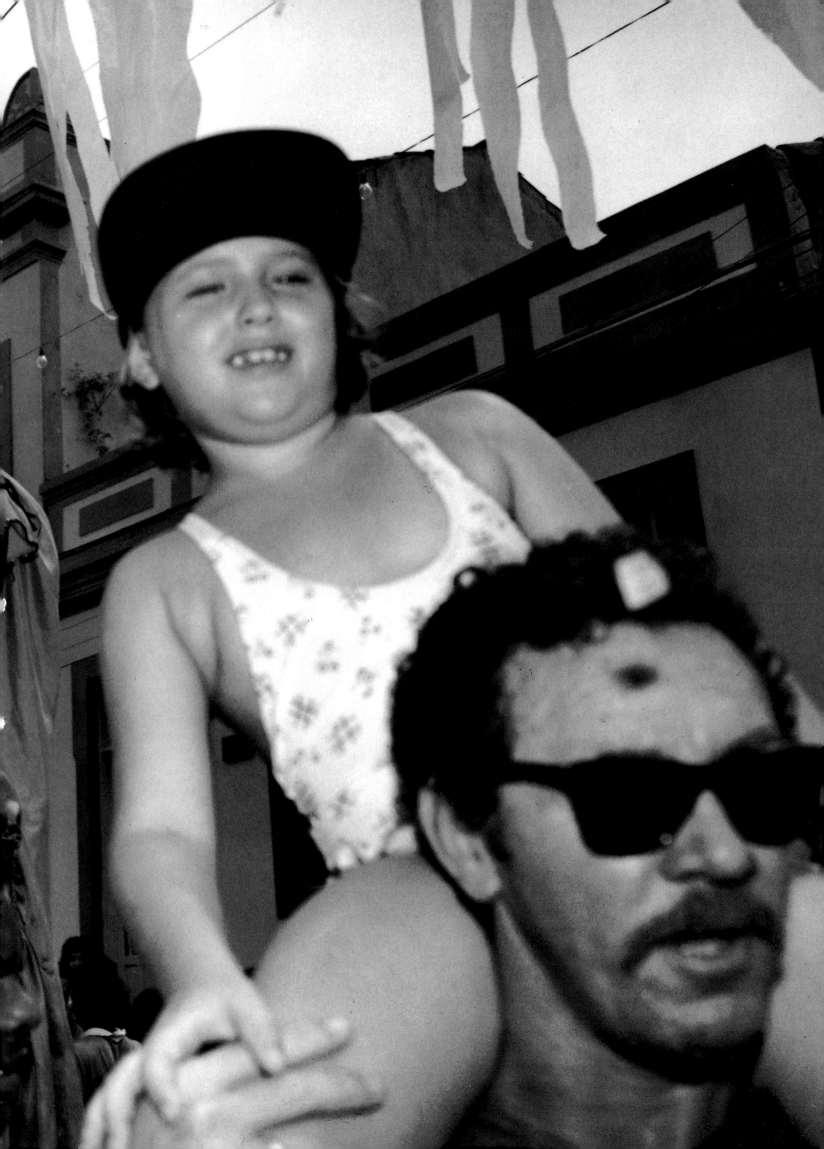

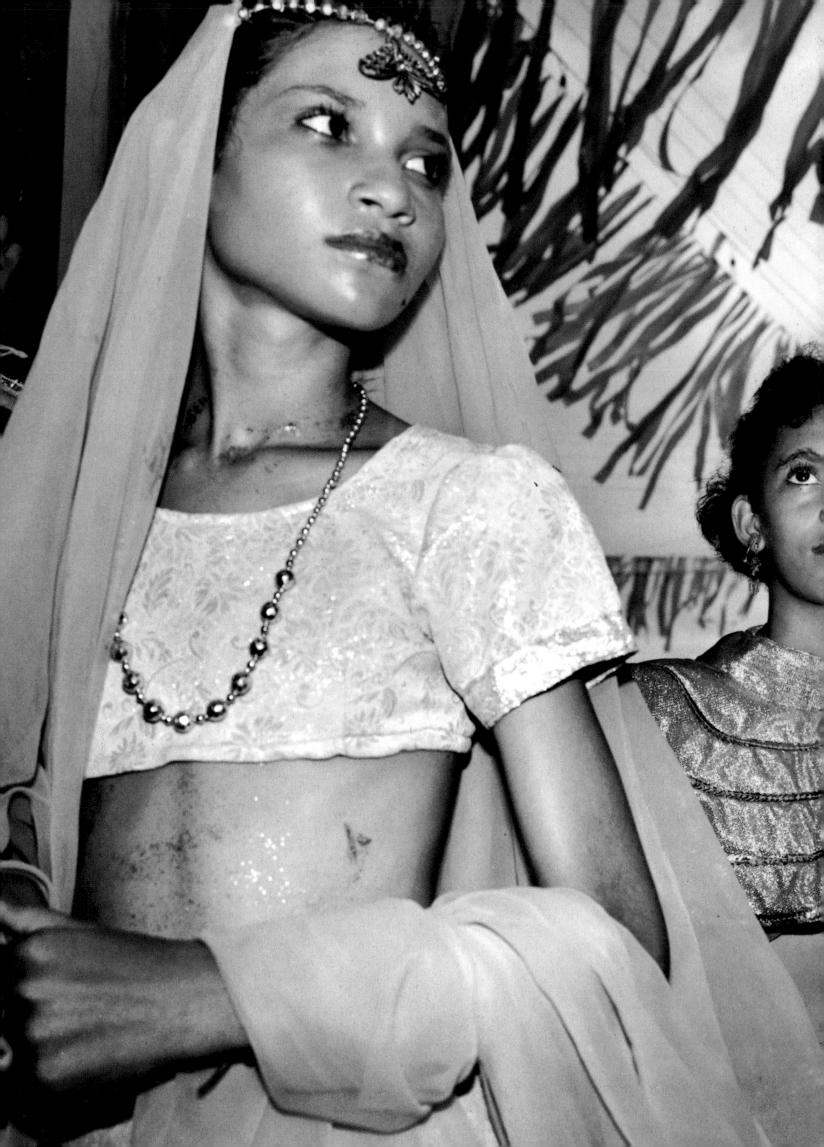

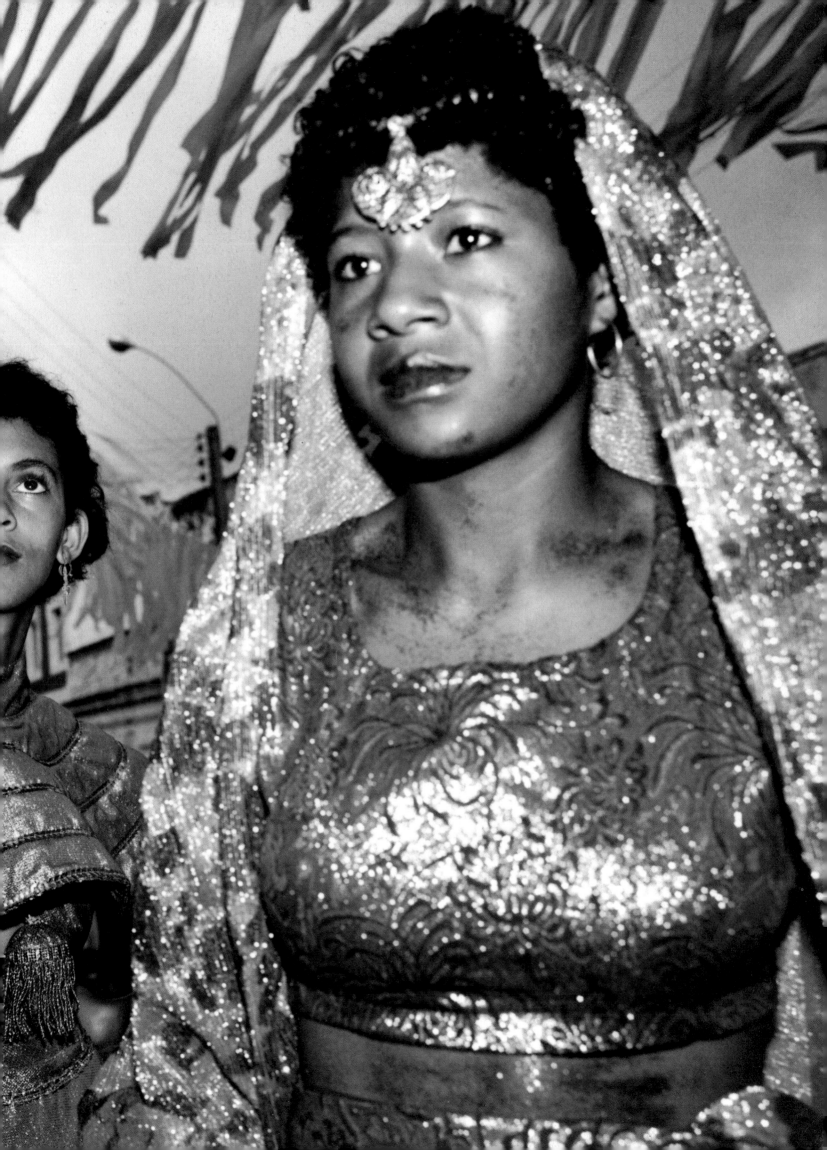

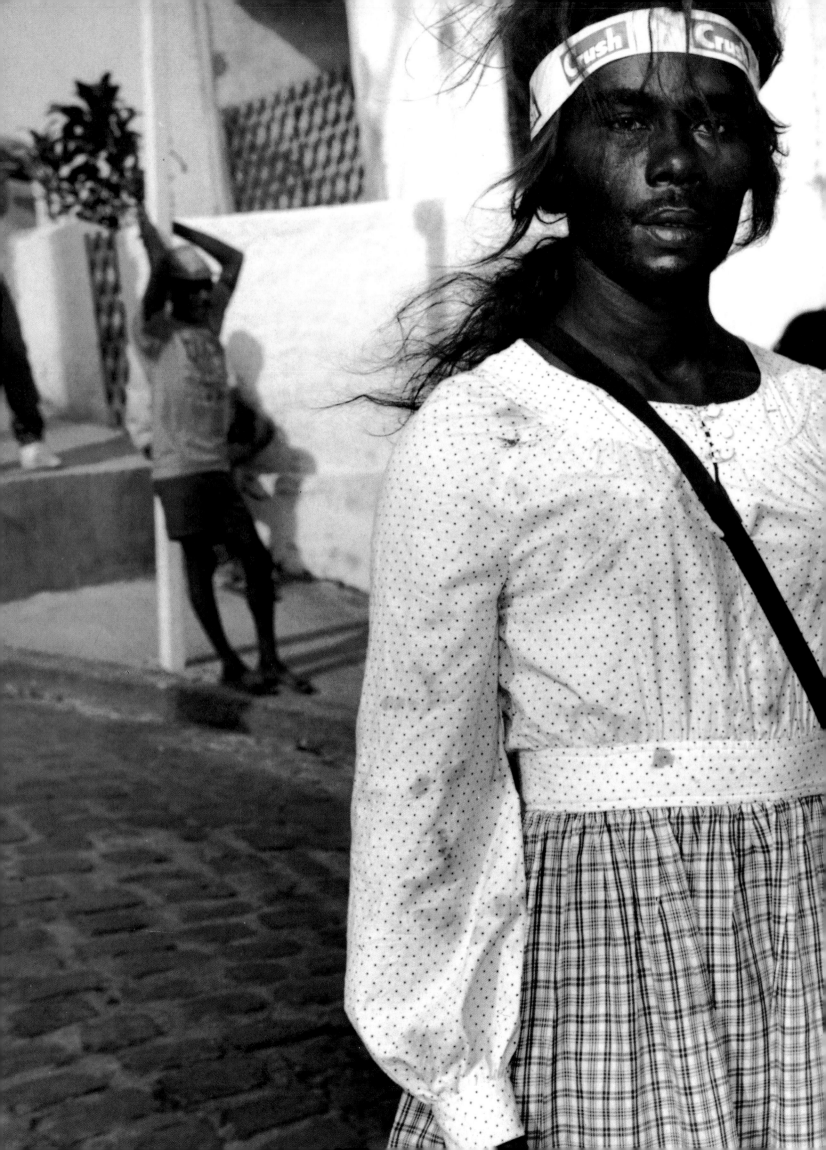

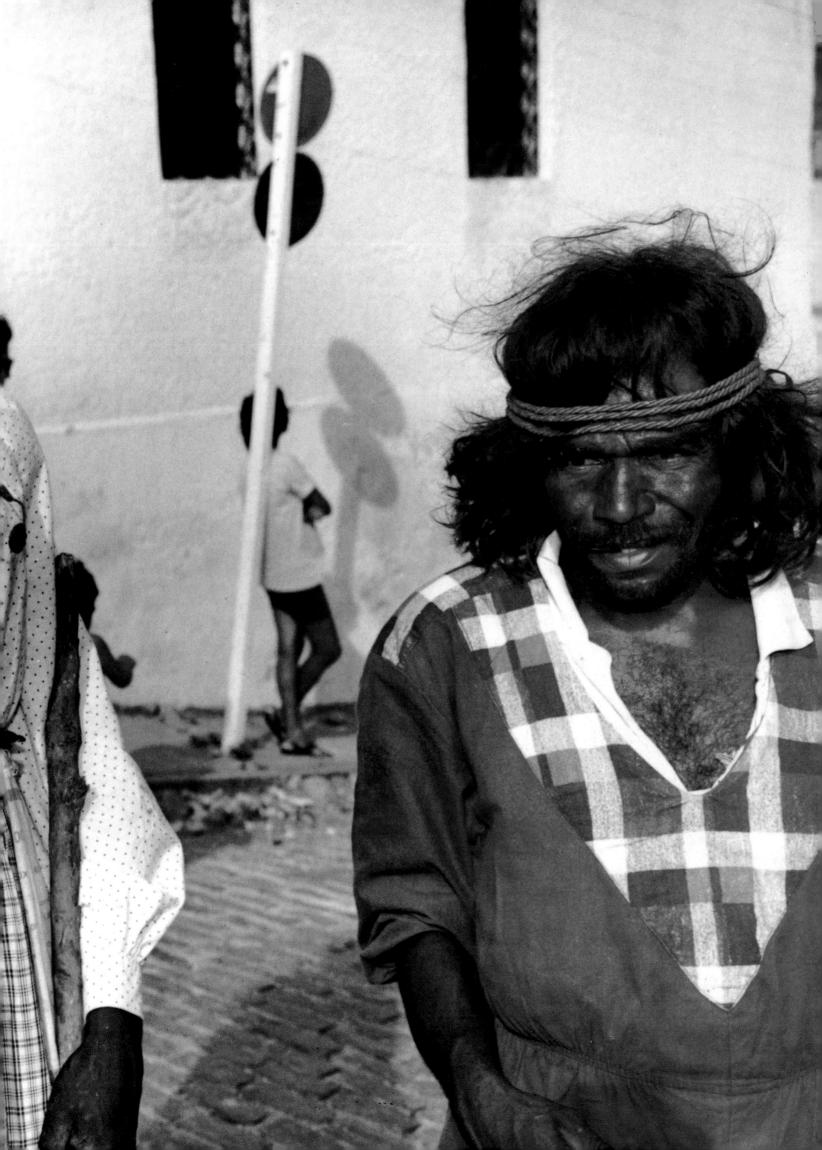

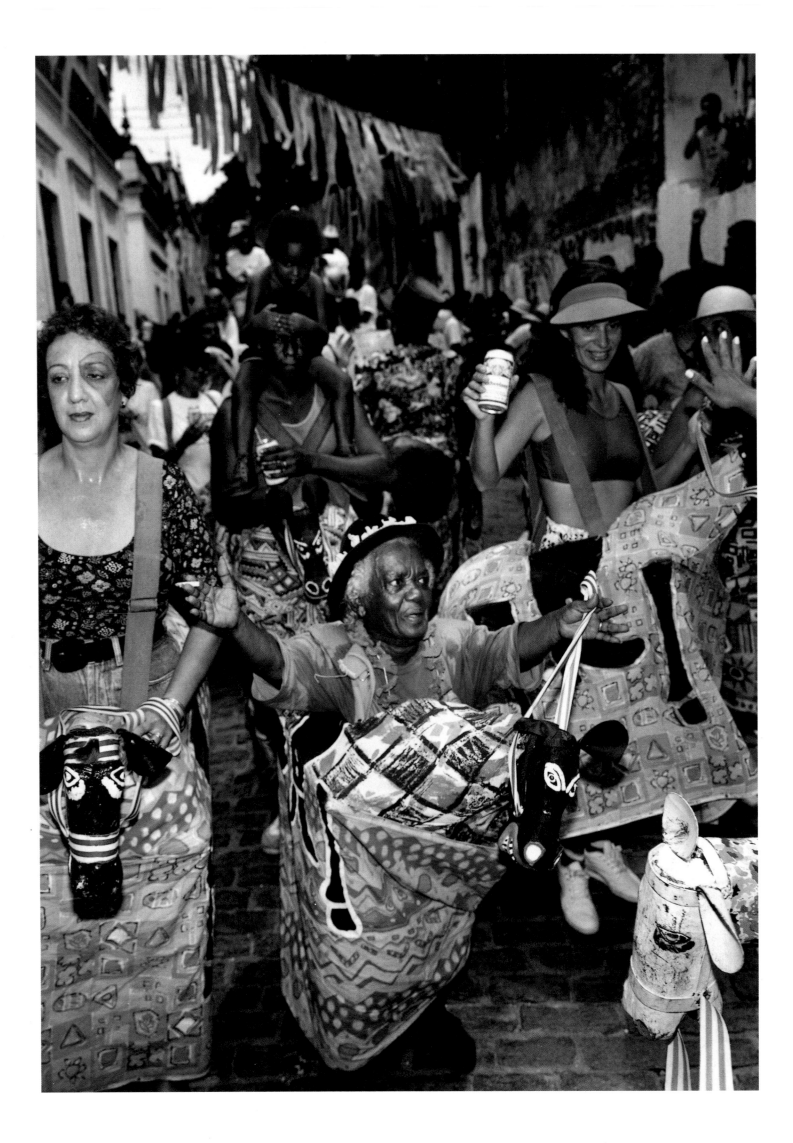

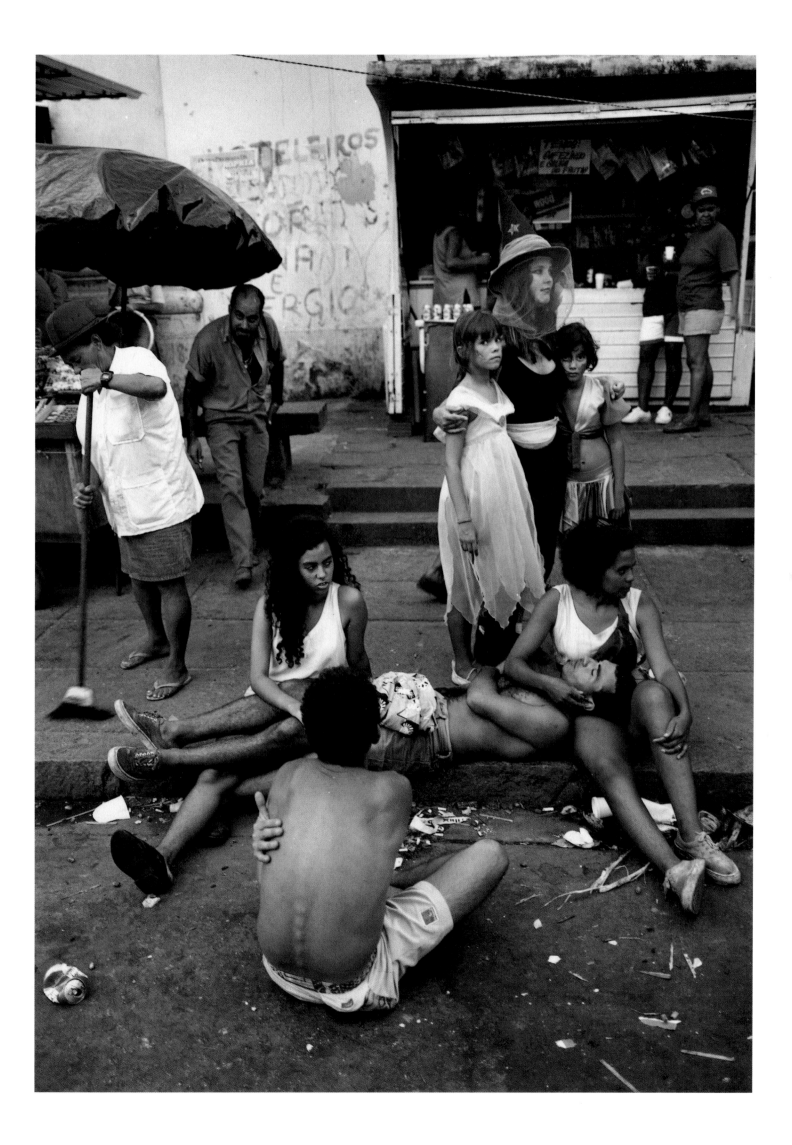

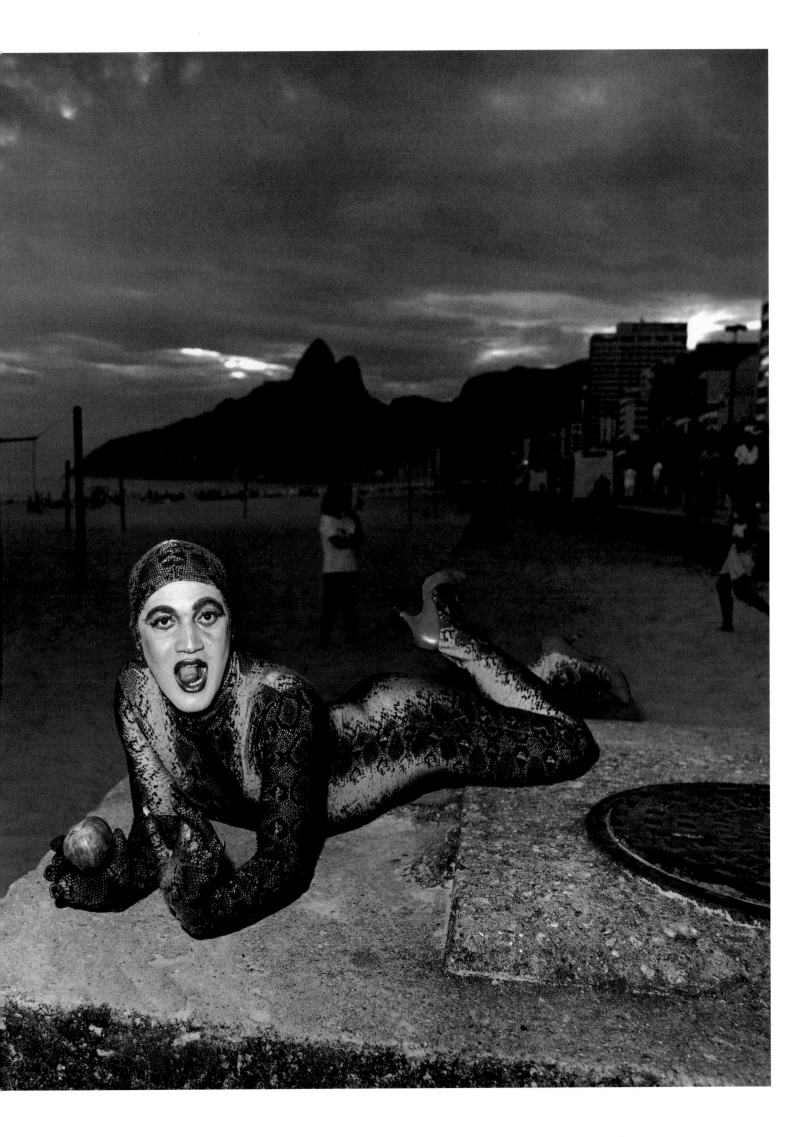

CAPTIONS

page 3

Carnival in Anhembi,
São Paulo, 1994

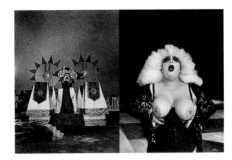

pages 20 and 21

Carnival in Anhembi,
São Paulo, 1994

The Sugarloaf Ball,
Rio de Janeiro,1991

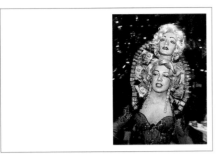

page 7

The Scala Ball
Rio de Janeiro, 1991

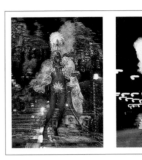

pages 22 and 23

Sambódromo,
Rio de Janeiro, 1991

Castro Alves Square,
Bahia, 1993

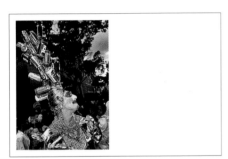

page 10

Carmen Miranda's Parade
Rio de Janeiro, 1991

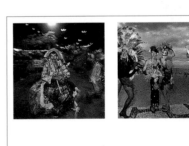

pages 24 and 25

Folklore Parade
Recife, 1992

Ipanema Band
Rio de Janeiro, 1991

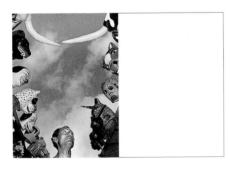

page 12

Masks' vendor
Recife, 1992

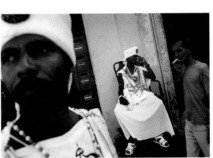

pages 26-27

Gandhi's children Parade
Salvador, 1993

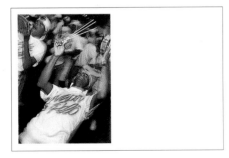

page 16

Street Carnival
Bahia, 1993

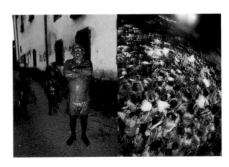

pages 28 and 29

The Mud Parade
Parati, 1995

Trio Elétrico
Salvador, 1993

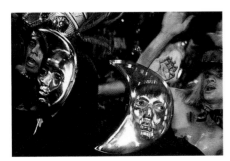

pages 18-19

The Scala Ball
Rio de Janeiro, 1991

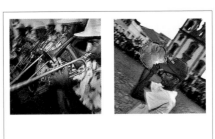

pages 30 and 31

Frevo Band
Recife, 1992

Pátio de São Pedro
Recife, 1992

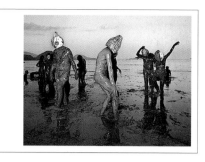

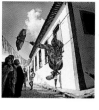
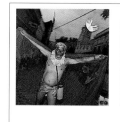

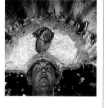
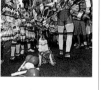

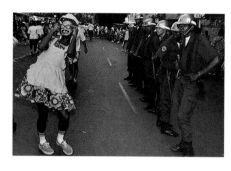

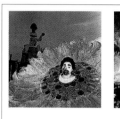

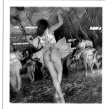
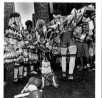

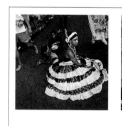

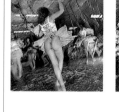
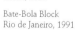

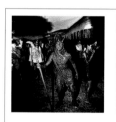
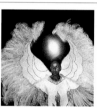

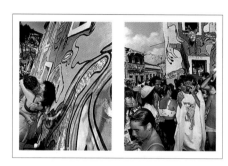

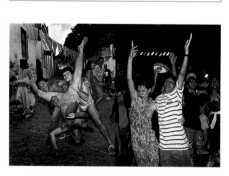

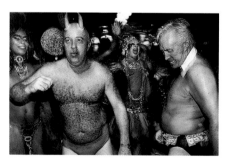

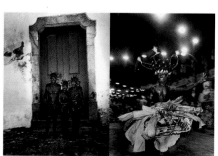
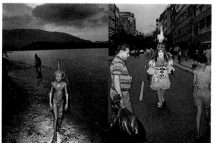

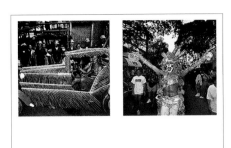

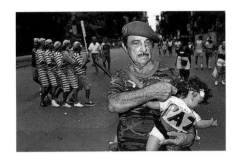

pages 56 and 57

Carnival in Campo Grande
Salvador, 1993

Camem Miranda's Band
Rio de Janeiro, 1991

pages 68-69

Rio Branco Avenue
Rio de Janeiro, 1991

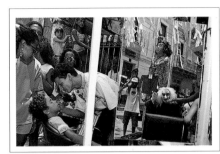

pages 58 and 59

Carnival in Anhembi
São Paulo, 1994

Miss Frevo Ball
Recife, 1992

pages 70-71

Street Carnival
Olinda, 1992

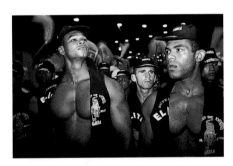

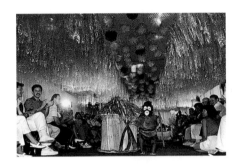

pages 60-61

Bodyguards for a Trio Elétrico
Salvador, 1991

pages 72-73

Costume competition
in the Glória Hotel
Rio de Janeiro, 1991

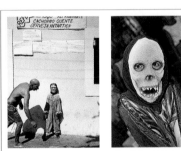

pages 62 and 63

Ipanema Parade
Rio de Janeiro, 1991

Rio Branco Avenue
Rio de Janeiro, 1991

pages 74 and 75

Street Carnival
Olinda, 1992

Rio Branco Avenue
Rio de Janeiro, 1991

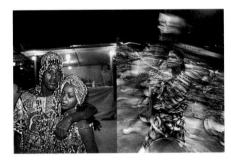

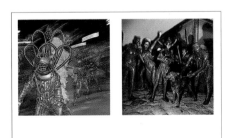

pages 64 and 65

Street Carnival
Bahia, 1993

pages 76 and 77

Parade in the Sambódromo
Rio de Janeiro, 1991

The Mud Parade
Parati, 1995

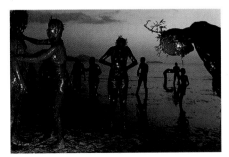

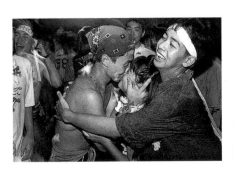

pages 66-67

The Mud Parade
Parati, 1995

pages 78-79

Japanese Ball
São Paulo, 1994

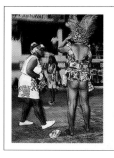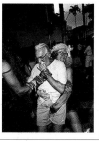

pages 80 and 81

Campo Grande
Salvador, 1993

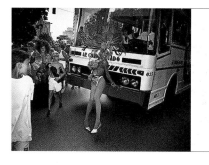

pages 92-93

Carmen Miranda's Parade
Rio de Janeiro, 1991

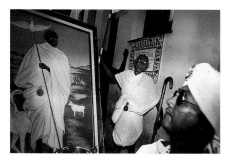

pages 82-83

Gandhi's chidren Parade
Salvador, 1993

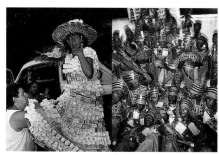

pages 94 and 95

Rio Branco Avenue
Rio de Janeiro, 1991

The Olodum Block
Salvador, 1993

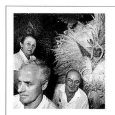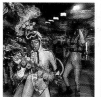

pages 84 and 85

Costume competition
in the Glória Hotel
Rio de Janeiro, 1991

Parade in the Sambódromo
Rio de Janeiro, 1991

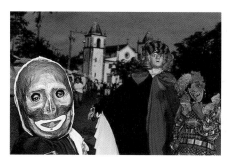

pages 96-97

Street Carnival
Olinda, 1992

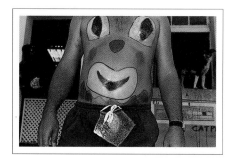

pages 86-87

Street Carnival
Olinda, 1992

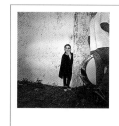

pages 98 and 99

Street Carnival
Olinda, 1992

Rio Branco Avenue
Rio de Janeiro, 1991

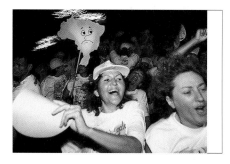

pages 88-89

Campo Grande
Salvador, 1993

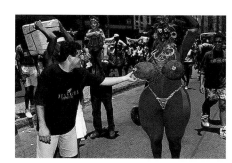

pages 100-101

Dawn's Rooster Parade
Recife, 1992

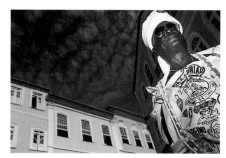

pages 90-91

Gandhi's children Parade
Salvador, 1993

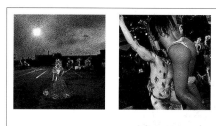

pages 102 and 103

Carnival in Anhembi
São Paulo, 1994

The Sugarloaf Ball
Rio de Janeiro, 1991

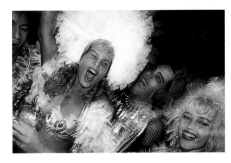

pages 104-105

The Hawaian Ball
Rio de Janeiro, 1991

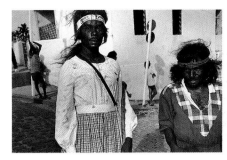

pages 116-117

Block of the Dirty
Olinda, 1992

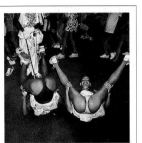

pages 106-107

Campo Grande
Salvador, 1993

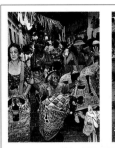

pages 118 and 119

Street Carnival
Olinda, 1992

Street Carnival
Recife, 1992

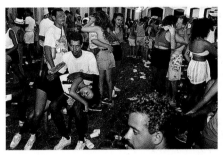

pages 108-109

Pátio de São Pedro
Recife, 1992

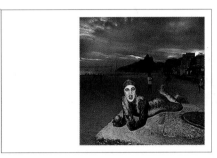

pages 120/121

Ipanema Band
Rio de Janeiro, 1991

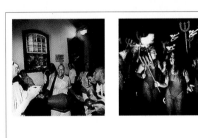

pages 110 and 111

Hare Krishna Block
Parati, 1995

Block of She-devils
Parati, 1995

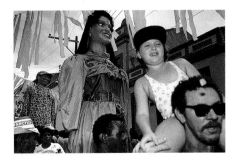

pages 112-113

Giant Dolls
Olinda, 1992

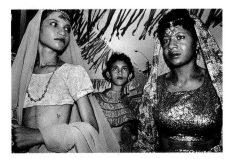

pages 114-115

Harem Girls
Olinda, 1992

7,500 copies of this book were
published in the Fall of 1996